photojojo!

insanely great photo projects and DIY ideas

AMIT GUPTA WITH **KELLY JENSEN**

PHOTOGRAPHY BY **KELLY JENSEN**

POTTER
CRAFT

NEW YORK

To everyone who taught us that you can still be a kid, even after you've grown up.

Published in the United States by Potter Craft, an imprint of the Crown Publishing Group, a division of Random House, Inc., New York.
www.crownpublishing.com
wwww.pottercraft.com

POTTER CRAFT and colophon is a registered trademark of Random House, Inc.

Library of Congress Cataloging-in-Publication Data
Gupta, Amit, 1979–
 Photojojo! : insanely great photo projects and DIY Ideas / Amit Gupta and Kelly Jensen ;
photographs by Kelly Jensen.
 p. cm.
 Includes index.
 ISBN 978-0-307-45142-2
 1. Photography—Digital techniques. 2. Handicraft. I. Jensen, Kelly, 1973– II. Title.
 TR267.G965 2009
 745.59—dc22 2008049029

Printed in China

DESIGN BY KARA PLIKAITIS

PHOTOGRAPHY BY KELLY JENSEN

FLIP PHOTOGRAPHY BY CHADCHEVERIER.COM; ORANGE COUNTY, CALIFORNIA
LINE ART BY KATE BINGAMAN-BURT
ILLUSTRATIONS PAGE 118 BY LA TRICIA WATFORD
INSTANT BOOKS PROJECT © 2008 ESTHER K. SMITH, ALL RIGHTS RESERVED, USED BY PERMISSION OF ESTHER K. SMITH
SUBVERSIVE CROSS STITCH®, PAGE 72, IS A REGISTERED TRADEMARK OF JULIE JACKSON.

10 9 8 7 6 5 4 3 2 1

First Edition

Dear Reader,

If you're trying to decide whether you should buy this book... Don't buy it. Naw, we're joshing you. THIS BOOK IS TOTALLY AWESOME.

Our honest opinion: If you like taking pictures, you will love this book. You'll be inspired, and your friends will be amazed, not only by the beautiful photo projects all over your home—and there will be plenty of those—but also by the marked improvement in your disposition and personal appearance.

Years later, whilst preparing an acceptance speech for a prestigious awards ceremony in a decadent European palace, you'll trace all your success back to this one moment when you decided to embrace your creativity and buy the *Photojojo!* book. Yep, that's right, this book changed your life. (You're welcome.) Someday, you'll buy a copy for your kids, and the circle will continue. Their creativity will blossom, and they'll go on to create great works of art, cure catastrophic diseases, or create a foundation to clothe the lobsters. You don't owe it to yourself to buy this book, you owe it to humankind.

If you've already bought this book and are simply the type that reads from cover to cover... Hello, new friend. Thanks for buying our book!

Photojojo! is the creation of Photojojo.com, a tiny little outfit where we publish a newsletter of the world's best photography tips and projects, sell amazing photography doodads, and toil night and day to make photography fabulous. We started Photojojo because we saw our friends taking thousands of photos with their new digital cameras and then forgetting all about them. That seemed kinda sad, because there are a million-and-two things you can do with those photos to make them even more rad. Over the years, we've shown millions of people how to have more fun with photography by getting their digital photos off their computers and into the real world, and we decided to take our own advice and make a book.

We think photography is awesome. It's an art form anyone can practice, one in which you can't make mistakes. Photojojo is here to make it awesomer. This book is full of some of the most fun, most amazing, most eye-poppingly gorgeous photo projects, ideas, and tips ever told. We hope you enjoy reading it even *more* than we enjoyed writing it. Because that was a frenzied, heart-wrenching, brain-zapping affair, really. But we think it was worth it. (Write us and tell us what you think! E-mail thebook@photojojo.com.)

Amit Gupta Kelly Jensen

PART ONE
Do More with Your Photos 10

(in two parts)

Photography is an art that's fun for everyone. This book shows you how to do **two** things:

* Do more with your photos. (DIY and craft projects for showing off your photos in fantastic ways.)

* Have more fun with a camera. (Inspiration, ideas, and new perspectives to get you out and shooting more photos.)

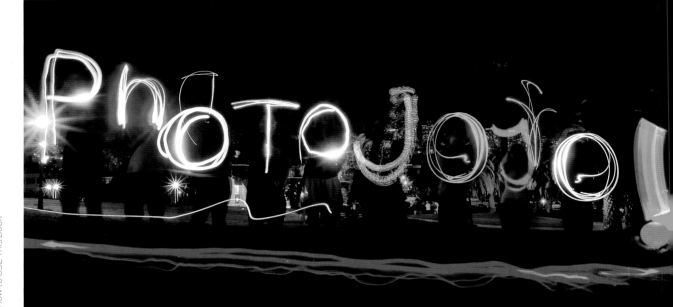

How to USE This Book

Photojojo is all about helping folks take better pictures and do more with them once they've got 'em. So here are a couple of useful pointers, because we love you so. First, check out the sections on how to take better pictures (page 149) and improve the ones you have (page 7). Then, read up on the materials you'll need for the projects we've put together (page 8), and the resources section telling where you can find those materials (page 184). And don't forget to check out the special *v*2.0 project variations scattered throughout the book. Then get in there! Start making stuff in Part One, and start having more fun with your camera in Part Two.

HOW TO
Improve
THE PICTURES
YOU ALREADY HAVE

Image-editing software is essential in the digital age. Even if you shoot film and scan your images, you'll need software to help you crop, resize, and generally whip things into shape. Regardless of which software program you use, **sit down with it and read the manual, do the tutorials, and learn everything you can about it**. The more you know, the better. More important than software, however, are the concepts of color, exposure, resizing, and printing, so we'll let you in on the essentials right now.

Edit on a Separate Layer

Programs such as Photoshop allow you to create separate layers. (This means that you can stack images on top of each other in the same document.) Make full use of this feature if you have it. Copy the background as a new layer and edit on that layer. That way, if you make mistakes, you can throw out that layer and start fresh.

If you have a program such as iPhoto that doesn't allow changes on a separate layer, copy the photo to a backup folder before you start editing. Then, if you mess up the picture while editing, you can delete it and start over. Never discard an original photo unless you're certain you never want to use it again.

Correct Color

In photography, the rainbow has six colors: Magenta is the opposite of green, red is the opposite of cyan, and yellow is the opposite of blue. This means that to correct a green color-cast (caused by fluorescent lights), you must shift the color of the picture toward magenta.

Every image editor has a different method of balancing color. Photoshop has a "color balance" function with sliders for magenta-green, red-cyan, and yellow-blue that you can shift to adjust the color. In iPhoto, there's a yellow-blue "temperature" slider and a magenta-green "tint" slider. Whatever program you use, know that color balancing isn't an exact science; it's just something you have to practice until you get a feel for it. The best way to learn is to choose a photo that looks perfect to you and use it as a reference.

Adjust Exposure and Contrast

If a picture looks too dark or too light, you can adjust the brightness to make it lighter or darker. Different methods include brightness and contrast, levels, and curves.

When you make a picture darker or lighter, the contrast tends to decrease proportionally. Unfortunately, this is another inexact science. Refer to your "perfect" picture, and if the one you're working on starts to look flat by comparison, punch up the contrast a bit.

Resize and Crop

Many images need to be cropped or changed to a different size before they can be used for prints or other projects. These are usually simple commands, called crop or image size, where you can plug in the desired vertical and horizontal dimensions.

There is also a little something called resolution (pixels per inch or "PPI"). Higher numbers are better: The higher the number, the more pixels your image has, which means it looks sharper and takes up more memory on your computer.

The only time low resolution is preferable is for e-mail and Web usage, where file size is critical. Otherwise, the lowest acceptable resolution for a print is 150 pixels per inch (2.5cm) at the final print size, but we suggest 300 ppi for best results. Before printing, check the page setup to make sure the printer is set for the desired paper size, orientation, and paper type (i.e., matte or glossy photo paper).

THE
Materials
YOU'LL NEED

The projects in this book all have different requirements, but we're listing the basics here so you know what you'll need before getting too far in.

Photo Stuff

Camera: Either film or digital will work just fine. Most of these projects will work with either a point-and-shoot or a single lens reflex (SLR). There are a few exceptions, but by and large you'll be fine with whatever camera you can get your hands on.

Computer: Whether Mac or PC, laptop or desktop, your computer doesn't have to be fancy as long as it works.

Image-editing software: Ideally, this would be Adobe Photoshop, but that's a really expensive program and not many of us can get our mitts on a copy (not legally anyway). Apple's iPhoto or Picasa for Windows are good substitutes, and GIMP is a great free alternative. See our resources section at the end of this book for more information (page 184).

Printer: Any garden-variety inkjet photo printer will do, as long as it prints on paper sizes up to 8½" x 11" (21.5cm x 28cm).

Scanner: Nice to have if you shoot film, but you can also get your local lab to scan your images and burn a CD for you when they develop your film.

Printing papers: We tend to keep matte and glossy photo paper on hand. In this book, we also call for some specialty papers such as printable magnet sheets and sticker paper, but those vary from project to project.

Printable fabrics: Canvas and cotton fabric sheets designed for use in inkjet printers. We used Inkpress canvas and cotton lawn from National Artcraft (Resources, page 184).

Tripod: Not necessary for most projects in this book, but you'll want one if you get more serious about photography. A tripod doesn't have to be expensive or fancy, as long as it keeps your camera still. (See the Camera Hacks section on page 162 to make your own.)

You will need some basic craft supplies for many of the projects in this book. You probably have most of them lying around already.

Craft Stuff

Pencils	Fine-tip permanent markers
Ruler	Craft knife and cutting mat
Scissors	Glue
Rubber cement	Glue stick
Paintbrushes	Tape: clear, electrical, and double-sided
Hole punch	

Tools

Again, the tools we use for projects comprise some pretty basic stuff. No table saws and intricate machinery here!

Power drill (with an assortment of bits and a piece of scrap wood to drill into)

Pliers

Screwdriver

Level

Tape measure or yardstick

Hammer



PART ONE
DO MORE WITH YOUR PHOTOS

Welcome to Part One of the best book you'll ever read.

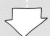

Really.
You think we're
kidding?
Hah!

Moby-Dick:
mere piffle.

*For Whom
the Bell Tolls:*
claptrap.

The Klingon
Hamlet?
Closer, and yet
still **no.**

MAKE stuff. BUILD stuff. just

⇨ Why is this the best book ever, you ask?
(And don't think we can't see that skeptical gleam in your eye.) Because it will show you how to take better photos and do more with them than any other book. Yes, that's right! Better photo ideas than even *Moby-Dick* has to offer! Wow!

Let's start out with some projects that get those awesome photos of yours off the computer and out into the world so you can enjoy them.

GET your PHOTOS out there.

[
Chapter 1:
EASY CHANGE-UP
Make Putting Up Fresh Photos
Quick 'n' Easy
]

GINORMOUS
Photo Mosaics

One of us here at Photojojo lives in an apartment where she can't put holes in the wall. And with her high ceilings, that's a lot of white wall to cover without using any nails. In the midst of her despair, she realized that there was a huge, easy, affordable, and (best of all) removable solution to the problem: the Ginormous Photo Mosaic. Though our mosaic differs slightly from traditional mosaic art, which uses small images or fragments to form one larger image or pattern, the Photojojo photo mosaic still shows off the bigger picture—the awesome memories you have of family and friends.

You can make this project as big or small as you want. In fact, **if you had enough prints, you could cover an entire wall from floor to ceiling.**

WHAT YOU'LL NEED:

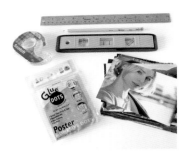

* One hundred 4" x 6" (10cm x 15cm) prints (all horizontal or all vertical, and all matte or all glossy)
* Ruler
* Clear tape
* Removable adhesive (We bought Glue Dots™ at a drugstore. They're great!)
* Level
* Pencil
* Yardstick (optional)

More Ideas:

* Show your pride by making each row a different color of the rainbow (i.e., all red photos in one row, all orange photos in the next row…).

* Try different shapes: Lay out your mosaic in a square, or cut around the edges to make a giant circle. Heck, make it in the shape of your favorite Space Invader.

* Take one photo and use a photo editing program to blow it up and split it into one hundred 4" x 6" pieces, then assemble the resulting prints to re-create the photo on a large scale.

STEP 1:
Decide how you want to lay out the photos in your mosaic. We used the little thumbnail-sized photos that came with our prints to make a miniature mockup. Random selection works just fine, though. You should plan on 10 rows and 10 columns, each made of 10 photos.

STEP 2:
Lay out each section on a clean work surface. You can go row by row, but we found it easiest to divide our mosaic into quarters, working with rows of 5 photos at a time.

Line up the first photo side by side with the second photo, with both photos facing down. You can use a ruler to make sure they're aligned straight along the bottom edge. Make sure they are perfectly flush along the edges, then tape them together on the back side. If you made a mockup, check to make sure you're taping them together in the right order. **a**

Repeat this step until you have 5 photos taped together.

STEP 3:
Keep making rows of 5 photos until you have a total of 5 rows. Now, lay the first row above the second row (make sure you've got the direction right according to your mockup). Line up the edges as flush as you can and tape each photo to the one below it. It's easier to line up each photo than to try to do a whole row at once. Continue taping rows together until you have a section of 25 photos taped together.

STEP 4:
Repeat steps 2 and 3 until all 4 quarters of your mosaic are assembled.

STEP 5:
Attach the removable adhesive to each photo in the mosaic, placing them toward the outer edge of the outer photos and in the center of the rest. (We like Glue Dots because they're easy to remove and don't leave marks on painted walls, but you can use that blue putty stuff, or double-stick tape. If you're using Glue Dots, remove one backing to attach it to the photo, but leave the other one on for now.) **b**

STEP 6:
Use your level and a pencil (and a yardstick if you have one) to mark the bottom edge of where you want your mosaic to hang on the wall. Mark where the center of the mosaic should be with an extra pencil mark. **c**

STEP 7:
Grab the right-hand bottom quarter of the mosaic. Remove the backings from the Glue Dots, if using, on the bottom row of photos. Line up the bottom edge with the mark on the wall so the photos just cover it, and align the left-hand edge of the row with the center mark. When you have it lined up (get a friend to help you eyeball it) press the removable adhesive onto the wall, starting on the right-hand edge and moving left.

Remove the backings from the next row of photos if necessary and press it into place on the wall, above the first row. Repeat, row by row, until the whole section is in place.

STEP 8:
Repeat step 7 with the other lower quarter, making sure the two quarters line up closely next to each other. When the lower half is in place, repeat steps 7 and 8 with the top quarters. **d**

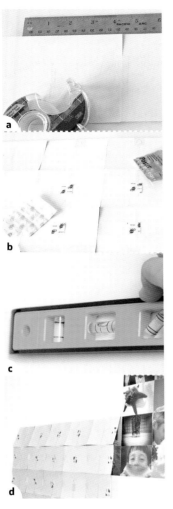

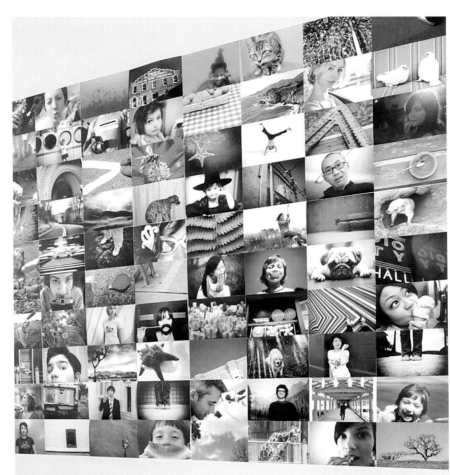

CHECK YOU OUT,
Superstar!

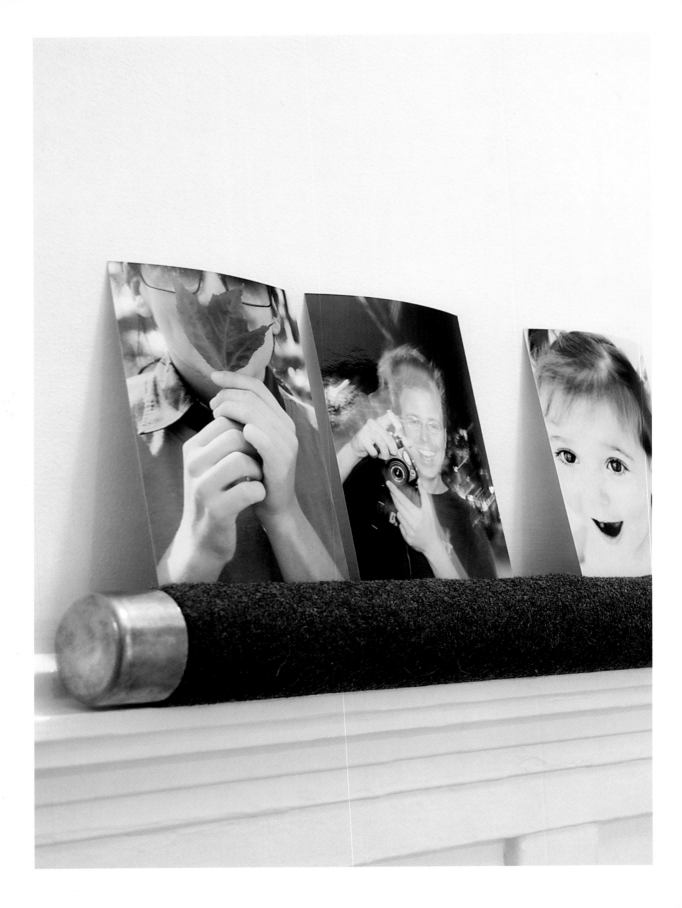

THE SLEEK, STYLISH
Photo Display Rail

Ever browse those schmancy interior design shops and find an amazing, perfectly modern, perfectly simple, perfectly everything chair/frame/whatever, only to have it ring up at $895 plus tax? Yikes!

Sometimes if you want high style, you just have to make it yourself. This picture rail is an easy way to make a photo display that you can quickly change and rearrange. It looks like it came right off the showroom floor at the fancypants design center (except better), and costs a fraction of what you'd pay there. Best of all, you can find everything you need in a quick spin around your home-improvement or hardware store. (Admit it, you've been looking for an excuse to go there anyhow.) So skip the trip to the design emporium. You'll save some shekels, and no stylish salespeople will look down their noses at your dusty sneakers. Take that, spendy stylemongers!

WHAT YOU'LL NEED:

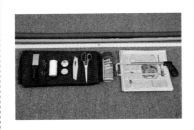

* 6' (1.8m) of polyethylene pipe insulation sized to fit ³/₄" (2cm) pipe. The insulation foam should be at least ³/₈" (9.5mm) thick.

* 6' (1.8m) of ³/₄"- (2cm-) diameter electrical conduit

* Hacksaw or tubing cutter

* 2 yd (1.8m) felt

* Scissors

* Spray adhesive

* Newspaper

* Utility knife

* 6'- (1.8m-) long strip of wood or metal to use as a straightedge

* Putty or taping knife

* Two 1¹/₂"- (4cm-) diameter copper pipe caps

* 2 L-hooks or cord and 2 eye hooks for mounting

* Photos

* Cardstock (optional)

STEP 1:
Cut the foam insulation and conduit to the desired length, using a hacksaw or tubing cutter. **a**

STEP 2:
Cut a strip of felt 7" (18cm) wide and 1–2" (2.5–5cm) longer than the conduit. **b**

STEP 3:
Using the slit along the foam insulation tube, spread the foam apart and apply spray adhesive to the inner side of the tube. Then, quickly spray the adhesive onto the conduit as well. **c**

Note:
When using spray adhesive, work outdoors and lay down some newspaper to protect your work surface from overspray.

STEP 4:
Wrap the foam insulation tube around the conduit. Try to keep the slit straight, but don't worry if it's not perfect—the key is making sure that the opposite sides of the slit fit tightly together. Make sure the foam has good contact and bonds well to the conduit. Use an extra shot of spray adhesive where needed. **d**

STEP 5:
Use your utility knife and makeshift straightedge to cut a second slit down the length of the foam. Make this slit on the opposite side of the foam from the factory slit. This is the only part of the project where you need to be precise. Keep your cut straight and parallel to the conduit and hold the knife at a consistent angle. Otherwise, your photos won't make a nice even row when you mount them. Also, make sure the cut goes all the way through the foam down to the conduit. You now have a long, squishy bar. Excellent. **e**

STEP 6:
Spread out the strip of felt so that it's flat and has no wrinkles.

STEP 7:
Apply spray adhesive to the outer surface of the foam tube and set it along the center of the strip of felt, with the slit you just cut facing up. Wrap the felt around the tube, working your way up and down the length of the tube to make sure the felt adheres well and doesn't have any wrinkles. If you mess up, peel the felt off and try again. **f**

STEP 8:
Trim off the excess felt, leaving enough material to tuck the edges into the slit you cut. Work slowly here. If you cut off too much, there won't be enough to push into the slit. You do not want the edge of felt to stick up. However, if you leave too much, it will bunch up, forcing the slit open, thus unable to clamp the photos properly. Use the putty knife to push the felt into the slit. **g**

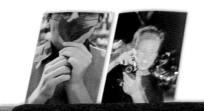

STEP 9:

Trim the ends of the felt flush with the ends of the foam and slip one of the copper caps onto each end. **h**

STEP 10:

Now all that's left is to mount it. Here are two ideas:

* Screw a pair of eye hooks into the underside of a shelf or cabinet. Make a loop of cord large enough to fit around the end of the bar, about 3" (8cm) in diameter. Thread the loop through one of the eye hooks before knotting it. Slip the knot to the backside of the bar where it will be out of sight. Repeat this step for the other end of the bar.

* Screw an L-shaped hook into the wall so that the leg of the hook extends sideways, parallel to the floor and the wall. Slip the leg of the hook between the copper end cap and the bar, and have a friend hold the bar in place while you mark where the other end cap lines up on the wall. Screw a second L-hook in at the location you marked. Slip the legs of both L-hooks between the bar and the end caps—the bar is light enough that the L-hooks will hold it in place on the wall.

STEP 11:

Position the rail so that the slit faces up and carefully push the edge of your photos into it. You may want to stiffen them with cardstock so they stand up nice and straight.

from contributing guru
.
Steven Dodds

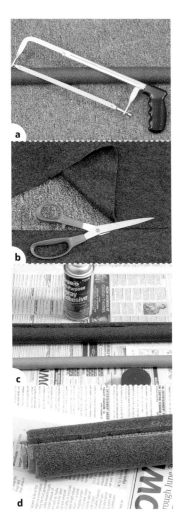

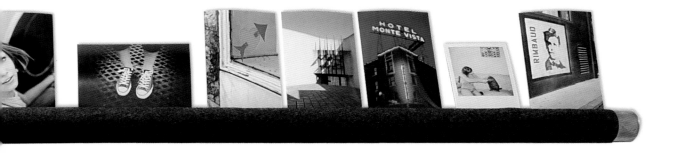

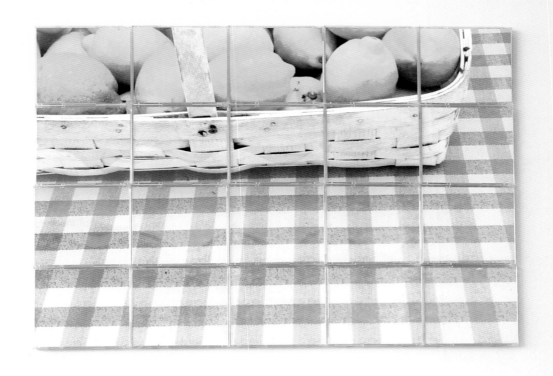

CD JEWEL
Case Frames

Come clean. Most of your walls are as bare as the day you moved in. Plus we know you've got a mess of CDs gathering dust in your closet. After all, who listens to CDs anymore?

Looks like you've got yourself two separate problems. But to the trained observer, the sage of interior design, and the knower of all things photographic (um, that's us), there is a single, efficient, even elegant solution. **Consider this a friendly intervention.** This clever project uses CD jewel cases to make rearrangeable, refillable photo frames for those empty walls of yours. Hang them individually, or tile them together to make a photo mural, shown opposite. As for the rest of your retro-clutter, you're on your own. After last year's magnetic tape–weaving disaster, we're not even getting near your VHS collection.

WHAT YOU'LL NEED:

* Many lovely photographs printed at 5" x 7" (12.5cm x 18cm)

* CD jewel cases (the standard size, not the slim kind)

* Cardboard, approximately 5" x 6" (12.5cm x 15cm)

* Scissors

* Ruler

* Tape (double-sided works best; archival if you're picky)

* Velcro tape or removable adhesive, such as Glue Dots

* 5" x 7" (12.5cm x 18cm) photo paper

Photojojo Fact!

Your friends might just be green with envy over this resourceful photo project, but you'll be living life even greener. CD jewel cases are made with PVC plastic, non-recyclable in most communities. So get crafty and upcycle unwanted jewel cases into photo frames. It's a great way to keep trash out of the landfill while kissing those plain old walls good-bye.

TO MAKE ONE FRAME:

STEP 1:
Remove the plastic insides that hold the CD from your jewel case. Take out the paper insert from underneath and remove the perforated edges. Trace an outline around the insert onto the cardboard, then cut it out. (You'll use these cardboard inserts to back your photographs and prevent them from buckling.) **a, b**

STEP 2:
Crop your photo to exactly $5^3/_8$" x $4^5/_8$" (13.65cm x 11.75cm) to fit snugly in the back of the jewel case. **c**

STEP 3:
Attach the cardboard cutout to the back of the cropped photograph using double-sided tape. Then, plop the photo into the back of the jewel case, facing out. Close the jewel case. **d, e**

STEP 4:
Affix a piece of the hooked side of the Velcro tape to the back of your finished case and a piece of the looped side of the Velcro tape to the spot on the wall where you'll hang your frame. Alternatively, place the removable adhesive on all 4 corners of the back of the case and stick it on the wall.

TO MAKE A MURAL:

STEP 1:
For this version, you'll need one high-resolution digital photo. Resize it in Photoshop (or your image editor *du jour*) to at least $26^1/_2$" by $18^1/_4$" (67cm x 46cm).

STEP 2:
Set the selection tool to a fixed size of $5^3/_8$" x $4^5/_8$" (13.65cm x 11.75cm). Starting in the top left corner of the photo, select an area and copy it.

STEP 3:
Create a new document sized $5^3/_8$" x $4^5/_8$" (13.65cm x 11.75cm) at the same resolution as your large photo. Paste the selection you just copied into this document.

STEP 4
In the large photo, line up a vertical guide at the right edge of the selection you just copied in step 2 and a horizontal guide at its bottom edge. Make sure the "snap to guides" setting is enabled (located in the View menu in most programs). Move the selection marquee to the right (if using Photoshop, hold down the Shift key while moving the marquee). The left edge should now align with the vertical guide you just added. Copy and paste the selection into the small document.

STEP 5:
Keep repeating step 4 until you have copied and pasted all areas of the large photograph and you have 20 layers in the small document. (Whenever you move down a row in the large document, remember to add a horizontal guide underneath the latest selection.)

STEP 6:
Print out each layer of the small document one at a time on 5" x 7" (12.5cm x 18cm) photo paper. Now you can follow steps 1–4 of the single frame instructions to create your individual frames. When it comes time to hang them on the wall, reassemble the picture in order, and place the jewel cases as close together as possible. Ta-dah! Super stylish, yet super eco. Good-bye empty walls and lame old CD cases! Nice work, pal.

a b c

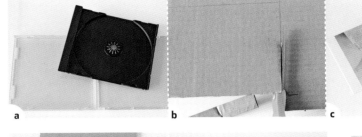

d e

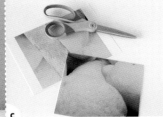

A Century ✛ of Music Packaging

1877: Thomas Edison invents the phonograph. By the 1880s, music on wax cylinders is being sold in cardboard tubes similar to modern-day oatmeal cartons.

1894: Gramophone records begin to compete with phonograph cylinders, surpassing them in popularity by the early 1900s. Originally simple paper sleeves, record covers became works of art by the 1960s. One of the most sought-after record covers today is the "butcher cover" of The Beatles' "Yesterday . . . and Today," a cover considered so vulgar by U. S. fans that it was pulled even before its full retail distribution.

1963: Phillips introduces the compact cassette tape, which was to drive the bloated 8-track to extinction. With the onset of audio tape recorders, the handwritten scrawl of the teen mixtape becomes ubiquitous.

1982: The first compact disc is produced in Germany (it was "The Visitors" by ABBA). Each CD originally came in a 12" tall cardboard box so it could be sold on record store shelves intended for vinyl LPs.

1994: MP3 files begin to inundate the Internet. The age of music as molecules comes to an end as the age of music as bits begins.

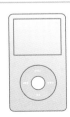

The Amazing, Gravity-Defying Magnetic Photo Chain

OKAY, we bet we only need to say this once: magnets.

No? Not enough? **Magnets. Magnets! MAGNETS!**
We love 'em. After all, without magnetism credit cards wouldn't swipe, much less dip, and televisions would never have brought their cathode ray glow to the living room. So we love this little trick that uses magnets to make a chain of photos on the wall. It makes it easy-breezy to swap out your photos for new ones. Plus it's cheap enough that you can make them for all your friends! Best of all, it's an excuse to buy magnets and lots of 'em. Get a bunch of extra ones so you can make a DIY field compass, chase iron filings around a piece of paper, or prevent Hardware Disease in domestic cows. (You think we're kidding about Hardware Disease? Go ahead, google it. For reals.)

WHAT YOU'LL NEED:

* 10 photographs
* 72" (1.8m) steel ball chain (We connected two 36" [91cm] lengths.)
* 2 "Type A" end ring connectors for ball chain (We got ours from www.ballchain.com.)
* 2 small nails and a hammer
* 10 neodymium magnets (You can get them online and at some craft stores. They're tiny and super strong!)

STEP 1:
If you have short lengths of ball chain, string them together with connectors (they usually come with one connector already attached) until you have a 72"- (1.8m-) long chain. Otherwise, proceed directly to step 2.

STEP 2:
Attach the ring connectors to each end of the chain. **a, b**

STEP 3:
Hammer a nail in the wall where you want to hang your photo chain. Use the ring connector to hang the chain on the nail and mark where the end of the chain hits the wall. Put another nail in at that mark, and hook the end ring connector over that nail. This will keep your photo rope from moving around too much when you change up your photos.

STEP 4:
Pick out 10 photos that you love, and hold them in front of the chain and attach them with the magnets. Jump up, jump back, and get down. You gots you some new decor.

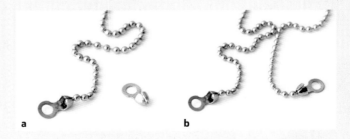

a b

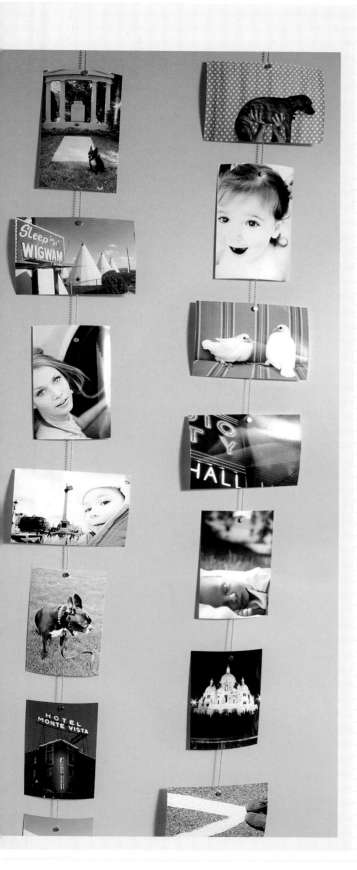

Wall of Chains

Wanna spice it up? Make a bunch of these magnetic photo chains and use them to cover a whole wall. Make them as long or as short as you want. Send us photos of your setup—we'd love to see what you make with this project! Or, hang your photo chains horizontally across the wall like a clothesline. Or heck, put up an actual clothesline and hang your photos on it with clothespins!

Minimal nail usage required.

TURN ALMOST ANYTHING INTO A
Photo Stand

Do you ever get the feeling that small household items are multiplying all around you? Somehow one rubber band in the junk drawer becomes a wad of thirteen rubber bands and a spool of thread. Two innocent tealights replicate in the dark spaces under the sink to become a nefarious brood of cluttering evil. And then the mismatched forks start appearing in the back of the silverware drawer, and you know the tide has turned against you. But fear not, harried citizen! You must learn the ways of Kung Foto before you can be freed. **Placing a photo on many small household items neutralizes their evil powers and turns them into harmless picture stands.** Forks can be subdued in this manner, as can the Wily Tealight. Sit, young Grasshopper, and we shall show you the ways of the Photo Stand.

WHAT YOU'LL NEED:

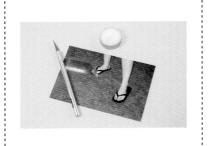

* Tealight
* Craft knife or scissors
* Photo

STEP 1:
Empty the tealight holder: Either dump the candle out or burn it until it's gone. Mourn a little. Get over it.

STEP 2:
Cut the tealight holder down the middle of one side. Cut to, but not through, the base of the holder. Repeat on the opposite side.

STEP 3:
Fold the tealight in half so that the halves of the base almost touch. You will create a half-moon shape. **a**

STEP 4:
Stick a photo in the slot. Make more. Populate your home with little tealight photo stands! **b**

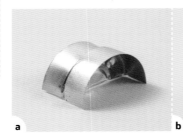

a b

Flying Jackalope, Wall Drug Wall, South Dakota

WHAT YOU'LL NEED:

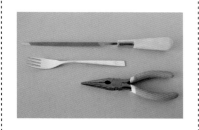

* Fork[†]

* Needle-nose pliers

* Photo

* Metal file

[†]When searching for forks, we recommend choosing silver-plated or nickel. Sterling silver is super strong and very tough to bend with pliers. Thrift stores and antique malls are the best places to find unique and vintage forks.

from contributing
guru
• • • • • • •
Nikki Mans

TURN A FORK INTO A PHOTO STAND

STEP 1:
Using the needle-nose pliers, bend back the 2 middle prongs of the fork. Don't worry about how far back at this point. You can always bend them more in step 3. **a**

STEP 2:
Grab the tip of each outer prong with the pliers and curl the ends up. **b**

STEP 3:
After you've bent and curled the fork, set it prongs down on a flat, hard surface to check that the fork stands up straight and doesn't wobble. If it wobbles, keep adjusting the prongs with your pliers until you get it right. To make sure that the angle is proper on the fork easel, place a photo on it. If the photo falls down, keep adjusting! **c**

STEP 4:
Now that you're done with the pliers, it's time to use the file. Smooth down any sharp edges or marks that you may have left with the pliers. Ta-dah! You're done! Now, go grab some more forks—these make great simple gifts and beat a boring photo frame any day. **d**

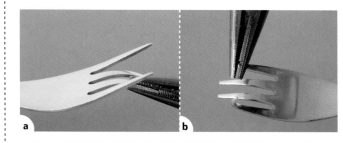

a

b

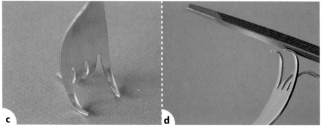

c

d

*v*2.0

Turn Chuck Norris into a Photo Stand

CHUCK NORRIS cannot be turned into a photo stand.
DON'T EVEN TRY.

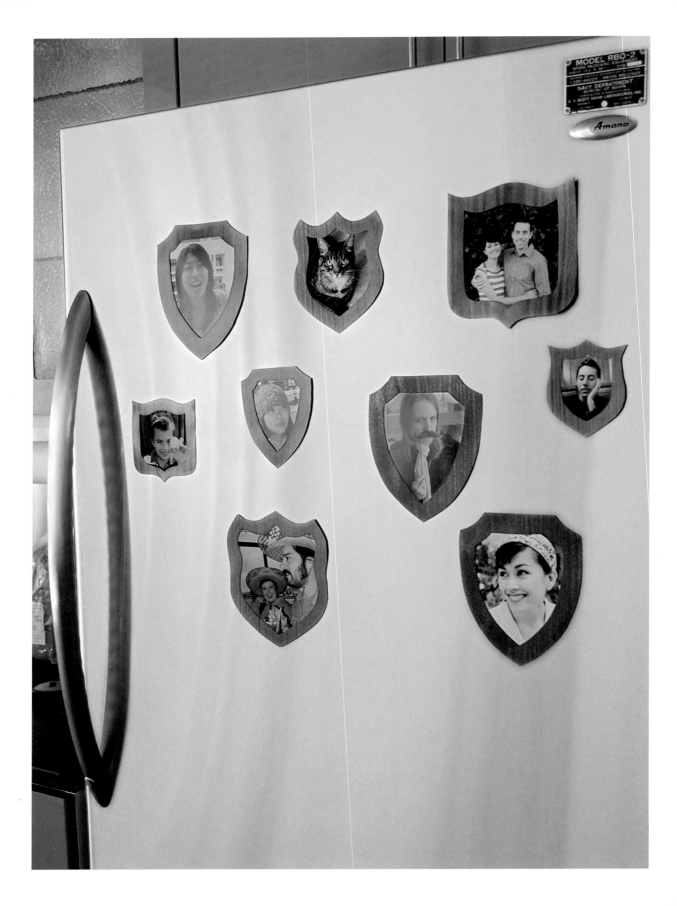

PIMP
Your Fridge

(Chic *Magnetic* Photo Frames)

When Marcel Audiffren filed patents in 1895 for "the world's first electric kitchen cabinet," he envisioned his customers using the large steel box to display photography and kids' artwork. It was a dismal failure.

Years later the American Audiffren Refrigerating Machine Company purchased the design and imbued the cabinet with cooling capability. The "fridge" soon became a fixture of modern life. **To this day it serves two primary purposes: the preservation of spoilage-prone foodstuffs and the display of snapshots, homework assignments, and the like.** If you are lucky enough to possess one of these modern marvels, allow us to suggest the addition of the magnetic frame. It is easy to make and adds a touch of old-world elegance to your photos and to your fridge. Monsieur Audiffren would be so proud.

WHAT YOU'LL NEED:

* Magnetic sheets (available at most craft stores and magnetsource.com)

* Pen

* Wood-grain self-adhesive shelf paper, enough to cover the magnetic sheet

* Scissors or craft knife

* Photos

STEP 1:
Draw a design for your frame on the back of the magnetic sheet. Make up any shape you want, traditional or abstract. We went with a fun wall-plaque theme. **a**

STEP 2:
Remove the backing from the wood-grain shelf paper and use it to cover the magnetic sheet.

STEP 3:
Cut out the outer shape of the design using the scissors or craft knife.

STEP 4:
Using the craft knife, cut out the inside of the frame, leaving at least a ½" (13mm) border so the frame window is smaller than the size of the prints you plan to use. Go rectangular like your photos or oval or circular if you want to highlight some part of the photo. (If you'd like, you can use the cut-out inside of your frame to create another smaller frame.) **b**

STEP 5:
Print and cut out your favorite photos, hold them to the fridge, then lay your magnet frame on top. The magnetic frame will stick to the fridge and keep your photo securely attached along with it!

from contributing gurus
• • • • • • •
Derek Fagerstrom and Lauren Smith

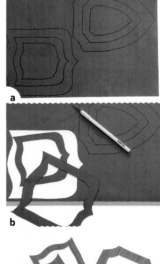

a

b

Meow!

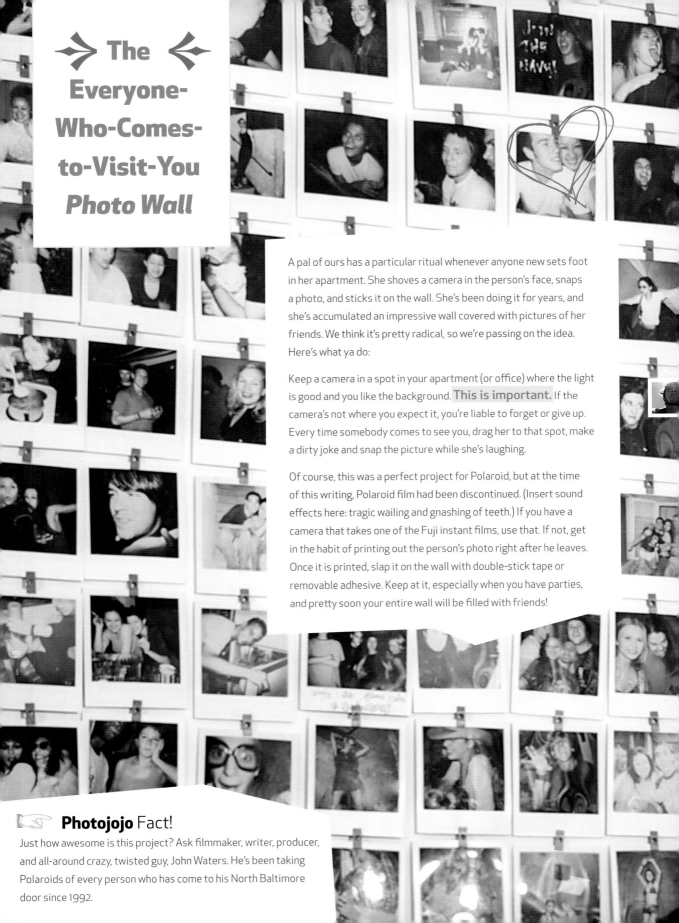

The Everyone-Who-Comes-to-Visit-You *Photo Wall*

A pal of ours has a particular ritual whenever anyone new sets foot in her apartment. She shoves a camera in the person's face, snaps a photo, and sticks it on the wall. She's been doing it for years, and she's accumulated an impressive wall covered with pictures of her friends. We think it's pretty radical, so we're passing on the idea. Here's what ya do:

Keep a camera in a spot in your apartment (or office) where the light is good and you like the background. **This is important.** If the camera's not where you expect it, you're liable to forget or give up. Every time somebody comes to see you, drag her to that spot, make a dirty joke and snap the picture while she's laughing.

Of course, this was a perfect project for Polaroid, but at the time of this writing, Polaroid film had been discontinued. (Insert sound effects here: tragic wailing and gnashing of teeth.) If you have a camera that takes one of the Fuji instant films, use that. If not, get in the habit of printing out the person's photo right after he leaves. Once it is printed, slap it on the wall with double-stick tape or removable adhesive. Keep at it, especially when you have parties, and pretty soon your entire wall will be filled with friends!

Photojojo Fact!

Just how awesome is this project? Ask filmmaker, writer, producer, and all-around crazy, twisted guy, John Waters. He's been taking Polaroids of every person who has come to his North Baltimore door since 1992.

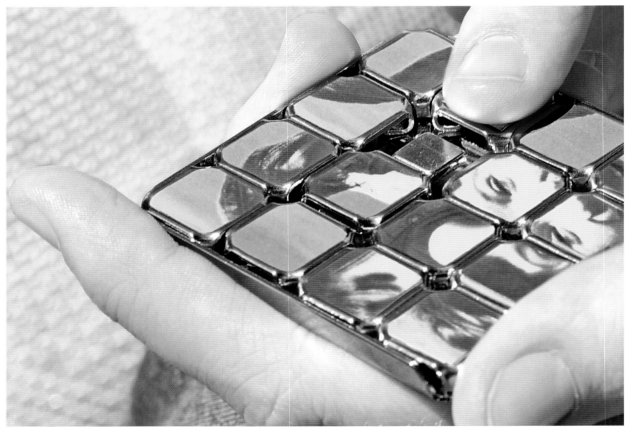

PHOTO SLIDER PUZZLES AND
Rubik's Cubes

Remember the goodie bags you got at birthday parties when you were a kid? Those were the best. You got to go to a party and run around drinking punch and whacking piñatas, and then at the end of the party, you got a whole bag of stuff. **Ring pops, candy necklaces, and even those little plastic slider puzzles. Life was great.**

Don't get us wrong; we like the parties we go to now. We've grown to love the Camembert, the canapés and the crudités (and fuzzy navels—a pretty good successor to Orange Hi-C and Tang). But we sure miss that little gift bag at the end of the party. So we're bringin' it back. We're starting with the old-fashioned tile puzzle and the perennially popular Rubik's cube, and adding a custom photo twist. They're super-easy to make, so we're making a whole bunch and putting together goodie bags for our next slumber party.

WHAT YOU'LL NEED:

* Slider puzzle (We got ours new from Amazon.com, but you could also reuse an old puzzle.)
* Ruler
* 1 really great picture
* Printable sticker paper
* Sharp pencil
* Craft knife and cutting mat (or scissors)

TO MAKE YOUR OWN PHOTO SLIDER PUZZLE:

STEP 1:
Measure the size of the individual tiles in the slider puzzle. Our tiles measured $9/16$" (14mm) square, but the colored area on each tile measured $7/16$" (11mm). We decided to make our stickers just big enough to cover the colored area. Multiply the number of tiles by the size of the tile to determine how big your photo needs to be. In this case: 4 tiles across, times $7/16$" (11mm), makes $1^3/4$" (4.5cm).

STEP 2:
Open up your photo in Photoshop (or whatever program you like best). Crop it to the overall size determined in step 1.

STEP 3:
Print the photo on sticker paper. Wait for the print to dry, then use a ruler and a sharp pencil to divide the photo into 16 equal squares. We drew lines at $7/16$" (11mm), $7/8$" (22mm), and $1^5/16$" (33mm), both horizontally and vertically. Use a craft knife or scissors to cut the print into squares, using the lines as guides. **a, b**

STEP 4:
Remove the backing from each sticker square and place it neatly over the colored area of the tile. Do this one by one, in order, reassembling the photo as you go. You will have one square left over, since a slider puzzle always has one missing tile. It is absolutely mandatory that you stick this sticker to the center of your forehead. **c**

Try these photo ideas for your slider puzzle:

* Extreme close-ups of your friends and family
* A close-up photo of a letter or number (particularly if you're making these for a birthday party)
* Pictures of your pets or other fuzzy wee beasties

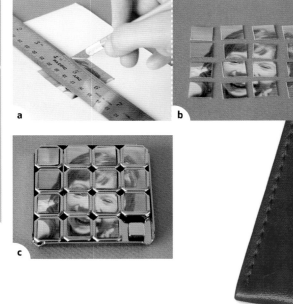

a

b

c

REMOVE TO PLAY

WHAT YOU'LL NEED:

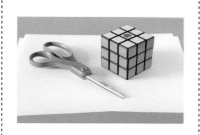

* Rubik's cube
* Ruler
* 6 really great pictures
* Printable sticker paper
* Sharp pencil
* Craft knife and cutting mat (or scissors)

TO MAKE YOUR OWN PHOTO RUBIK'S CUBE:

Use a Rubik's cube instead of a slider puzzle and sextuple the fun. Try making a cube with six different photos of the same person. Photograph a friend in front of six different-colored backgrounds, with a different facial expression for each color. Or take close-up photos of objects with six different colors (oranges, grass, or roses, for example) and use one for each side.

STEP 1:
Measure the size of the individual squares on the Rubik's cube. On ours, the stickers measured ⁵/₈" (16mm) square, so we figured making our own stickers ¹¹/₁₆" (17mm) square would cover those up nicely. (Turns out we were right.)

STEP 2:
Open up your photos in your pet image editor. Crop or resize them to 2" (5cm) square or a size appropriate for your Rubik's cube. Print the photos on sticker paper and let the ink dry.

STEP 3:
Use a ruler and a sharp pencil to divide each photo into 9 equal squares. We drew guidelines at ¹¹/₁₆" (17mm) and 1³/₈" (3.5cm), both horizontally and vertically.

STEP 4:
Cut out one of the portraits, then cut along the pencil lines to divide the portrait into squares. Choose one side of the Rubik's cube to cover with that portrait. Stick the squares onto that side, in order, so you reassemble the portrait. **a, b**

STEP 5:
Repeat step 4 until all the cube's sides are covered. **c**

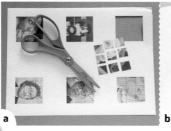

a

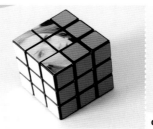

b

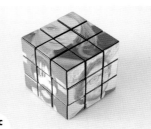

c

tip

Don't give in to the temptation to cut all the squares out at once—you'll end up with a whole bunch of unidentified squares, and it will be a pain in the butt to figure out where they all go.

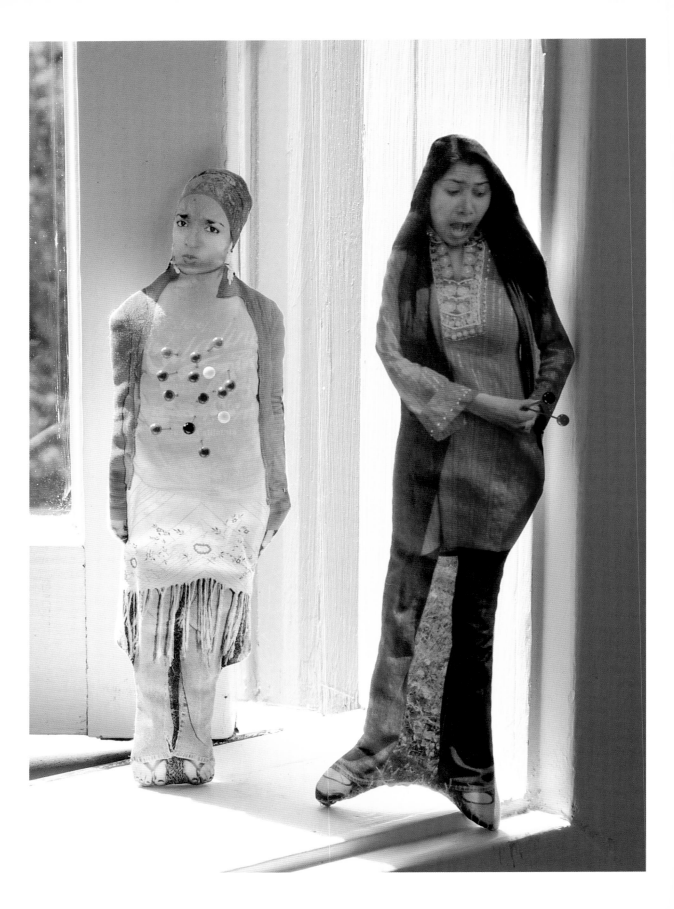

PHOTO *Dolls*

(Voodoo *and* Otherwise)

We saw a movie poster recently that said, "Evil Hands Are Happy Hands." We like it: It's snappy, concise and has a message we can get behind. We're thinking of adopting it as the official Photojojo motto.

In the interest of making our hands just that much more evil, we've started making voodoo dolls. Personal ones. With pictures of our friends and enemies on 'em.

What shall we do with our newfangled voodoo dolls? Shall we poke them with pins? Shall we hold their feet over the fire? Perhaps we'll prop them up in front of the TV and make them watch public access programming for hours on end. *Mwah ha ha ha HA!*

Oh yes, there's no denying it. It's getting mighty evil around here.

WHAT YOU'LL NEED:

* Photo or camera
* Inkjet-printable photo fabric (We got ours from nationalartcraft.com.)
* Liquid fabric softener (optional)
* Light box (optional)
* Tape (optional)
* Pencil
* 8½" x 11" (21.5cm x 28cm) piece backing fabric (We used white cotton twill.)
* Pins
* Needle and thread (or sewing machine)
* Scissors
* Chopstick (optional)
* Tweezers (optional)
* Filler (We used fiberfill, but rice or lentils also work well.)
* Miniature torture implements (optional)

STEP 1:
Choose (or take) a photo of your intended ~~victim~~ friend. You'll want a photo where the whole person's body is visible, head to toe. Any position will work, but one with the arms at the sides and the legs together will save a lot of cussin' later on.

STEP 2:
Resize your photo so the figure is as tall as you want the doll to be. Don't make the figure more than about 10" (25.5cm) tall or you won't have enough fabric to sew it together.

Prints on fabric tend to look a little washed out, so punch up the saturation and contrast more than you ordinarily would. If it looks too garish on screen, it's about right.

Make a test print in grayscale on plain paper to make sure you have the dimensions right, then go ahead and make your print on the fabric sheet just as you would on an ordinary sheet of paper. **a**

STEP 3:
Let your prints dry for at least 15 minutes. Then peel off the plastic or paper backing.

STEP 4:
Depending on the manufacturer's instructions, you'll need to soak your fabric for 10 minutes in room-temperature water, preferably distilled, to prevent bleeding. If you're making more than one voodoo doll, soak each fabric print separately. Should you notice ink bleeding from your print, soak it instead in a mixture of 1 part liquid fabric softener to 3 parts water. **b**

STEP 5:
Remove the print from the water, lay it flat, and let it dry completely. We laid ours out on paper towels to dry them more quickly. The print will take a while to dry; we left ours alone overnight. Take a break, take a nap, take five, go browse MySpace— do whatever you nutty kids are doing these days.

STEP 6:
Lay your print facedown on a light box or tape the print against a window. Trace the outline of the figure on the back of the fabric with a pencil. **c**

STEP 7:
Stack the photo print and the piece of backing fabric so the photo side faces the front side of the backing fabric. Pin in place along the edge of the fabric—you don't want to poke holes in the photo. **d**

STEP 8:
Stitch the 2 pieces together along the outline you traced. Leave a 2" (5cm) opening at the bottom or along one of the legs. You can do this with a sewing machine, but there will be lots of turns and corners and pointy bits to maneuver around. If you have the patience for hand sewing, this is your time to shine. **e**

Trim the excess fabric away with scissors, following the outline of the doll and leaving a ¼" (9mm) seam allowance. **f**

STEP 9:
You will have sewn the doll inside out, but never fear. Turn the doll "outside-out" through the unsewn opening. Use a chopstick or the eraser end of a pencil to help you ease out the tight corners.

If you have skinny little arms and legs to deal with, try pushing from the inside with the chopstick and pulling from the outside with a pair of tweezers. (Remember the cussin' we mentioned at the beginning? Now is the time for that.)

STEP 10:
Stuff the doll with filler, making sure you get the filling into all the nooks and crannies. Packing tightly will make a firmer doll; packing loosely will make a floppier doll. It's up to you, just make sure the stuffing is even instead of lumpy. It's also useful to note that overstuffing with filling will make your person look very tubby. If you're making a doll of that annoying cheerleader who always picked on you freshman year, this will be really fun for you. **g**

STEP 11:
Tuck in the edges of the opening and stitch the doll shut from the back. Approximate the size of the stitches sewn earlier so that this area won't be as noticeable. **h**

For the record, voodoo dolls aren't used for evil in real voodoo practice. The big wicked pins you hear about are actually supposed to represent money, or love, or stuff like that. That said, we're not suggesting that running over an ex-boy/girlfriend doll with your car won't make you feel a whole lot better. It just won't magically crush him or her. Oh yeah! We almost forgot! We haven't tested this photo fabric for toxicity, so don't give them to young kids or anybody else who's likely to chew on them.

Ouch!

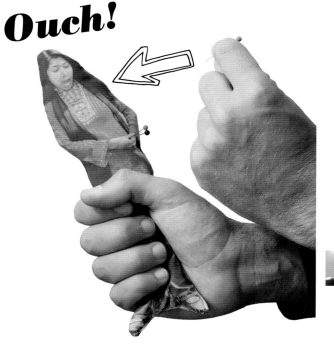

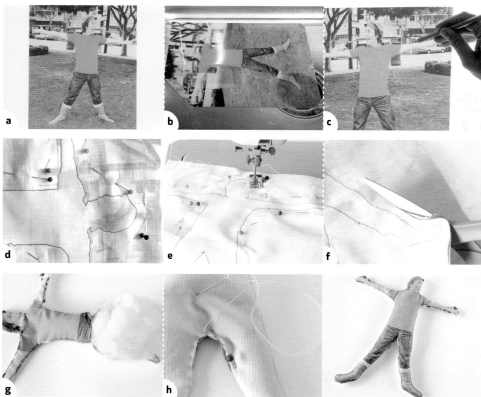

a b c
d e f
g h

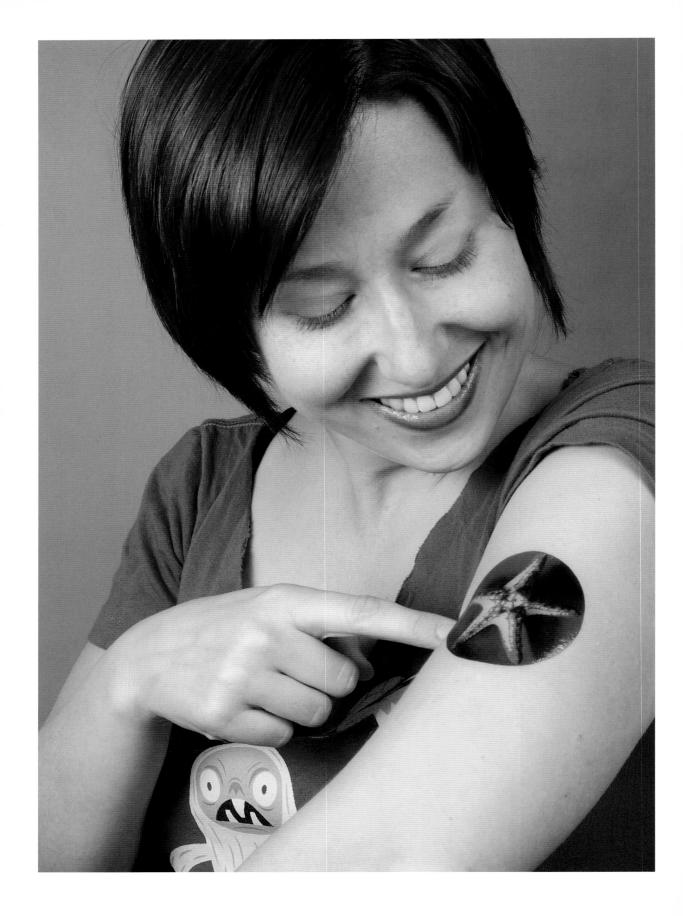

Photo Tattoos

(For Your Wild Side *and* Your Mild Side)

Look—tattoos make you look super-tough. There's no arguing that. But they hurt, and we're chicken, so we don't have any. Besides, what would we choose to wear on our skin forever? We change our minds about as often as we change our socks, and we just know we'd pick something we'd be embarrassed about five minutes later.

The solution? Temporary tattoos. And not the kind you get out of the coin-operated candy machine at the supermarket, either. We mean good ones. PHOTO ones. That's right, chickadees—you can get inkjet-printable tattoo paper and **turn any photo you want into a tattoo.** Think of the possibilities! Show off your girly side with butterflies and goldfish, or embrace your inner nerd with a picture of an old Apple II. Now let's get you inked up.

WHAT YOU'LL NEED:

* Super-awesome digital photos
* 1 sheet 8¹/₂" x 11" (21.5cm x 28cm) water-slide temporary tattoo paper. (We ordered ours from decalpaper.com.)
* Scissors or craft knife and cutting mat
* Jar lid and pencil or circle cutter (optional)
* Washcloth or sponge and warm water

STEP 1:
Pick out a particularly amazing photo to display on your sweet self. We liked these pictures of starfish. Choose photos with backgrounds that (a) enhance the tattoo design, or (b) can be easily trimmed away. If you choose to remove the background, you can do that using image editing software like Photoshop or by hand with a pair of scissors.

STEP 2:
Using the computer, resize the photos to the size you want your tattoo to be. Bear in mind that temporary tattoos are small for a reason: Larger ones have a plastic-y feel and may look oddly wrinkled on the skin. Arrange your tattoos to print out on one 5" x 7" (12.5cm x 18cm) sheet, and print a test copy in grayscale on plain paper to make sure you've got the layout and size right.

STEP 3:
Tattoo paper comes with 2 sheets: the decal and the adhesive. Cut a decal sheet down to two 5" x 7" (12.5cm x 18cm) sheets. (At about $4 per sheet, you don't want to waste any of this paper.) Be very careful not to touch the surface of the paper, since any fingerprints will show up on your print. Cut an adhesive sheet down to two 5" x 7" (12.5cm x 18cm) sheets as well.

STEP 4:
Print your photos on the decal paper, using the plain-paper settings. Allow to dry undisturbed for 5 minutes. **a**

STEP 5:
Remove the backing from the adhesive sheet and apply it to the printed side of the tattoo sheet. Carefully smooth out any air bubbles. **b, c**

STEP 6:
Cut out the tattoo, keeping as close as possible to the edge of the tattoo. Since we decided to keep some of the background, we used a jar lid and pencil to trace the desired shape before cutting out our starfish. **d, e**

STEP 7:
Choose where you want to apply your tattoo, preferably an area free of body hair, such as the upper arm. Wash the chosen area and dry thoroughly. Make sure your hands are also dry, then remove the second side of the adhesive backing (the clear layer). Press the tattoo firmly to your skin for 20 seconds. Using a damp washcloth or sponge, wet the paper side of the tattoo for 60 seconds. When the release paper is thoroughly wet and you can see the tattoo through the paper, remove the release paper to reveal your fresh new tattoo. **f, g, h**

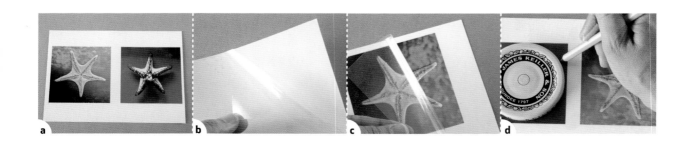

TEN THINGS YOU DIDN'T KNOW ABOUT TATTOOS

1. TATTOOING DEVELOPED INDEPENDENTLY AMONG INDIGENOUS CULTURES IN NORTH AMERICA, SOUTH AMERICA, AFRICA, ASIA, EUROPE AND OCEANIA.

2. ÖTZI, WHOSE BODY LAY FROZEN FOR 5,300 YEARS IN THE ÖTZAL ALPS, HAS 57 TATTOOS.

3. TRADITIONAL SAMOAN TATTOOS COVER EVERYTHING FROM A MAN'S WAIST TO HIS THIGHS. AND WE DO MEAN EVERYTHING.

4. AFTER KING HAROLD DIED DURING THE BATTLE OF HASTINGS IN 1066, HIS BODY WAS IDENTIFIED BY HIS TATTOOS.

5. ONE METHOD OF REMOVING A TATTOO IS SALABRASION: SOAKING AND SCRUBBING THE TATTOO WITH SALT AND WATER.

6. ONE OF THE FIRST TATTOOING MACHINES WAS MADE FROM A MODIFIED ELECTRIC DOORBELL.

7. WINSTON CHURCHILL HAD AN ANCHOR TATTOOED ON HIS ARM, AND FRANKLIN DELANO ROOSEVELT HAD A TATTOO OF HIS FAMILY CREST.

8. "LYDIA THE TATTOOED LADY" WAS JIM HENSON'S FAVORITE SONG. THE MUPPETS SANG IT ON THE FIRST *MUPPET SHOW* AND AGAIN AT JIM HENSON'S FUNERAL.

9. DESPITE PERSISTENT URBAN LEGENDS, TATTOOS WILL NOT EXPLODE IN AN MRI MACHINE.

10. THE CURRENT GUINNESS RECORD HOLDER FOR MOST TATTOOED PERSON IS LUCKY "DIAMOND" RICH. HIS ENTIRE BODY IS TATTOOED IN BLACK INK, INCLUDING THE INSIDES OF HIS MOUTH AND EARS.

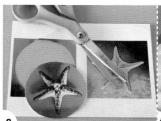
e

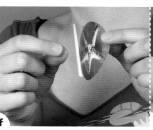
f

g

h

Photo Cupcakes

for the cupcake revolution

Just when you thought cakes and cupcakes couldn't get any better, now there are companies that will print up your very own edible icing. Simply send them your digital photograph, and they send you back a photograph to eat! Lickety-split! Your tasty photo icing arrives as sheets of sugar on paper backing, sealed in a plastic bag. You can slide it onto cakes, cookies, or cupcakes right away or store it for up to six months. Instructions are included, and sizes range from 2½" (6.5cm) round to 11" x 17" (28cm x 43cm), so you have plenty of options. Yep, photo cupcakes are our new favorite thing.

WHAT YOU'LL NEED:

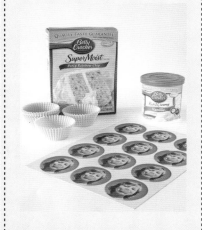

* Happy, cupcake-y photo
* Cupcakes
* Photo icing
* Icing or frosting
* Butter knife

STEP 1:
Find a picture to put on your cupcakes. We used one of our li'l buddy Modesty. If your picture doesn't have a white background, trace out the subject in your favorite image editor before uploading it, or choose to have the photo icing company you've chosen cut it out for you. Any white in your photograph will blend in nicely with the icing on your cupcakes. Of course, we're rebels, so we said, "White, shmite," and used a blue picture. Blue, ya hear us? Take that!

STEP 2:
Upload your picture to whatever icing image company you choose. (We used Icing Images at icingimages.com.) Then, choose your icing pleasure. We picked a dozen 2½" (6.5cm) circles. Your photo icing will take a few days to arrive, so this is a good time to research some cupcake recipes. Try Chocolate Peanut Butter or Thai Iced Tea! (Or skip to our special Top Secret Photojojo Family Recipe, opposite.)

STEP 3:
Your photo icing will arrive flat-packed in a cardboard mailer. You'll need to slather on some frosting before applying the photo icing, so after you make your cupcakes of choice, wait to frost them until they're completely cool. Your patience will be rewarded. Take the icing sheets out of their bag and let them air out at room temperature for half an hour while the cupcakes cool, following any instructions the manufacturer has included.

STEP 4:
Apply a good dollop of frosting to each cupcake, and spread it as flat as possible on top so the photo icing will bond well.

STEP 5:
You need to apply your photo icing while your frosting is still moist. It's easy: Just peel one of the circles off the paper backing and lay it down on a cupcake, making sure it makes contact with the frosting throughout. Put a photo on each cupcake, and let your cupcakes sit for a while so the photo and the frosting will meld into each other. Ta-dah! Eat them, give them to a friend, or just look at 'em.

TOP SECRET Photojojo Family Recipe for
Red Velvet Cupcakes:

Makes approximately two dozen cupcakes

This recipe came to Photojojo courtesy of Patty Rosenkrantz, who says it's been in her family for generations and originated "somewhere in the South."

Red Velvet Cupcakes
1 stick of butter, softened · 1½ cups sugar · 2 eggs ·
3 Tbsp. red food coloring (1 small bottle) · 2 rounded tsp.
cocoa · 1 tsp. vanilla · 2 cups flour · 1 tsp. salt · 1 cup
buttermilk · 1 Tbsp. cider vinegar · 1½ tsp. baking soda

Step 1: Preheat to oven to 350° Fahrenheit.
Step 2: Beat the butter and sugar together until
creamy. Add eggs, one at a time, and beat until fluffy.
Step 3: Mix together the red food coloring, cocoa,
and vanilla. Add to the above mixture.
Step 4: In a separate bowl, sift together the
flour and salt. Gradually add to the batter,
alternating with buttermilk. (OVER)→

Step 5: Mix the vinegar and baking soda
together (foamy!) and fold into the batter.
Step 6: Fill a cupcake pan with paper liners,
and spoon batter into the cups. Make sure each
cup is no more than 3/4 full. Bake for 20-30
minutes, until a toothpick inserted in the center
comes out clean. Cool completely before frosting.

Icing for Red Velvet Cupcakes
1 cup milk · 5 slightly rounded Tbsp. flour ·
1½ sticks of butter, softened · 1 cup sugar

Step 1: Mix the milk and flour together in a
saucepan and cook over medium heat until very
thick. Cool completely in the refrigerator.
Step 2: Add the butter and sugar and beat
until fluffy (5 minutes or longer).
Step 3: When the cupcakes are cool, frost
those suckers and dig in!

TOP SECRET

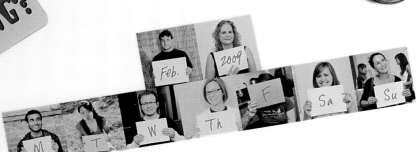

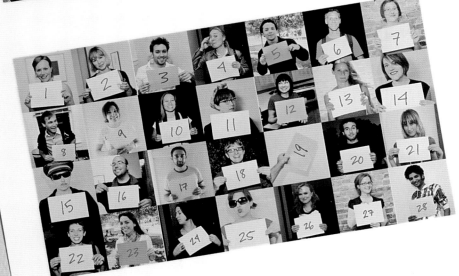

THE *Human Calendar*

One of our favorite Web haunts is a very cool website made by Craig Giffen called the Human Calendar. **Basically, Craig made a calendar where every day is a picture of one of his friends holding a number.**

The thing is, we don't know any of those people. We're sure they're very pleasant—they look friendly enough—but we figured we could make a version using our own pals. So we did! We took photos of just about everybody we knew and put them all together to make a calendar. Jen got to be the year, and Matt ended up as Wednesday, and Kristen called dibs on the 22nd since that's her birthday, and . . . well, you get the idea. And the best part is that we can rearrange the pictures every month and keep the calendar going forever.

WHAT YOU'LL NEED:

* Camera

* 1 sheet 8¹/2" x 11" (21.5cm x 28cm) paper or cardstock (Any light or bright color is fine.)

* Heavyweight matte photo paper

* Hole punch

* Hammer and nail

Photojojo Fact!

Most countries currently use the Gregorian calendar. The Persian calendar, however, predates the Gregorian by 503 years and is technically more accurate. It's only used in Iran and Afghanistan, but if you're there, start making friends and taking pictures. Infinitely adaptable, The Human Calendar fits that dating system, too.

STEP 1:

Take pictures of everybody you know holding a blank piece of paper or cardstock. Keep the composition of the photos the same: cropped at waist-level, holding the paper at about chest height. You'll need at least 40 photos. When we did this, we carried a camera and a piece of paper everywhere—to parties, to meetings, to work, to the showers at the gym—anywhere we had a chance of running into a friend. Family reunions and weddings are a good bet, too.

(If you don't have 40 friends, don't be sad. Check out the Versions on the opposite page. And remember, Photojojo always loves you!)

STEP 2:

Whew! That was a lot of photos! Import them all into Photoshop (or what have you) and crop each one to 1" x 1" (2.5cm x 2.5cm) square at the same resolution.

STEP 3:

Create a new document, sized 8¹/2" wide by 11" tall (21.5cm x 28cm), the same resolution as your photos. Make a grid of 1" (2.5cm) squares with 7 columns and 8 rows. The easiest way to do this is to set guides as follows.

Vertical: 3/4" (2cm), 1 3/4" (4.5cm), 2 3/4" (7cm), and every inch (2.5cm) up to 7 3/4" (19.5cm).

Horizontal: 1" (2.5cm), 2" (5cm), 3" (7.5cm), and every inch (2.5cm) up to 9" (23cm).

Add an extra vertical guide at 4 1/4" (11cm) to mark the center point.

STEP 4:

Now you can start copying and pasting your cropped photos into the calendar document. Make sure the "snap to guides" (often in the View menu) is on—it'll help you line everything up perfectly. Plop 2 photos in the center of the top row—these will be the month and year. Plop 7 photos in the next row for the days of the week. Consult a calendar to find out where to place the photos for the rest of the grid. Place one photo for each day of the month in question, and save this document as the month it represents.

STEP 5:

Now, you can fill in the dates 2 ways. Add text in your image editor to give the days, dates, and other info, or print out the sheet and fill in the info by hand. Using the computer makes the finished calendar look a little cleaner, though doing it by hand is a little quirkier.

STEP 6:

Yay! One month down, 11 to go. For the other months, rearrange the photos all over the calendar: switch it up so everybody gets to be a day of the week, or a month, or however you want to work it. Don't forget to save each month as a separate document!

STEP 7:

When you have everything arranged just the way you want it, print out each month on nice, sturdy paper (we like heavyweight matte photo paper). Use a hole punch to put a hole in the same spot on each page. Hang your lovely custom calendar up on a nail, and wait for the compliments to roll in. And they will, amigo, they will.

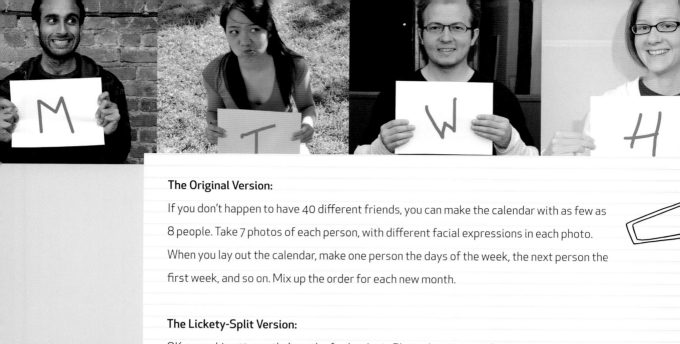

The Original Version:

If you don't happen to have 40 different friends, you can make the calendar with as few as 8 people. Take 7 photos of each person, with different facial expressions in each photo. When you lay out the calendar, make one person the days of the week, the next person the first week, and so on. Mix up the order for each new month.

The Lickety-Split Version:

OK, so making 12 months' worth of calendar in Photoshop is great, but it takes some doing. Want something quicker? Do one month, but leave the numbers off. Print, laminate. Now use a whiteboard marker to fill in the days of the month. Ding! Your calendar is ready!

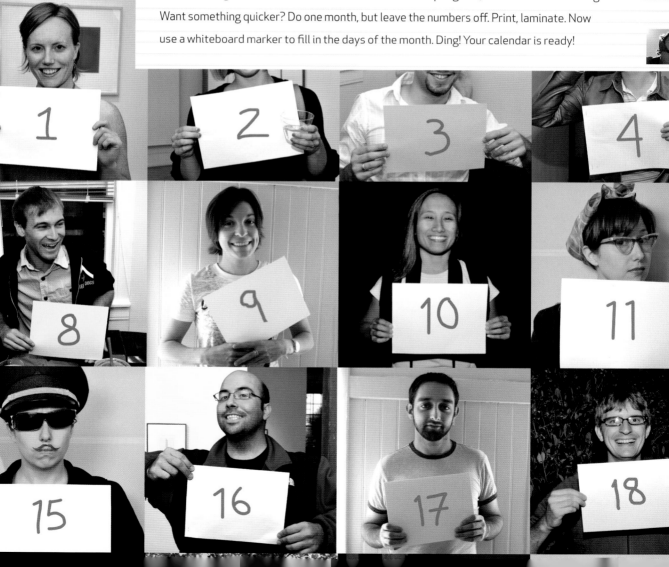

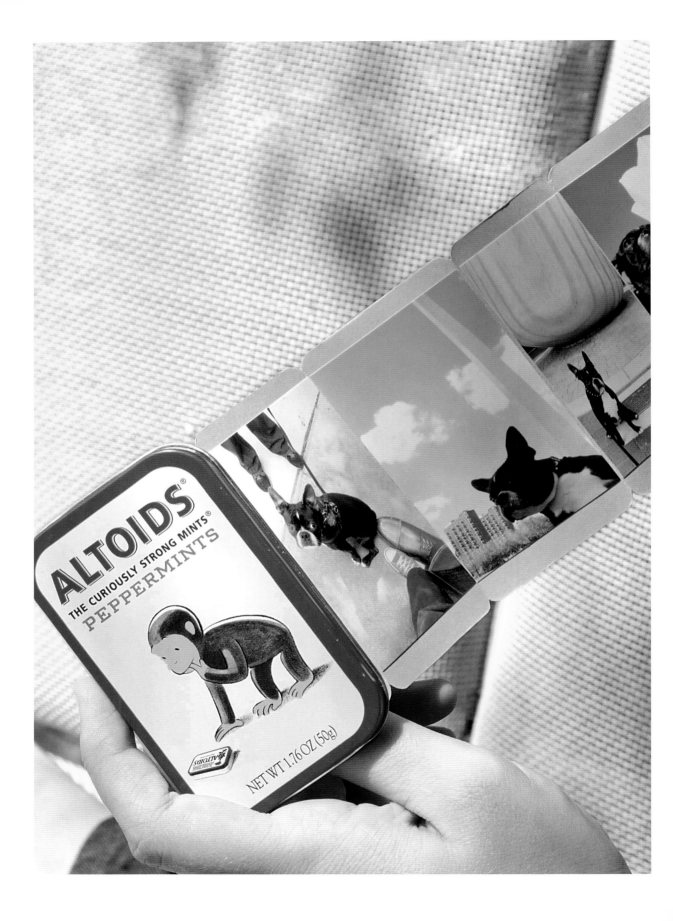

SUPER-SNEAKY
Tin Photo Album

Let's face it. Ever since you got that new baby/puppy/Tahitian cabana boy, you've been taking way too many pictures. Snap, snap, snap: pictures from every angle, in every different kind of light, wearing every single outfit. Now your friends and coworkers see you coming with a stack of new photos and they avoid you any way they can: ducking down the fire escape, sprinting around the corner, leaping out the window . . .

Well, they can't escape you anymore, because we've got 'em outfoxed! **Just offer them an innocent-looking Altoids® tin and when they open it, HA!** They're snared into looking at your secret miniature stealth photo album. Wrest every "ooh" and "ahh" from your victims, force them to coo with delight over your pictures: you've earned every grudging syllable.

Just when they thought it was safe to go back to the water cooler . . .

WHAT YOU'LL NEED:

* Altoids tin
* 1 sheet 8½" x 11" (21.5cm x 28cm) paper or cardstock
* Ruler
* Pencil
* Scissors or craft knife
* Glue stick
* 10 wallet-sized photos (2" x 3" [5cm x 7.5cm])
* Corner-rounder punch (optional)

STEP 1:
Eat all the Altoids in one sitting. Drive to the hospital.

STEP 2:
When you've recovered from having your stomach pumped, mark a 10" x 3½" (25.5cm x 9cm) rectangle on the paper, then divide the rectangle into five 2"- (5cm-) wide sections.

STEP 3:
Use the scissors or knife to cut out the rectangle. This will be the foundation piece on which you'll build your album. **a**

STEP 4:
Fold the rectangle accordion-style along the section lines you marked, then open it back up and flatten out the rectangle. **b**

STEP 5:
Using the glue stick, attach each of your photos to a section of the folded paper. Use the fold lines as guides for placing the photos. Five photos will fit on each side. **c**

If you like, you can leave one end page blank and glue it to the inside of the tin.

STEP 6:
Fold up the album. If you have a corner-rounder punch, use it to round the corners of the folded album. If you don't have a corner-rounder, place a coin at one corner of the folded album, trace around it, and use that line as a guide to round the corner with the scissors. Repeat for the remaining 3 corners. **d**

STEP 7:
Stuff your snazzy new album in the Altoids tin! For an extra touch, you can decorate the cover of the tin by gluing on a photo or decorative paper. We left ours as is to be extra stealthy. That's it! And since this tin album is nigh invulnerable, you can take it anywhere without fretting that your photos will get scuffed up. **e**

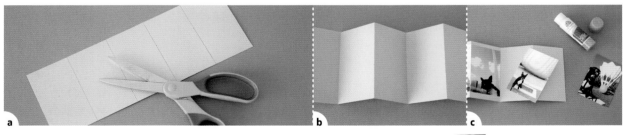

a b c

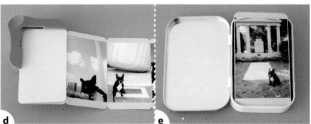

d e

tip

Photos that work well for this sort of album are ones that are recognizable at small sizes. Portraits work nicely. Intricately detailed pictures of far-away things do not.

ALTOIDS: A BRIEF HISTORY

Though nowadays you can find any number of small tin boxes, by far the most ubiquitous is also the most "curiously strong"—the Altoids mint tin. This sturdy little case debuted in the 1920s, replacing the cardboard cartons that had protected the tiny mints for more than a century prior. Indeed, as the Altoids company touts, England's King George III may have sucked upon much the same ye olde peppermint as we do today. Originally marketed as an aid to digestion (hence its medical-sounding "–oid" suffix), once Altoids crossed the pond, it became the nation's number one mint on claims of fresh breath alone.

Such popularity stems in no small way, we think, from the handy tin box, which crafty boys and girls use to create portable musical instruments, cell phone chargers, flashlights, amplifiers, synthesizers, and pretty much anything else that can be crammed into its dimensions—including, of course, photographs.

THE CURIOUSLY STRONG MINTS®

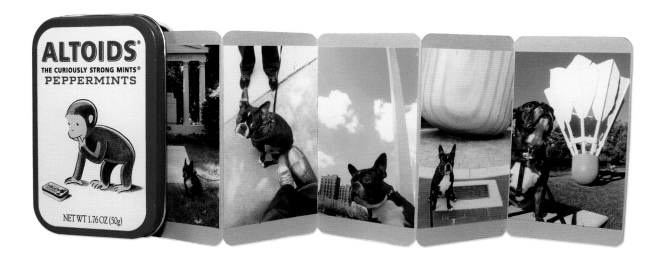

The big black sketchbook. Everybody has one, mostly because they're always on the discount shelf at the big chain bookstore. Yeah, they're useful, and yeah, they're affordable, but wouldn't you rather have something more interesting?

"Of course," comes your reply. And you've seen the more interesting versions. Sure they have cool photos on the cover, or neat graphics, or multicolored pages. But they're also kinda pricey.

So here's the happy medium: **create your own notebook and choose the cover from your own photos.** Make the pages out of maps, or wrapping paper, or any paper you can find. It's as affordable as the standard-issue sketchbook, with as much cachet as the designer version, plus that particular flair that could only be your own.

WHAT YOU'LL NEED:

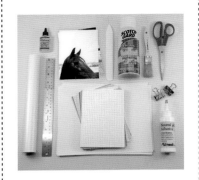

* 1 horizontal digital photo
* Inkjet-printable photo canvas
* Waterproofing spray (such as Scotchgard)
* Two 5" x 7" (12.5cm x 18cm) photos
* White glue (we just happened to have some archival PVA bookbinding glue handy, but any school or craft glue works fine) or rubber cement
* Paintbrush
* Waxed paper
* Large, very heavy books
* Paper cutter (or scissors and lots of patience)
* ¹/₂"- (13mm-) thick stack assorted scrap paper (such as old maps, nice wrapping paper, or copy paper stolen from work)
* 2 clothespins or binder clips
* Ruler
* Spoon (or a bone folder, which you can find in the bookmaking section of art supply stores)

STEP 1:
Choose a horizontal photo, keeping in mind that the right-hand half of the photo will be used as the front cover for your book. Using your image-editing software *du jour*, resize your lovely photo to 7" high by 10¹/₂" wide (18cm x 26.5cm). Print your image onto the photo canvas and let it dry thoroughly. Spray the bejeezus out of it with waterproofing spray. Trim the photo to size with scissors, making the edges as neat as humanly possible. **a**

STEP 2:
Spread out some newspaper or scrap paper to cover your work area. Place the photo you just printed facedown on the newspaper.

STEP 3:
Choose which photo you want to use for the inside front cover of the book. Apply a thin layer of glue to the back of this photo, spreading it evenly over the entire surface with the paintbrush. Try not to get any glue on the front of the photo. **b**

 Note:
Sometimes a thick layer of glue can discolor the cover photo. If you're worried about it, use rubber cement instead and pay special attention to sticking down the corners of the photos.

STEP 4:
Line up the print with the left-hand edge of the canvas photo and press it into place.

STEP 5:
Repeat steps 3 and 4 with the other print, placing it on the right-hand edge of the canvas photo. Measure the space in the center between the photos—this will be the spine of your book. **c**

STEP 6:
Tear off a large piece of waxed paper, at least 21" (53.5cm) long, fold it in half crosswise, and slip the cover inside. Place heavy books on top and let the glue dry while you work on the rest of the project. **d**

STEP 7:
Using the paper cutter, cut your scrap paper into 5" x 7" (12.5cm x 18cm) pieces. Stack the pieces and tap them a few times on each edge to even up the stack. Tap the long left-hand edge of the stack a few more times to make sure it's even. Clip the stack together with binder clips or clothespins. Use the ruler to measure the stack to make sure it fits into the space you measured for your spine, and add or take out pages as needed. **e**

STEP 8:
Apply a line of glue along the long left edge of the stack. Use the brush to spread the glue evenly along the spine. Rinse your brush and let the stack dry for about 2 minutes. **f**

STEP 9:
Repeat step 8, but with a slightly thicker layer of glue and 5 minutes' drying time.

STEP 10:
Fold another piece of waxed paper in half and slip the stack inside. Plonk heavy books on top and leave it alone for 15 minutes. Take the dog for a walk or make yourself a peanut-butter-and-jelly sandwich. Yum. **g**

STEP 11:

Check the spine of the book to see if the glue is dry. If it is, continue to step 12. If not, let it dry for a few more minutes and make some chocolate milk to go with that sandwich.

STEP 12:

Remove the cover from beneath its books and waxed paper and make sure it's completely dry. If so, fold the cover along the inside edge of the left-hand photo print. Crease the fold with the back of a spoon or a bone folder. Repeat along the edge of the right-hand photo. **h**

STEP 13:

Apply a layer of glue to the canvas between the 2 photo prints. Remove the stack of pages from under the book and waxed paper and press the spine edge firmly onto this strip. Holding the stack of pages perpendicular to the work surface, turn the book over and press the cover down onto the spine. Let the book dry overnight. **i, j, k, l**

doodle away! — uh·oh...

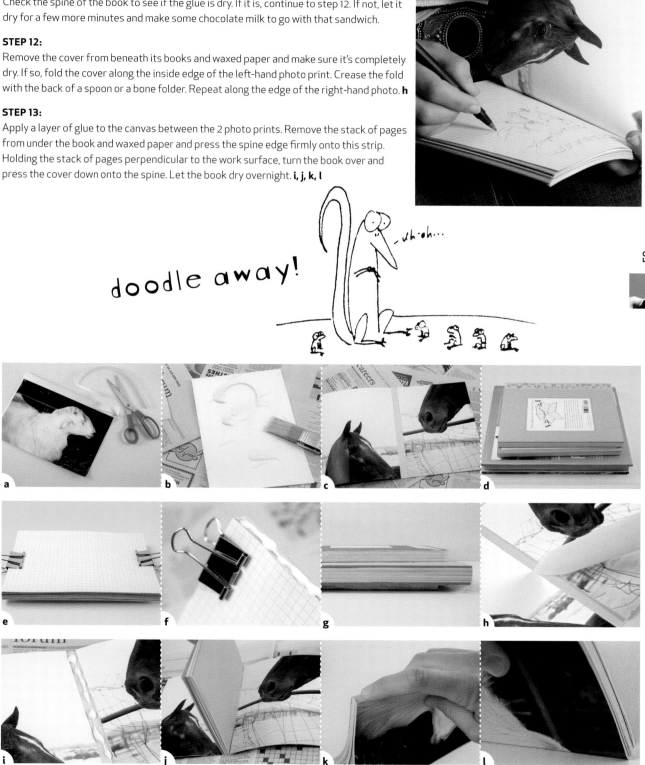

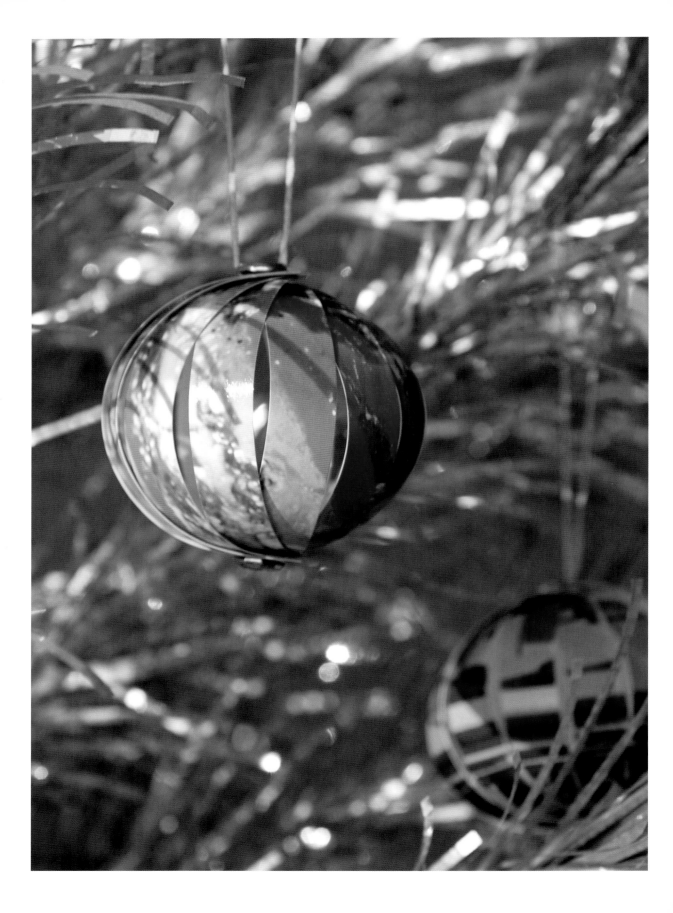

PHOTO *Ornaments*

(The Xmas Miracle You've Been Waiting For)

Eggnog, gingerbread houses, the old traditional Festivus pole, Sinterklaas (for our Dutch friends), the smell of frying latkes, Chrismukkawanzaa cards, endless shopping, and lots and lots of festive cheer. We love the holidays.

We'll show you how to make beautiful ornaments in just fifteen minutes—using your own oh-so-festive photos. They look great on a Christmas tree, Hanukkah bush, or atheist celebratory plantlike object. But they're just as nifty as decorations to hang from your mantle or from the ceiling. (And it doesn't have to be just around the holidays—those of you who drag your wilted trees to the curb in mid-July know what we're talking about.) Even better, they can be sent easily through the mail and make great gifts!

WHAT YOU'LL NEED:

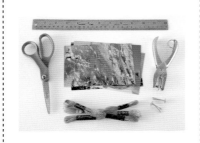

* 4" x 6" (10cm x 15cm) photograph (Horizontal photos work best.)

* Scissors

* Ruler

* Hole punch

* 2 paper fasteners (a.k.a. brads)

* String (Pick a color that complements your photo.)

from contributing guru
• • • • • • •
Alicia Kachmar

STEP 1:
First things first, let's pick a photo. A 4" x 6" (10cm x 15cm) print will result in an ornament that's roughly the size of a tennis ball. For smaller or larger ornaments, use a smaller or larger photo. Horizontal photos work better than vertical ones. For a vibrant ornament, pick a photo that's predominantly a single color or one that captures an interesting pattern, shape, or texture.

STEP 2:
Use your scissors to cut your photos vertically into 10–11 strips, each about 1/2" (13mm) wide. These strips will form the ribs of your ornament and each must be wide enough to have a hole punched comfortably in it. **a**

STEP 3:
Stack the strips 4 at a time and use the hole punch to make a hole at the top and bottom, centered about 1/4" (6mm) from the edges. Repeat until all your strips have holes in them.

STEP 4:
Stack all the photo strips in order from left to right and stick a paper fastener through the hole on one end. Repeat with the other hole, then bend back the fasteners on the reverse side to complete the bundle. **b**

STEP 5:
Curve your bundle of photo strips gently into a U-shape, with the photo side forming the outside of the U. This will give your ornament its spherical shape when it's fanned out. Repeat a few times until the strips hold the curve. **c**

STEP 6:
Fan out each strip and evenly distribute them to form the globe of the ornament. With all the strips fanned out, your ornament should look nearly finished. If the shape of your ornament isn't as round as you'd like, gently squeeze the ornament to coax it to take the shape you want. (Hey, some of us prefer our ornaments squat and donut-shaped.)

STEP 7:
Pick a color of string that goes well with your photo and cut a piece 6" to 8" (15cm–20.5cm) long. Loop the middle of the string around the top fastener a few times to tie it to the ornament. Tie a simple knot to join the 2 loose ends of the string to make the loop. Ta-dah! Your ornament is finished and ready to hang from a tree, mantle, wall, ceiling, doorframe—wherever you fancy! **d**

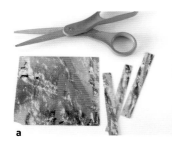

a

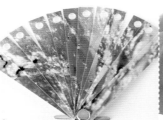

b

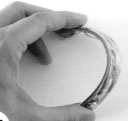

c

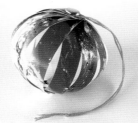

d

Break the Ice
→ and Make ←
New Friends
at Parties

It's party time (excellent!), but you know hardly anyone on the guest list. What's a would-be wallflower to do? Why, bring your camera and a few props, of course! Pack some of our great photo projects and you'll have your party-animal pals posing for mug shots, jumping for joy—even leaping in the tub—in no time. Just don't forget to get a few shots of yourself with all your new friends.

from contributing guru
• • • • • • •
Nichole Esmon

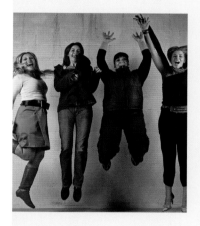

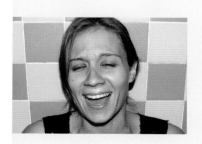

Bright Idea #1: Who framed _____?

Hand your friends-to-be a pair of bunny ears and a large, empty picture frame and tell them to strike a pose within the frame. In the unlikely event that you don't have bunny ears on hand, tiaras, fake mustaches, and pig snouts work equally well.

Bright Idea #2: Make 'em jump!

Ratchet up the energy with some shots of your fellow partygoers jumping for joy. It's a well-documented fact that you can't look dour when you're leaping, so you're guaranteed cheery shots. Have fun with this one, but please jump responsibly. The ladies might want to shed their stilettos before taking to the skies. The gentlemen, too, if that's their thing.

Bright Idea #3: Mug 'em

Every really great party results in at least a few mug shots. With a small dry-erase board and a marker, you can create your own mug shots while keeping the boys in blue out of the picture, and your new pals won't have to call their parents to bail them out in the morning. Everyone wins. Be ready with a few timely suggestions for your willing subjects. Here are a few ideas to get you going:

* Have your subjects jot down a *nom de plume* on the dry-erase board, along with a fictitious crime. Have them hold the board up while you take their picture.

* Tell them to write one thing about themselves that most people don't know.

* Ask them to proclaim their favorite vice.

Bright Idea #4: Hit the showers

Bathrooms often feature interesting backdrops such as colorful tiles and shower curtains. And who doesn't love standing in the tub and smiling for the camera? Ask your friends to sing their favorite shower-stall tunes and catch them as they croon, or see just how many people will fit in one bathtub. Just try not to showcase your host's grubby grout. Keep snapping and have fun!

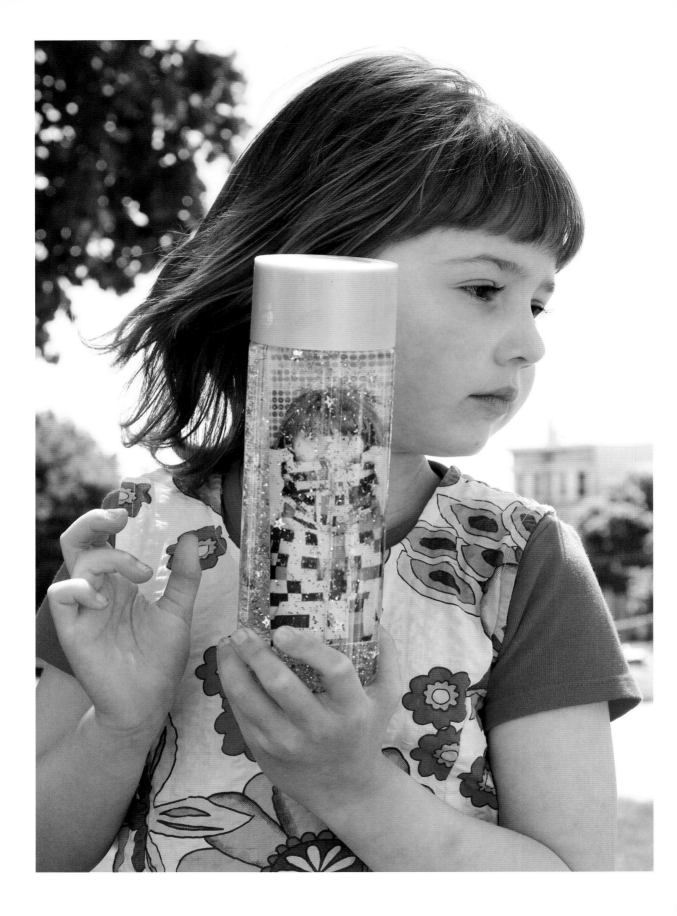

DIY
Snow Globe

Whether you're dreaming of a white Christmas, a frosty Kwanzaa, or an upsettingly and unseasonably snowy Arbor Day, there's no guarantee that your snowy wish will be granted.

Luckily, we have a portable source of snow-related joy:* Photojojo's DIY Snow Globe. **Grab a bottle, photo, glitter, and corn syrup, and you can have winter in your pocket all year 'round.**

For this project you'll need two photos (around 4" x 6" [10cm x 15cm]) in portrait orientation. We recommend cheerful photos of friends or family—or a photo of an enemy posed to look as if he's stuck inside a giant, glittery jar.

*Rigorous, double-blind studies have proven the DIY Snow Globe effective in melting the hearts of spouses, friends, and small- to medium-size children.

WHAT YOU'LL NEED:

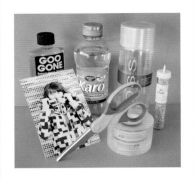

* Water bottle or empty mason jar (Voss and Fred water bottles work particularly well.)

* Adhesive remover, such as Goo-Gone, and paper towel

* 2 vertical photos

* Scissors

* Clear packing tape (the wider the better)

* Good old-fashioned water

* Clear (light) corn syrup

* Glitter and sparkles

* Glue (optional)

STEP 1:
If you're using a water bottle for this project, you need it empty. Quench your thirst and guzzle that thing in one go, rock star.

STEP 2:
Peel any labels and stickers off the bottle, scraping it gently to remove as much paper as possible. Apply the adhesive remover with a paper towel and spread it onto any sticky surfaces left on your bottle. Let it sit for a few minutes, then rub it off. You should now be left with a clean bottle. (Lather, rinse, and repeat if necessary until it's perfectly clean.)

STEP 3:
Trim your 2 photos so they're about $1/2$" (13mm) smaller in height and width than your bottle, leaving enough space to let the photo float freely but snugly. **a**

STEP 4:
Now you need to do some quick makeshift waterproofing. Measure out enough packing tape to cover both sides of your photos, with a little bit extra for a small border. Lay down a strip of tape sticky side up and press the first photo facedown onto it. Ease it down from top to bottom, pressing gently to remove air bubbles. Use a second piece of tape to cover the rest of your photo if your first piece wasn't wide enough. Overlap a bit to prevent water from entering. **b**

Now put the second photo down on top of your first photo so they're back-to-back. As before, use tape to cover the surface of the second photo, making a photo sandwich. Remember that the tape is waterproofing your photos, so don't leave any areas untaped, watch out for tears, and make sure the edges are tightly closed. Finally, trim the edges so there's no more than $1/4$" (6mm) of tape on each edge.

STEP 5:
Roll up your photo and put it through the opening at the top of your bottle. Do it quickly so the photo doesn't stay rolled up for long. It'll unroll on its own inside the bottle after a while. **c**

STEP 6:
Prepare a mixture of 1 part water to 1 part corn syrup, pour it into the bottle, and add glitter. Seal the bottle cap to the bottle with glue, if desired. Shake and enjoy. **d, e**

from contributing guru
.
Liz Slagus

More Ideas:

* Use a cheese grater to grind up a white PVC pipe to create plastic snow. Or add sequins and buttons to the glitter for variety. Use a glue gun to draw or write on the outside of your jar or bottle, then pour glitter on the hot glue for extra-sparkly goodness.

SHAKE,
SHAKE,
SHAKE,
and Enjoy!

architecture

yleCity **NEW YORK**

yleCity **LONDON**

MÜTTER MUSEU

ONIC **LA**

INSTANT *Book*

(Instantly!)

One sheet of paper. Eight photographs. One instant photo album.

Somewhere between origami and bookbinding, instant books are just what they sound like: a couple of folds, a flick of the knife, and five minutes later you have an eight-page booklet filled with your photos. Try making one of these with a blank piece of copy paper first, just to get the hang of it. It's so easy, and so clever, that you'll be dying to make them for everybody you know. Make miniature vacation albums and send them to your friends. It's bound to be a lot more fun than the standard "wish you were here" postcard. Or use them as a creative departure for traditional stuff like wedding invitations and holiday cards. They take practically no time to make, but folks will remember them forever.

WHAT YOU'LL NEED:

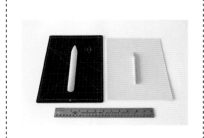

* 1 sheet blank copy paper

* Spoon or bone folder (in the bookmaking section of the art supply store)

* Scissors or craft knife, cutting mat, and straightedge

* 6–8 really amazing photos

* Heavyweight matte photo paper, 8½" x 11" (21.5cm x 28cm)

* Double-sided tape (optional)

More Ideas:

* X-Ray Album: You can also make instant books by laying objects, and even snapshots, directly on a photocopier or scanner bed. Trial and error is your friend here—print one, fold it, see how it works, and adjust. When you like what you have, you can instantly publish by pressing the print button. Try a variety of papers in your printer to see which you prefer.

STEP 1:
Grab a piece of blank copy paper, and let's try this out. It'll take about 2 minutes. Fold your paper in half vertically, with the peak of the fold toward you. Then burnish the crease with the back of a spoon or a bone folder, and unfold.

STEP 2:
Fold your paper in half horizontally, burnish, and unfold. **a**

STEP 3:
Fold the sides into the vertical crease in the middle, and unfold partway, so that from the side the paper looks like a W. **b**

STEP 4:
Cut a slit in the center of your original vertical crease, from the center "mountain peak" to the "valley" of the W. The cut will be 5½" (14cm) long. **c**

STEP 5:
Holding the paper with the center point of the W pointing down (to make an M) and the horizontal crease parallel to your body, push the sides of the M together. Then fold the paper in half toward you. This will form a cross shape. Flatten all the sides of the cross shape to the right to form the pages of the book. Burnish the book flat. **d, e**

Voilà! Instant book! If the pages are a little uneven, don't try to trim them. If you cut through any of the folds, the book will fall apart. **f**

STEP 6:
Okay, now, to make your final book, open a new document sized 8½" tall by 11" wide (21.5cm x 28cm) in whatever image-editing program you prefer. Set vertical guides at 2¾" (7cm), 5½" (14cm), and 8¼" (21cm), and set a horizontal guide at 4¼" (11cm).

STEP 7:
Crop your photos to 2¾" wide by 4¼" tall (7cm x 11cm) and copy and paste them into the new document. This is how to lay out the pages:

Bottom row, left to right: page 8 (back), page 1 (front), page 2, page 3.

Top row, left to right (these photos should be flipped upside down): page 7, page 6, page 5, page 4.

If you want, you can lay out the front and back pages with text to make them more like book covers and fill the middle pages with photos.

page 7	page 6	page 5	page 4
page 8 (back)	page 1 (front)	page 2	page 3

STEP 8:
Print the document onto the heavyweight matte photo paper and let the print dry. Follow steps 1–5 to put your book together. When you're finished, use double-sided tape to hold pages 3–4 and 7–8 together for a finished look.

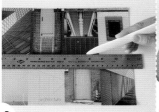
a

b

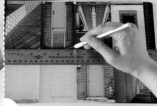
c

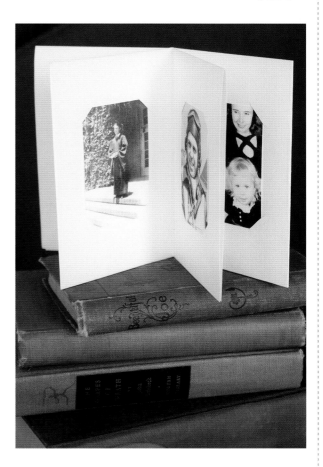
d

e

f

from contributing
guru
· · · · · · ·
Esther K. Smith

*v*2.0

The Classic Album

WHAT YOU'LL NEED:

* Heavy watercolor or art paper
* 6–8 wallet-sized photos (2" x 3" [5cm x 7.5cm])
* Photo corners (optional)

For a more traditional photo album, make your instant
book from a heavier sheet of 8½" x 11" (21.5cm x 28cm)
paper, following steps 1–5. Instead of printing directly on
the paper, cut small diagonal slits (about ½" [13mm] long)
into the pages where the 4 corners of each photo will
rest. (Lightly pencil where you want the slits to appear,
then unfold the book and flatten to cut.) Tuck the corners
of the photos into the slits to hold them in place. If you
do not want to cut into the paper, glue photo corners
onto the pages instead.

Cross-Stitch → Meets ← Photography

Convert a favorite photo into a cross-stitch pattern and surprise someone special with an extra-cool dose of cross-stitchy goodness.

from contributing guru
• • • • • • •
Julie Jackson

There are many ways to convert a photo into a cross-stitch pattern, especially with the Intertubes at your fingertips. A quick Internet search will show you software programs and online conversions, both free and not so free. If you're new to cross-stitch, you can also find how-tos, advice, and illustrated tutorials. A good place to start is subversivecrossstitch.com.

There are a few little tricks to keep in mind that will save you a lot of headaches when selecting a photo for conversion:

Pro or no? How experienced are you with cross-stitch? If you're a beginner, you'll probably want to keep the number of stitches and the number of thread colors to a minimum.

Start small: The size of the image makes a big difference. Cross-stitch can get pretty tedious when working on a large canvas. Smaller is simpler, so start small! Also, cross-stitch fabric comes in gauges: 14-count material has 14 holes per inch (2.5cm) and is pretty standard. You can use a smaller or larger gauge, but think twice before going past 18-count material, lest you end up like a blind mole rat—cross-stitch at that tiny size can make you loco.

Shady shades: Too many shades of one color can be hard to work with, so be careful out there. Some programs will let you choose the number of colors. Try to stay under 10 colors whenever possible; the fewer the better.

Keep it simple: Choose a photo that has clean lines and a simple background. If your favorite photo doesn't fit that description, pull it up in a program such as Photoshop and adjust the contrast, put in a solid background, or try it in black and white.

Once you get the pattern right, the rest is pure fun—and just think of what an incredible present you can crank out for a special occasion! For the person who has everything money can buy, it's a special expression of handmade goodness. It's a bit of a challenge, but it'll be obvious you really put your heart in it—it's a guaranteed good freak-out with bonus ego points if the portrait is of the recipient. And you can do it!

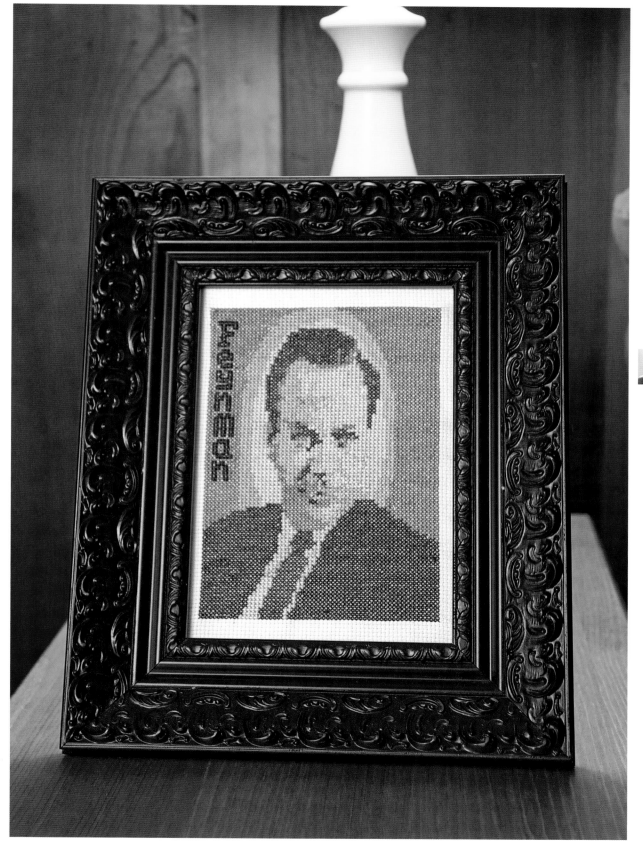

CHAPTER 4:
[ON THE GO]

CUSTOM PHOTO
Laptop Sleeve

Remember when everything you owned had awesome pictures on it? Your lunchbox had Han Solo and Chewbacca; your Trapper Keeper had unicorns and rainbows; even your pen held a tiny ship that sloshed from side to side. How come work isn't like that? How come the stuff we schlep around all day now is plain Jane? There's the plain black satchel that everyone gets sooner or later, for free, a leftover from some forgotten conference. Or the neoprene laptop sleeve, nameless and bland, and utterly lacking in inspirational qualities.

Break the mold, people! Take a stand against the soulless, picture-less homogenization of your workaday trappings! **Make yourself a photo laptop sleeve, and you can put any picture you want on it. Unicorns, robots, even Zooey Deschanel!** (We call dibs on Zooey though.)

WHAT YOU'LL NEED:

* Newspaper or kraft paper
* Pencil
* Marker pen (optional)
* Ruler
* Scissors
* Fabric marker (optional)
* $^1/_2$ yd (46cm) cushy fabric (such as padded coat lining or heavy fleece) for the lining
* 2 high-resolution photos (at least 300 PPI at letter size, one for the front and one for the back)
* 5 sheets of inkjet-printable photo canvas (We used Inkpress brand.)
* Waterproofing spray (such as Scotchgard)
* Binder clips, clothespins, or straight pins
* Iron
* Sewing machine or a needle
* Coordinating or contrasting thread
* Clean tea towel or old T-shirt
* Pinking shears (optional)

STEP 1:

Lay your laptop on a large sheet of newspaper or kraft paper. Trace around the computer with a pencil. Set the computer aside. If your pencil marks are hard to see, go over them with a dark marker. Use a ruler to add a $^3/_4$" (2cm) margin to each of the long sides and one short side. Add a 1" (2.5cm) margin to the remaining short side (this will be the top of the sleeve). The margin area will be the seam allowance when you sew the pieces together. (The *what?* Seam allowance just means you need a little extra fabric because you can't sew on the actual edge of the piece.)

Cut out your template along the margin line. **a**

STEP 2:

Fold your fabric in half, wrong side out, and trace your template onto the fabric with a pencil or fabric marker. Cut out both layers of fabric so you end up with 2 identical pieces, front and back. Careful with those scissors: that's how we lost our leg back in 1938.

STEP 3:

Measure the size of the newspaper template and write down the dimensions. Open both of your photos in Photoshop or other image-editing software, and crop or resize them to the dimensions of the template. For our trusty 13" MacBook, these dimensions were $10^7/_8$" wide x $14^3/_4$" tall (27.5cm x 37.5cm).

STEP 4:

Create a new document sized 11" wide x $8^1/_2$" tall (28cm x 21.5cm) at the same resolution as your resized photos. If the dimensions for your laptop are different than above, create a document slightly wider and longer than your dimensions. (For best results, always aim to resize your photos to be 300 PPI at the size that they will be printed.)

STEP 5:

Set the selection tool to a fixed size of 11" wide x $8^1/_4$" tall (28cm x 21cm). Select and copy the bottom half of the front photo. Paste this into the center of the new document, with equal margins on all sides. Return to the photograph and select the inverse (this will select the top half of the photo). Copy and paste that into the new document as well. Repeat this step with the remaining (back) photo. You should now have 4 layers in the small document.

STEP 6:

Print each layer of this document one at a time onto photo canvas. In Photoshop, you can do this by turning off the eye icon on every layer except the one you want to print, so only that one is visible. Print 2 copies of the bottom half of the picture that you've chosen for the front of the bag. (You'll make a handy pocket out of one later.) Use the borderless setting on your printer, or the size of the printed image may be slightly smaller. If you don't have a borderless setting, it's not a big deal—the white border will be hidden in the seam allowance when you sew everything together. **b**

STEP 7:

Let your prints sit undisturbed until they're completely dry, then spray them thoroughly with waterproofing spray to protect them in case they get wet. Two to three coats should do.

STEP 8:

Clip the top and bottom halves of each photo together, right sides facing each other (you can use pins instead of clips, but be sure not to poke holes in the photo). Line up the margins of the 2 halves and stitch along the margin line. The idea is to stitch the 2 pieces together as seamlessly and with as little overlap as possible so it looks like one uninterrupted photo. If you have trouble seeing where the margins are, hold the print against a window and trace the line on the back of the print with a pencil. **c**

Turn the stitched pieces facedown and iron the seams flat, then trim the excess white canvas from the tops of the photos. **d**

STEP 9:

Fold back the border at the top of the extra lower half of the front photo. Iron it flat, then stitch it down. This is a small border, so your stitches will be close to the edge of the fabric. Place the lower half on top of the front piece, aligning it so it matches the photo seamlessly. Clip the 2 pieces together. **e**

Stitch around the sides and bottom of the lower half, making your stitches ⅛" (3mm) from the edge of the fabric.

Now the front of your sleeve will have a handy pocket for storing comic books, airline safety manuals, or instructional pamphlets about world domination. And you're more than halfway to a finished bag! Give yourself a neck rub and fix yourself a celebratory sangria. You deserve it.

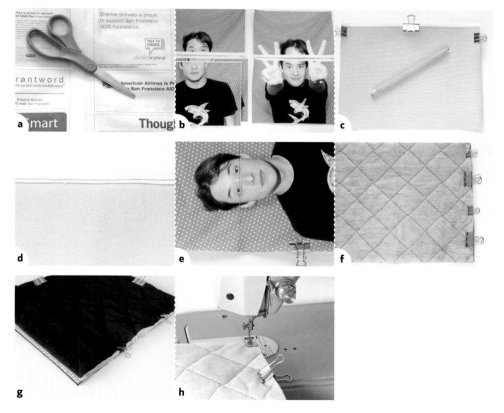

Holy moly, this laptop sleeve rules!

STEP 10:

Clip your back photo to a piece of the lining fabric, right sides facing in. Stitch along the top edge, making your stitches ¹/₂" (13mm) from the edge of the fabric. Whistle a jolly tune (sea shanties are also acceptable). Flip the lining piece over so the right sides of both pieces face out. Cover the piece with a clean tea towel or old T-shirt and iron the whole thing flat. (Ironing directly on the printed canvas might cause the iron to stick to the photo.)

Repeat this step with the front photo and the other piece of lining. **f, g**

STEP 11:

Clip the front and back pieces together with the photos facing in. Stitch around the bottom and sides, making the stitches ¹/₂" (13mm) from the edge. Trim any loose threads or fuzz from the edges of the fabric with scissors or pinking shears. **h**

STEP 12:

Ease your sleeve right side out. Canvas is fairly stiff and may require a little finesse to keep it from creasing. Poke the corners into shape with the eraser end of the pencil. Lay the tea towel over the sleeve and iron it flat. That's all there is to it, young bucko. Slide your laptop into your unconscionably cool custom sleeve, go find a Wi-Fi hotspot, and make all your Targus-toting peers jealous.

Picture Ideas for Your Laptop Sleeve

* Broadcast your retro mojo with a picture of a Commodore 64 or Apple II.
* Turn your laptop inside out with a photo of your keyboard on one side and a photo of your screen on the other.

Phone Home

Because the Custom Photo Laptop Sleeve is just an open-ended pouch, it's a cinch to adapt the instructions for other devices. This version has a flap closure to keep your iPhone, MP3 player, or tricorder from escaping. It would also make a stellar little makeup pouch, or a bag for your laptop's mouse and power cable. Once you've got the recipe down, you can make it any size you want.

WHAT YOU'LL NEED:

* Ruler
* 2 excellent digital or scanned photos
* 1 inkjet-printable photo fabric sheet
* Waterproofing spray
* Scissors
* Pencil or fabric marking pen (optional)
* Small piece of liner fabric, 8½" x 11" (21.5cm x 28cm) at most
* Binder clips or clothespins
* Sewing machine or needle and thread
* Clean tea towel or old T-shirt
* Iron
* Sew-on Velcro tabs

STEP 1:

Measure your device, adding 1" (2.5cm) to the width if it is ½" (13mm) thick or less. If the device is thicker than ½" (13mm), add an extra ½" (13mm) for each ½" (13mm) of additional thickness.

STEP 2:

Using your calculation from step 1, resize your photos in image-editing software, adding 1" (2.5cm) to the length of the picture for the front of your case and 3" (7cm) to the length of the picture for the back.

STEP 3:

Print your document onto an inkjet-printable fabric sheet, let dry, and coat with waterproofing spray. Let dry.

STEP 4:

Cut out your photos and use as templates to draw 2 rectangles on the back side of the lining fabric. Cut out the rectangles you just marked. Then, use the binder clips to clip each photo to its matching lining piece, front sides facing.

STEP 5:

Sew around the sides and top of each photo and lining pair, making your stitches ¼" (6mm) from the edge. Leave the bottom edge on each unsewn. Turn both pieces right side out, cover the photo with a towel, and iron the pieces flat.

STEP 6:

Clip the sewn front and back pieces together, lining side facing out. Starting at the top edge of the front piece, sew around the sides and

bottom, using the same ¼" (6mm) seam allowance.

STEP 7:

Turn the piece right side out, tuck the edges of the flap toward the center, and iron flat, protecting the photos from the hot iron with a towel.

STEP 8:

Sew Velcro tabs to the front and the flap to keep the pouch closed. Of course, snaps, buttons, and zippers work too, but we prefer space-age Velcro. That's all there is to it! Slip your device inside and hit the town.

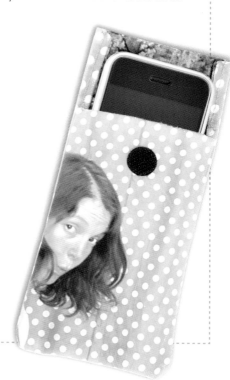

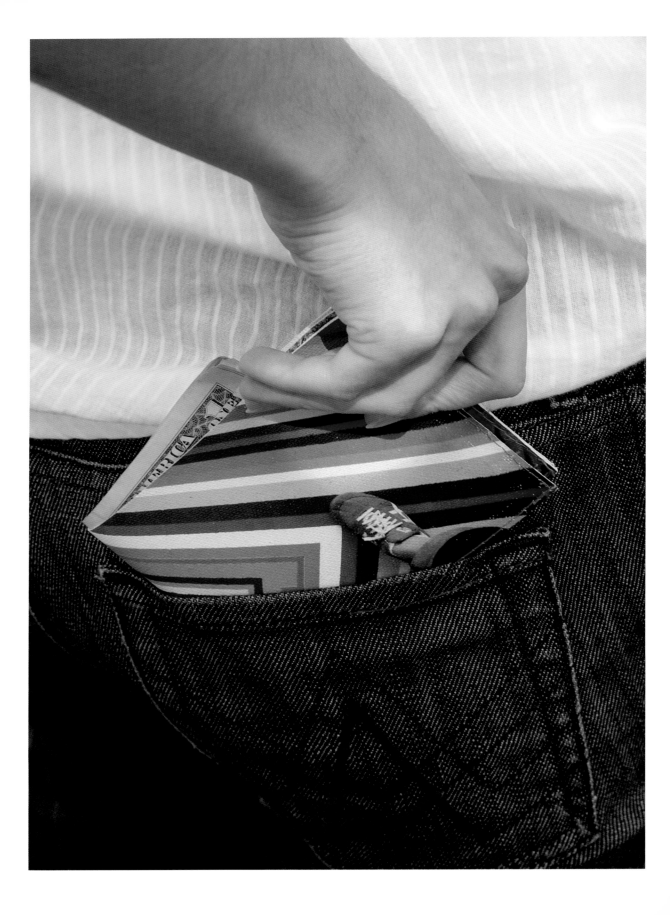

DIY
Photo Wallet

When it comes to buying a wallet, the main question is why? Why would you buy a wallet when you can make one with your own photos on it? One that screams "you, you, YOU!" every time you transact your bidnezz—that's what you need.

After all, you work pretty darn hard to earn the money in your wallet. Doesn't your hard-earned cash deserve some respect? Shouldn't the fruit of your labor reside in picturesque glory, counting the hours until it gets the chance to flow back into the great green sea of the economy? **Your bills deserve a handmade home of their own.**

You work hard for the money, so you better treat it right.

WHAT YOU'LL NEED:

* 2 horizontal photos

* 1 sheet of inkjet-printable photo canvas

* Waterproofing spray (such as Scotchgard)

* Scissors or rotary cutter and cutting mat

* Fray Check or similar seam sealant (keeps cut fabric edges from unraveling)

* Ruler

* Pencil

* At least 7" x 9" (18cm x 23cm) clear vinyl

* Clothespins or binder clips

* Sewing machine or a heavy-duty needle

* Coordinating or contrasting thread

* Matte clear tape (optional)

* Thimble (optional)

STEP 1:

Choose 2 photos that you really love and that go well together.

Use your image-editing software to resize each of them to 9" x 3½" (23cm x 9cm). Arrange them so that both will print out on one 8½" x 11" (21.5cm x 28cm) sheet. Print out the photos onto a sheet of photo canvas and let dry.

STEP 2:

Apply waterproofing spray to the photo canvas until it screams for mercy (2 or 3 good coats). This is important—you don't want your photos to run when you get caught in the rain.

Carefully cut out the photos using scissors, rounding the edges if you like. Rounded corners won't get bent as easily as square ones when you use your wallet. Apply a thin bead of Fray Check to the cut edges to keep them from unraveling or fraying. **a**

STEP 3:

Use a ruler to measure six 4" x 2" (10cm x 5cm) rectangles of clear vinyl; mark the edges with a pencil. Carefully cut out the vinyl. The edges of this vinyl will show in the final product, so be as neat as you can. Use a rotary cutter if you have one. **b**

STEP 4:

Decide which photo you want to use for the interior of the wallet. You'll use this one in the next step. Set the exterior photo aside for now.

STEP 5:

Line up one vinyl rectangle along the right-hand edge of the interior photo, ³/₈" (9.5mm) below the top edge. Clip the rectangle into place using a clothespin or binder clip (using pins would poke holes in the vinyl). Sew the bottom edge of the rectangle to the photo using long stitches and a sharp, heavy-duty needle (such as a leather needle). Trim the extra thread when you're done. **c**

Note:

If you are using a sewing machine and the presser foot sticks to the vinyl, place a piece of matte clear tape on the underside of your sewing foot. Voilà! Instant nonstick surface. If you're sewing this project by hand, you'll need to use a good amount of force to get the needle through the vinyl. Use a thimble to keep your poor sweet thumbkins from getting sore.

STEP 6:

Line up another vinyl rectangle along the right-hand edge of the photo ³/₈" (9.5mm) below the top of the rectangle you just sewed on. Clip in place and sew along the bottom edge of the rectangle. Repeat this step with one more vinyl rectangle. These will form the card pockets of your wallet. **d**

STEP 7:

Sew a line along the inside edge of all 3 vinyl pieces, attaching them to the photo. Leave the outside edge unsewn for now. **e**

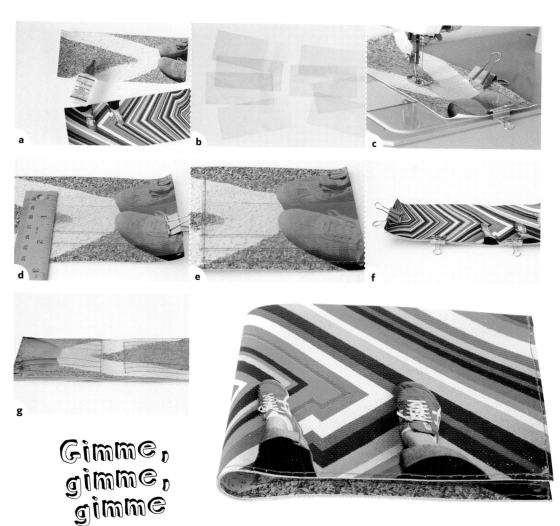

Gimme, gimme, gimme

STEP 8:

Repeat steps 4–7 along the left-hand edge of the inside photo with the remaining pieces of vinyl.

STEP 9:

Turn the whole piece over and place the outside photo faceup on top of the interior piece. Line up the edges of both pieces and clip them together. The blank sides of the photos should be facing each other. **f**

STEP 10:

Turn the whole piece over again so that the interior photo is facing you and sew along the short side edges and the bottom of the piece. Stitch close to the edge, making sure to stitch down all the outside edges of the vinyl pieces as well as the exterior photo. Trim the extra thread, get out your spendin' money, and put it in your a-ma-zing new wallet. Who's money? Who's money, you ask? You, gentle reader. You're money. **g**

Picture Ideas for Your Wallet:

* stacks of bills
* loose change between the cushions of your couch
* a panorama of a favorite cityscape
* every member of your family lined up in a row

THE *Purse*

With the *Secret* Photo Lining

Why spend your hard-won doubloons on fancy printed fabric when you can make your own at home? All you need is a really great photo and some printable cotton fabric. Oh yes, you heard right. Printable, washable, colorfast, glorious fabric that runs right through your inkjet printer. You can put any dang photo on it that you want.

And what better way to show off your bee-yoo-tee-ful custom fabric than by making Amy Karol's adorable clutch? **With a cheeky flash of photo lining, it's practical, it's functional, and it's so cute you could plotz.** Plus it's a great starter project if you've never made a bag before. Basic skills are all you need, but the final result looks far from amateurish.

WHAT YOU'LL NEED:

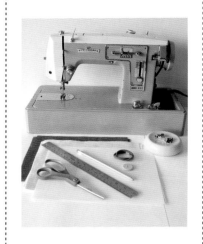

* Really good digital photo

* Two 8¹/₂" x 11" (21.5cm x 28cm) sheets inkjet-printable fabric (Resources, page 184)

* Liquid fabric softener (optional)

* Two 8¹/₂" x 11" (21.5cm x 28cm) pieces outside fabric. (We used corduroy, but velvet, tweed, or silk would all look great.)

* Two 8¹/₂" x 11" (21.5cm x 28cm) pieces cotton flannel

* Ruler

* Pencil

* Scissors

* Pins

* Sewing machine or needle

* Coordinating and/or contrasting thread

* Iron

* Elastic cording

* Big vintage or stylish-looking button

STEP 1:
Using image-editing software, resize your photo to 8¹/₂" x 11" (21.5cm x 28cm) and print. If your printer can print borderless, use that setting. If not, no big deal—the borders will be hidden in the seam allowance. **a**

STEP 2:
Let the prints dry for at least 15 minutes. Then peel off the plastic or paper backing. **b**

STEP 3:
Soak the fabric prints, one sheet at a time to prevent bleeding, for 10 minutes in room-temperature water. The instructions say to use distilled, but we used tap water and it turned out fine. Of course, there may be some pending karmic retribution of which we are as yet unaware. **c**

STEP 4:
Drain the prints, lay them flat, and let them dry completely. We laid ours out on paper towels to dry them quicker. Take a break, since it'll take a while for those prints to dry (maybe even overnight). **d**

STEP 5:
Pin the outside fabric pieces right sides together. Then sew around the sides and bottom, making the stitches ¹/₄" (6mm) from the edge. Set aside. **e**

STEP 6:
Once the prints are completely dry, make a sandwich of flannel and prints. The flannel pieces are the bread, and the prints (right sides together) are the peanut butter and jelly. Pin it all together. Yum! Stitch around the sides and bottom, making your stitches ¹/₄" (6mm) from the edge. Turn the bag inside out so the flannel lining is on the outside, and iron the whole thing flat. **f**

STEP 7:
With right sides together, place the lining bag inside the outer bag. Line up the edges and pin them in place. Cut 2"–3" (3cm–5cm) of elastic cording, make a little loop, and pin it to the center top of the bags. Make sure that the loop falls between the outer and inner bags. Stitch around the top of the bags, ¹/₄" (6mm) away from the edge. Be sure to leave an opening (about 3" [7.5cm] long) on the side opposite the elastic. This is where you will turn the bags inside out. **g, h**

STEP 8:
Turn the bags inside out by pulling them through the opening. When you have the bags right side out, tuck the lining bag into the outer bag. Iron the whole thing flat. **i**

STEP 9:
Edge-stitch the opening closed, making sure to tuck in the edges. If you're good at hand sewing, you may find it easier to do this by hand. **j**

STEP 10:
Figure out where to place the button by putting some stuff in the bag and folding it in half. Wherever the loop falls when the bag is full is where you want to add the button. Sew the button on. **k**

Ta-dah! You just made a bag! While exceptionally stylish for carrying your essentials about town, we also think these make really cool camera cases. We've taken to putting lenses in ours and tucking it into our camera bag for daytrips.

⚠

Prints on fabric tend to look a little washed out, so punch up the saturation and contrast more than you ordinarily would. If it looks garish on-screen, it's probably about right.

Make a test print in grayscale on plain paper to make sure you have the dimensions right. Then go ahead and make your print on the fabric sheet just as you would on a normal sheet of paper. If it looks good, go ahead and make a second print. (You need 2 identical pieces to make the lining.)

Really Good Digital Photo Ideas:

* green grass
* blue sky with clouds
* the water in a swimming pool
* the inside of another purse, complete with ballpoint pens and stray lipsticks

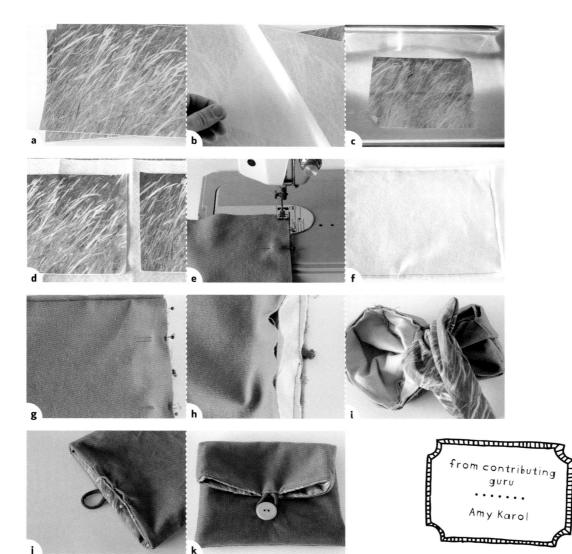

from contributing guru
• • • • • • •
Amy Karol

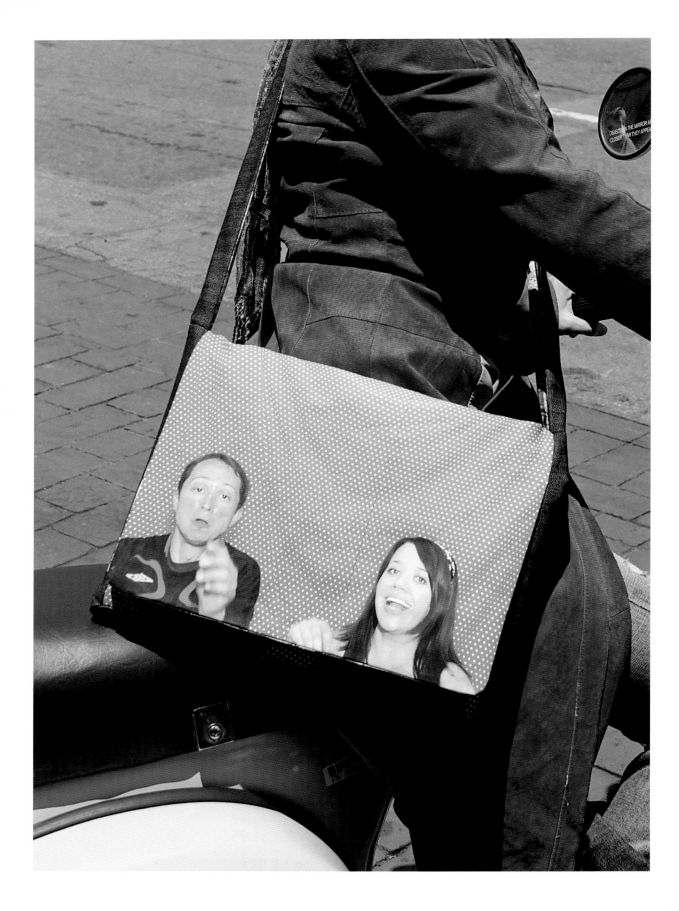

PHOTO
Messenger Bag

We love messenger bags. They're hip and useful and they hold a ton of stuff. But sometimes we wish there were a little more variety available. Actually, scratch that—we wish there were a LOT more variety available. It bums us out when we see somebody on the subway with the same cool one-of-a-kind bag we *thought* we'd found. So we gathered up some photos and some printable canvas, and we made our own. **We think it's pretty awesome, and it's not too hard to make, even if you've never made a bag before.** In fact, we had never made one before this, and it came out great. So give it a shot! We promise that nobody else will have a bag exactly like yours.

WHAT YOU'LL NEED:

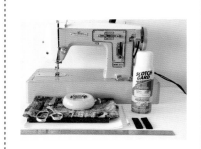

* Kraft paper or thin cardboard

* Ruler

* Pencil and/or fabric marking pen

* Scissors

* ³/₄ yd (68.5cm) lining fabric (We used lightweight printed cotton.)

* ²/₃ yd (61cm) heavy fabric, such as denim or corduroy, for sides, bottom and strap

* Rotary cutter and cutting mat (optional)

* Pins

* Sewing machine

* Coordinating and/or contrasting thread

* Iron

* 3 high-resolution photos (all horizontal—choose ones that go well together, since you need one for the back, one for the front, and one for the outside flap of the bag)

* Inkjet-printable fabric (We used Inkpress photo canvas.)

* Waterproofing spray (such as Scotchgard)

* Binder clips or clothespins

* 2 strips of Velcro

STEP 1:

Mark the following rectangles on a piece of kraft paper or thin cardboard using a ruler and pencil:

A: 11" x 14" (28cm x 35.5cm)
B: 3" x 11" (7.5cm x 28cm)
C: 3" x 14" (7.5cm x 35.5cm)
D: 3" x 22" (7.5cm x 56cm)*

Cut out each rectangle with scissors. Mark each piece with the letter assigned to it above. This will help keep you organized.

STEP 2:

Use the lettered rectangles as templates to trace out rectangles on the lining fabric. You will need to cut 3 of piece A, 2 of piece B, 1 of piece C, and 2 of piece D.

*If your fabrics are both longer than 44" (112cm), you can double the length of piece D and use one 3" x 44" (7.5cm x 112cm) piece instead of 2 shorter ones. If you do this, skip steps 5 and 6.

Once you've finished tracing, cut out the shapes. (Just for the record, the sewing geek here at Photojojo finally bought a rotary cutter and cutting mat and loves it for this kind of stuff. If anyone wants to take that cutter from her, they will have to pry it from her cold dead fingers.)

swatch of lining

(straps)

STEP 3:

Mark the fabric for the sides, bottom, and strap of the bag as follows: 2 of piece B, 1 of piece C, and 2 of piece D (or one 3" x 44" [7.5cm x 112cm] piece). Cut out the shapes.

swatch of sides, bottom, and strap

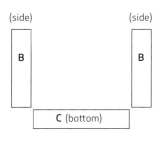

(straps)

STEP 4:

Pin the side and bottom fabric right sides together at the short ends, with one piece B on each side of piece C. Stitch these pieces together using a ¼" (6mm) seam allowance. (The seam allowance is already accounted for in the measurements of the rectangles.) This will form one long strip of fabric with 2 seams. Press the seams open with your iron. **a**

a

Note:

Use the same ¼" (6mm) seam allowance for the rest of this project.

STEP 5:

Pin and sew the 2 D pieces of strap fabric together at the short end to form one very long strip. Press the seam open. **b**

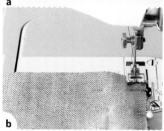
b

STEP 6:

Repeat steps 4 and 5 with the corresponding pieces of lining fabric.

STEP 7:

Now it's time to make the bag's strap. Pin the strap and lining strap pieces to each other, right sides facing in. Sew along each long edge, leaving the short ends open. Turn the strap inside out and iron it flat. Set aside. **c**

c

STEP 8:

If your printer only prints paper up to 8½" x 11" (21.5cm x 28cm), you'll need to tile together an 11" x 14" (28cm x 35.5cm) photo using 2 smaller sheets. Fire up the computer and open up your photos in Photoshop or another image editor. Resize or crop all 3 photos to measure 13⅓" wide x 10½" high (34cm x 26.5cm).

Note:

If your printer can handle 11" x 14" (28cm x 35.5cm) paper, you can print your 3 photos at that size and skip all the way ahead to step 16. Do not pass Go, do not collect $200. Don't forget to waterproof your prints, though; step 13 is very important!

STEP 9:

Create a new document sized 8½" wide by 11" tall (21.5cm x 28cm) at the same resolution as the photos you just resized. Set guides at ¼" (6mm) from the edges all the way around.

STEP 10:

Set the selection tool to a fixed size of 8½" wide by 11" (21.5cm x 28cm) tall. Select the left-hand section of one of your large photos, copy it, and paste it into the blank document. Now select the inverse (in Photoshop, open the Select menu, then choose Inverse), copy it, and paste it into the same document.

STEP 11:

Repeat step 10 with both of the remaining photos until you have 6 layers in the 8½" x 11" (21.5cm x 28cm) document.

STEP 12:
Print each layer of this document one at a time onto photo canvas. (In Photoshop, do this by turning off the eye icon on every layer except the one you want to print, so only that one is visible.) Use the borderless setting on your printer, or the size may be slightly smaller.

STEP 13:
Let your prints sit undisturbed until they're completely dry, then spray them down with waterproofing spray to keep the ink from running if they get wet. Two to three coats should do the trick. **d**

STEP 14:
Clip the halves of each sheet together, facing each other (you can use pins instead, but be sure not to poke holes in the photo). Line up the borders in the center of the sheet and stitch along the borderline. The idea is to stitch the two pieces together as seamlessly and with as little overlap as possible so it looks like one uninterrupted 11" x 14" (28cm x 35.5cm) photo. Turn the stitched piece facedown and iron the seams flat.

STEP 15:
Repeat step 14 with the other 2 photos until you have 3 large sheets: front, back, and flap. **e**

STEP 16:
Pin the side and bottom piece (the one you made in step 4) to the front photo with right sides facing in. Pin the corners first, then work your way outward. Make sure to use pins only along the edge of the fabric so you don't poke holes in the photo. Stitch the front photo to the side and bottom piece. Repeat this step with the back photo and the other side of the side and bottom piece. Check it out—your bag's coming together already! Turn the bag right side out and iron the seams. (We'll call this the "outer bag" in our instructions below.) Use the iron only on the side and bottom fabric, as the iron might stick to the photo canvas. **f**

STEP 17:
Repeat step 16 with the corresponding lining pieces. (Use 2 A rectangles in place of the photos.) Leave a 3"–4" (7.5cm–10 cm) hole in the bottom of this lining bag—you'll use it to turn everything inside out later on. **g, h**

STEP 18:
To make the bag's flap, pin the fuzzy sides of the Velcro strips to the remaining A piece of lining fabric. Place the Velcro near the 2 bottom corners but at least 1" (2.5cm) away from the bottom and side edges. Sew them down, as close to the edge of the Velcro as you can. You can also do this step by hand with a needle and thread. This lining piece will become the underside of the flap. **i**

STEP 19:
Pin the hook sides of the Velcro strips to corresponding places on the front of the bag. Sew them in place with a needle and thread.

STEP 20:
Pin the flap picture to the A piece, right sides facing in. Make sure to use pins only along the edge of the fabric so you don't poke holes in the photo. Sew the pieces together along the bottom and sides. Turn the flap inside out and iron it flat. Use the iron on the lining side so the photo doesn't stick to the iron, working around the Velcro pieces.

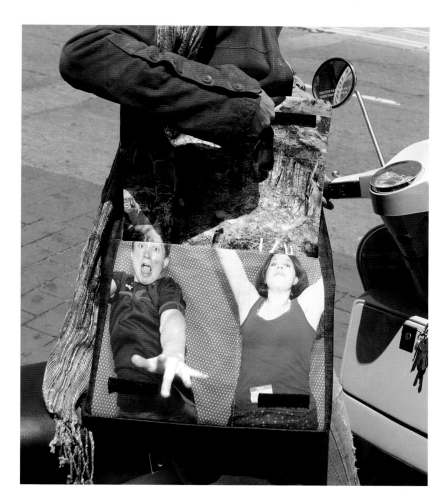

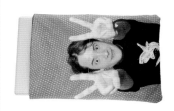

⬇

Oh, and by the way?
The Custom Photo Laptop Sleeve we designed (page 74) happens to fit perfectly in this messenger bag. Total coincidence. **Really**. We wouldn't dream of luring you into making a matching project.
Not us. No sir.

STEP 21:
Turn the outer bag inside out and pin the flap to the back of the outer bag, with the lining side of the flap facing the inside of the outer bag. Stitch the flap to the bag, $^1/_4$" (6mm) from the edge.

STEP 22:
Pin the short ends of the strap to the side sections of the outer bag, with the lining side of the strap facing the inside of the outer bag. Stitch the strap to the bag. **j**

STEP 23:
Pin the lining and outer bags together at the top edges, with the outer bag inside the lining and right sides together (i.e., the photo side facing the right side of the lining). Tuck the flap and the strap in between the outer bag and the lining bag. Stitch the top edges together.

STEP 24:
Turn the bags right side out by pushing all the material through the hole in the bottom of the lining. You should now have a lining bag attached to an outer bag. Sew up the hole in the lining and push the lining down into the body of the bag. Iron the top edges of the bag and collapse into a state of drooling exhaustion. You are all done, amigo. After you wake up from your 5-hour nap, take that bag of yours out on the town!

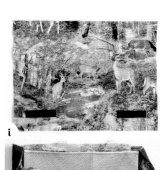

i

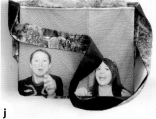

j

CHAPTER 5:
[AROUND
YOUR DIGS]

HUMONGOUS
Wall Mural

Made of (Fake) Trees

If you drool over Alfred Hitchcock's oeuvre, if you adore the subtle clink of ice in a whiskey on the rocks, if you schedule your life around *Mad Men* and wistfully ponder the injustice of the fact that you were born in this modern era, then this project is for you. You're the type who appreciates the finer things in life: the hi-fi stereo, the modern lines of mid-century Danish furniture, the lost art of mixing a perfect Mai Tai.

What you don't particularly appreciate are the white, unpaintable walls of your twenty-first-century rent-a-box apartment. They lack style, they lack verve . . . they salt your game. Well, hold onto your impeccably spotless fedora, Mr. Man-about-Town. We've got a dynamite little number here: the wood-grain photo mural. It's brimming with continental class and so cheap you'll think inflation never existed.

WHAT YOU'LL NEED:

* High-contrast 4" x 6" (10cm x 15cm) photo

* 2 rolls of 18" (46cm) wood-grain shelf paper, one light color, one dark color (We used Con-Tact™ paper.)

* Scissors (or craft knife, straightedge, and large cutting mat)

* Clear tape

* Level

* Pencil

* Yardstick

* Art projector (available from art stores—we scored a Tracer Jr. on eBay)

* Extension cord (optional)

* Extra-fine-tip permanent marker (optional)

* Craft knife and lots of extra blades

* Tweezers (optional)

STEP 1:
Make your photo black and white and really contrasty. You can do this using desaturation and levels in image-editing software, but we have a soft spot for lo-fi technology. We just photocopied our photo until it was entirely black and white—no shades of gray left at all. (An entirely appropriate use of the company photocopier.) **a**

STEP 2:
Cut 4 pieces of shelf paper, each 36" (91cm) long and 18" (45.5cm) wide, 2 pieces of each color. Use the grid lines on the back of the shelf paper to make your cuts as straight as possible, or use a straightedge, craft knife, and cutting mat. **b**

Align the like-colored pieces side by side so they form a 36" (91cm) square, and tape a the center seam down the back with clear tape. This will keep the pieces aligned properly when you put the shelf paper on the wall.

STEP 3:
Decide where you want to put up your mural. At the top edge of where you want the mural to be, trace a 36" (91.5cm) horizontal line on the wall using a level, a pencil, and a yardstick. **c**

STEP 4:
Decide which color you want the background to be. For example, if you have more black than white in your picture, you'll probably want to use light shelf paper for your background.

Align the top of the background paper with the line on the wall, peel off the top edge of the backing, and stick the paper to the wall. Slowly peel the backing down, sticking the paper to the wall as you go and smoothing out any air bubbles. **d**

Repeat this step with the other color of shelf paper, putting it exactly over the top of the background piece. If your squares don't align perfectly on top of each other, use a straightedge and a craft knife to even out the edges. Use the knife very lightly so you don't cut into the wall. **e**

Note:

Later on in this project, you'll use a craft knife to cut away just the top layer of shelf paper. If you're uncertain of your delicate knife-wielding skills, put up 2 layers of the background color before covering them with the final layer.

STEP 5:
Position your photo under the art projector, dim the lights, and turn the projector on. Move the projector away from the wall until the photo fills the square of shelf paper. You may need to use an extension cord to get the projector far enough away, and you'll probably have to set it on a chair or stepladder to raise it high enough. Once you have everything set up, focus the projection.

STEP 6:
Grab a pencil and start tracing around all the lines of your photo. Work systematically so you don't miss any lines—move either left to right or up and down until the entire photo is transferred. Pencil will be visible on light-colored shelf paper, but for dark-colored shelf

When using the knife, remember to use a very light touch. You want to cut just through the top layer, not into the second one or through to the wall. Change blades often as you cut out your mural, at least 5 to 10 times.

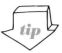

Of course, if you live someplace where you can actually paint your walls, all you have to do is trace your photo on the wall, grab some paint and small brushes, and paint your own masterpiece.

paper use an extra-fine-tip permanent marker. Mark an X on the inside of the shapes you plan to cut out.

When you think you're all done, hit the lights before you move or turn off the projector. Look at all the spots you missed. Tsk, tsk. Turn the lights off again and finish the job.

STEP 7:
Once you have finished tracing the outlines of your image, use a craft knife with a brand-new blade to cut out the areas you traced, working carefully to cut through only the top layer of shelf paper. Use the photo as a guide to see which bits stay and which bits get removed. Sharp tweezers can help you remove the top layer of shelf paper. You can also use your fingernail or the tip of the knife. (If you remove the wrong piece by accident, you can just stick it right back on. Yay, shelf paper.) **f**

STEP 8:
When you've removed all the little bits and pieces, step back and admire your handiwork. Mix yourself a martini, put on some Frank Sinatra, and bask in the knowledge that Charles and Ray Eames would approve.

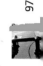

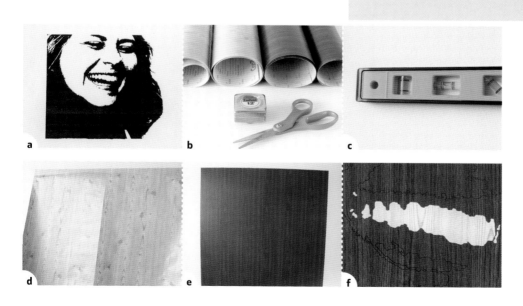

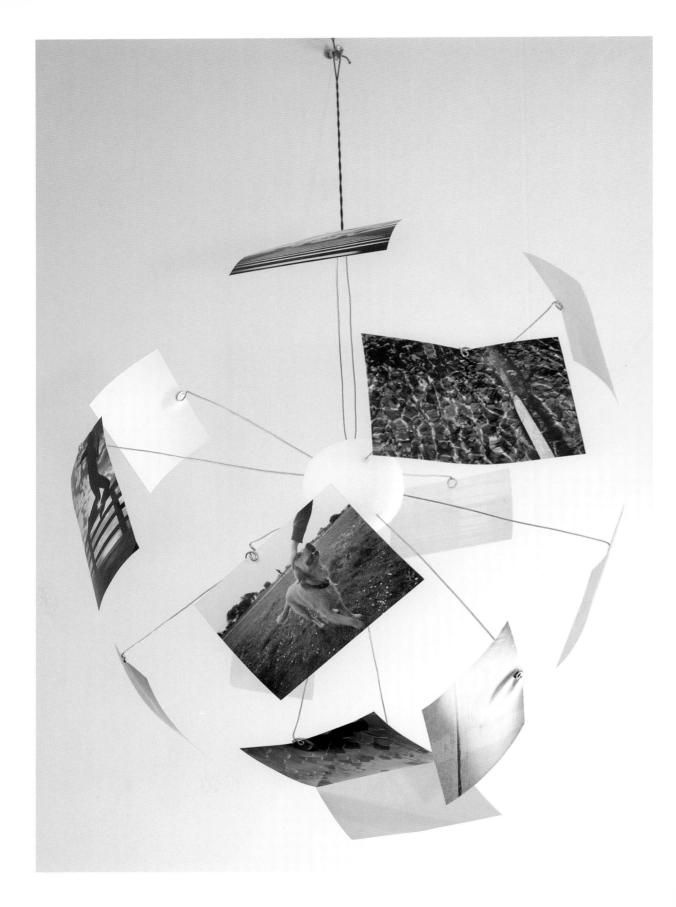

PHOTO
Chandelier

Half–photo frame, half-Sputnik, all fabulous. We call it the photolier. It hangs from the ceiling, twirling gently, showing off your photos in Atomic-age style.

If you ever watched *Sleeper*, or *2001: A Space Odyssey*, or *Buck Rogers* and wished that you too could have that fabulous space-age decor, **the Photo Chandelier can be your first step to futuristic utopia.** Trust us. We, too, know that old sci-fi longing, the siren song of Lucite and chrome and polished white plastic orbs. We may not have a teleporter yet, or an interplanetary space station, or even a run-of-the-mill army of rampaging, murderous killbots. But at least we have the Photo Chandelier, and it soothes our decorative soul.

WHAT YOU'LL NEED:

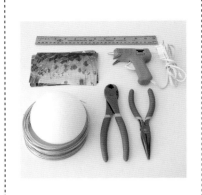

* Heavy-gauge steel wire (We used 14 gauge from the hardware store, but floral wire from the craft store would work just as well.)
* Wire cutters
* Needle-nose pliers
* Glue gun
* Newspaper
* 4" (10cm) foam craft ball (You can find them in the flower-arranging sections of craft stores.)
* String or fishing line (optional)
* Thirteen 4" x 6" (10cm x 15cm) photographs
* Ceiling hook

from contributing guru
• • • • • • •
Danielle Strle

STEP 1:
Cut a 12" (30.5cm) length of wire. Straighten it out to form a spoke. Use the pliers to twist the end into a spiral. Push the center of the spiral out a little bit so it will be able to hold a photo when you're done. Bend the spiral over so it's perpendicular to the rest of the spoke. **a**

STEP 2:
Repeat step 1 until you have made 13 spokes.

STEP 3:
Cut a longer length of wire, about 15" (38cm), and bend the end into a simple loop with the pliers. Keep this piece handy for the next step. **b**

STEP 4:
Heat up the glue gun (a.k.a. the Scorcher) and set it on some newspaper so it doesn't drip on your work surface. And for the love of Pete, don't get any hot glue on yourself because that stuff burns. Apply a drop of hot glue to the ball, then push the longest spoke about 2" (5cm) into the ball, through the drop of glue. You will hang the chandelier from this spoke, so consider it the top center point of the ball. **c, d**

STEP 5:
Use the top spoke to determine where the equator of the ball lies. Then glue and push in 4 spokes equidistant around that imaginary line. You can mark where they should go with a pencil if you want to be extra careful.

STEP 6:
Now imagine a line encircling the ball halfway between the equator and the top point. Glue and insert 4 spokes equidistant around this line. They should go in at an angle halfway between those of the equator spokes and the top spoke. Stagger their placement so they fall between the equator spokes. **e**

STEP 7:
Repeat step 6 on the bottom half of the ball. **f**

STEP 8:
Glue and insert the last spoke at the pole opposite the top spoke. Unplug the glue gun and let it cool down.

STEP 9:
Attach a length of string or fishing line to the loop on the top spoke so you can hang it from a hook on the ceiling. Of course, if you made the loop big enough and want the chandelier to hang close to the ceiling, you can skip the string entirely.

STEP 10:
Slip a photograph into the spiral part of one of the spokes. You may have to bend the photo slightly to get it into the spiral, but after that it should hold securely. Repeat this step until all of your photos are in place.

STEP 11:
Put a hook in the ceiling where you want to hang the chandelier, and put that puppy up. Invite some pals over to enjoy some swank cocktails (Midori Meteor, anyone?) and toast to progress in the newfound elegance of your future-tastic digs.

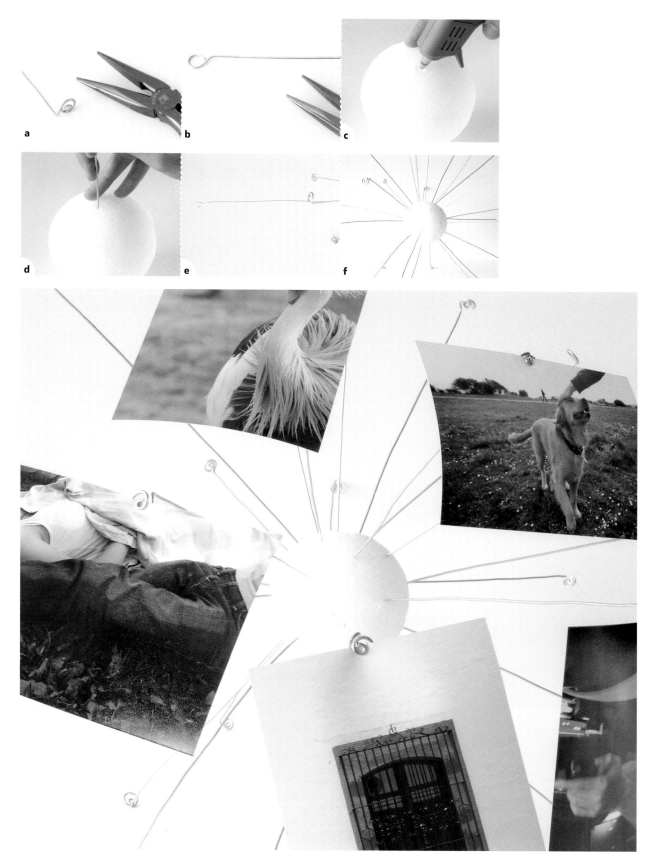

a

b

c

d

e

f

HARDCOVER BOOK
Photo Frame

We admit it: we judge books by their covers. We do it all the time. There have been days when we've left the thrift store with a whole sackful of books with no more redeeming qualities than a fetching dust cover, or a pleasant-looking spine. It often happens on these occasions that the cover turns out to be better than the book itself. (Really, what made us think we were actually going to read that sixties-era tome on "new" developments in Belgian foreign policy?) **So what do you do when life gives you book lemons? Make book lemonade.** Cut a window in the cover of the mediocre book, slip a photo behind it, and display the fantabulousness for all to see. Nerd chic: wave of the future.

WHAT YOU'LL NEED:

* Seriously awesome vintage book

* Seriously awesome 4" x 6" (10cm x 15cm) photo

* Ruler

* Pencil

* Cardboard or small cutting mat

* Utility knife

* Sandpaper (optional)

* Paint and small paintbrush (optional)

* Artist's tape or photo-safe clear tape (You can find artist's tape near the masking tape at art supply stores.)

tip

You can make these frames vertical or horizontal, and you can make them any size you want. If you've got a huge kid's book, fill it with an 8" x 10" (20.5cm x 25.5cm) photo or make lots of little windows for wallet-sized pictures.

STEP 1:
Measure your book's cover to figure out where the center is, then mark out a 3^1/$_2$" x 5^1/$_2$" (9cm x 14cm) area where you want your photo to go. Mark lightly with a pencil in case you need to erase it later. **a**

STEP 2:
Slip the cardboard or cutting mat between the cover and the pages of the book. Use the ruler as a straightedge and cut along the lines you marked with a utility knife. You'll need to make a series of shallow cuts along the same line, since you won't be able to cut all the way through the cover in one go. **b**

STEP 3:
Pop out the rectangle you just cut, and erase any stray pencil marks. If you like, you can sand the edges of the cut lightly to smooth down any stray slivers or ragged bits. For a really polished look, paint the cut edge a contrasting color. Just be sure to mask off the cover with masking tape so no paint spills over onto the front of the book. Let the paint dry before continuing to the next step. **c, d**

STEP 4:
Position your photo behind the cutout rectangle and neatly tape it into place. Stand the book on end, and you've got yourself a frame! Hurrah! **e**

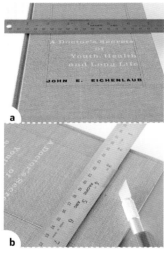

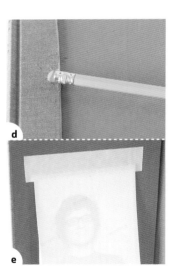

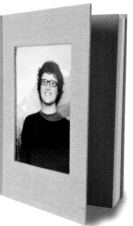

BACKLIT PHOTO
Tube Lamp

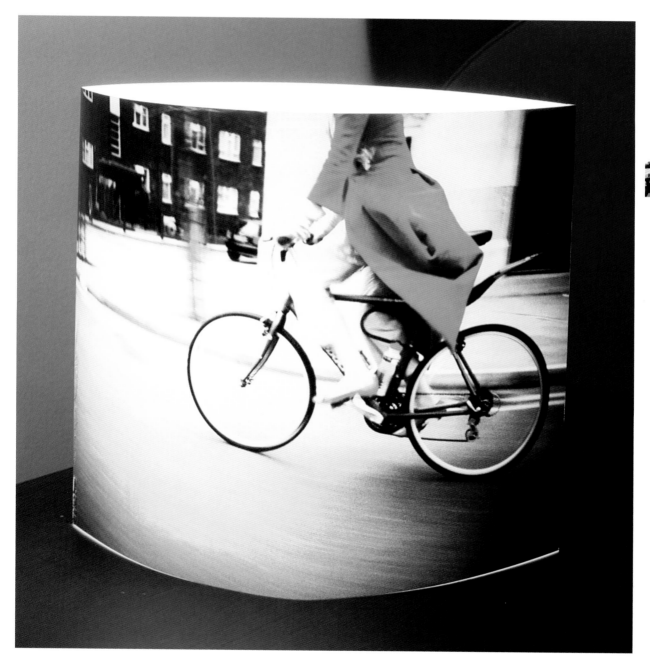

WHAT YOU'LL NEED:

* Digital photo you love very much
* 2 sheets 8½" x 11" (21.5cm x 28cm) glossy inkjet photo paper (preferably without a watermark on the back)
* Utility knife
* Glossy clear tape
* Jar with the following specifications:
 Glass, not plastic
 Holds 24–32 fluid ounces (.7L–.95L)
 4"–5" (10cm–12.5cm) diameter
 6"–7½" (15cm–19cm) tall
 Wide mouth (2½" [6.5cm] or more)
 Deep (¾"–1" [2cm–2.5cm]) plastic lid (not metal)
* Block of wood, drill, and ¼" (6mm) bit
* Wire cutters and wire coat hanger
* Pliers
* Replacement lamp cord with plug (cord switch optional)
* Brass lamp socket
* Screwdriver
* Mini CFL daylight or soft white bulb (15 watts or less), or small incandescent bulb (25 watts or less)
* White plastic mailing-tube lid, 4"–5" (10cm–12.5cm) diameter (optional)

Ever since we saw *The Breakfast Club*, we've thought lamps were too intimidating to make ourselves. Remember that kid who made one in shop class, and it didn't work, and he almost shot himself with a flare gun? Yikes!

So we'll admit that this is the first lamp we've ever made. But you know what? The thing actually works! And yes, we are total nerds, but we got a huge rush from plugging our lamp in and having the light turn on. **It works, it looks really cool, and we didn't even get mocked by the shop teacher.** Whew.

Note:

If finding the perfect glass jar for this project seems complicated, fear not! Just use a large glass mayonnaise jar, or the largest instant coffee jar you can find.

from contributing guru
• • • • • • •
Michael Herzog

STEP 1:
Empty, wash, and dry your jar well. Remove the label.

STEP 2:
Resize your photo if necessary, so it takes up the entire sheet of paper. You can use either a landscape- or portrait-oriented photo. Bright, saturated photos work best (pastels will look washed out). Print the photo on the glossy photo paper. If your printer has a borderless printing capacity, use it. If you want the same photo on the front and back of the lamp, make another print. If you want a blank back, grab an extra sheet of glossy photo paper. If you want different photos on the front and back, choose another photo and repeat. **a**

STEP 3:
On the piece that will be the back of the lamp, cut a small, upside-down, V-shaped notch in the bottom center of the paper. It should be about ½" tall and ½" wide at the base (13mm x 13mm). This will let the cord pass through when the lamp is done. **b**

STEP 4:
Align your prints next to each other, face up. Tape them together along their vertical sides, as neatly as you can, using one long strip of glossy tape. Fold the photos together, facing out, and tape the other side as neatly as possible. This will form a flattish tube.

STEP 5:
Place the jar lid on top of the wood block. (The block is there to keep you from drilling into your work surface.) Carefully drill a ¼" (6mm) hole in the side of the lid, very close to the flat side. You can also do this with a utility knife if you don't have a drill. **c**

STEP 6:
Carefully reshape the hole with a utility knife so it looks like a cartoon mouse hole. Cut to, but not through, the flat side of the lid. This is where the cord will feed out of the jar. **d**

STEP 7:
Use the wire cutters to snip out an 8" (20cm) length of wire from the coat hanger. Bend the wire in half, then into the shape pictured (like a Z with a vertical point in the middle). When finished, it should fit into the jar lid and the bottom legs should be flat against the inside of the lid. **e**

STEP 8:
Remove the cardboard lid liner and cut a ¹/₂" (13mm) cross in the center. **f**

STEP 9:
Assemble the jar lid, wire shape, and lid liner in that order, threading the point of the wire shape through the slits in the lid liner.

STEP 10:
Thread the narrow end of the cord through the hole in the lid, from outside to inside. Do *not* plug in the cord yet. **g**

STEP 11:
Tie the cord into an underwriter's knot. To make this knot, hold the lamp cord so it forms a Y. Following the shape of the Y, make a loop on each end of the wire, holding the end of one loop in front of the joined cord and the end of the other loop at the back of the joined cord. Slip each end through the loop formed by the opposing wire and tighten the knot.

STEP 12:
To wire the socket to the cord, remove the socket from its brass shell and thread the cord through the nipple of the socket's base. (Okay, you can stop giggling now; that's what it's called.) Loosen the screws on each side of the socket.

STEP 13:
Strip the ends of each wire by cutting just through the plastic casing and pulling it off to expose the wire. Strip about ¹/₂" (13mm) from each wire. Wrap the neutral wire (the ribbed one) around the base of the silver screw on the socket and the other wire around the base of the brass screw. Tighten the screws. **h**

STEP 14:
Slip the brass shell back onto the socket, pull the excess wire into the base of the socket, and snap the base cap into place. **i**

STEP 15:
Impale the brass socket through the nipple onto the wire shape attached to the lid. This is totally safe as long as the cord is NOT plugged in. **j**

STEP 16:
Screw in the lightbulb. A soft white or daylight mini CFL will give you the most accurate color balance. Pretty. If your jar is on the small side, a candle-flame-shaped or small appliance bulb may fit better.

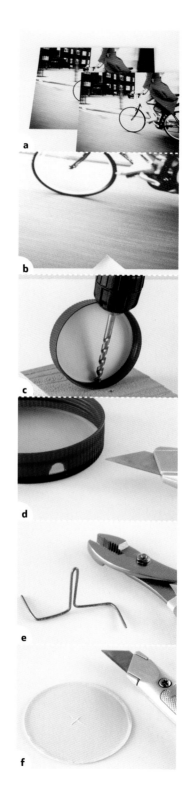

a

b

c

d

e

f

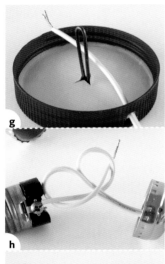

g

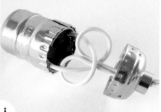

h

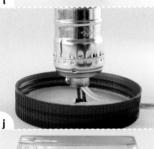

i

j

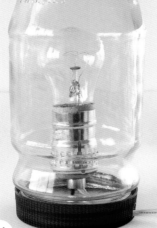

k

l

STEP 17:
Carefully insert the bulb assembly into the jar and screw on the lid. Don't screw it on too tight, as this may pinch the cord and/or make the jar wobbly. **k**

STEP 18:
Set the jar on its lid and slip the photo tube over the jar, slipping the notch in the back picture over the cord.

Note:

Use a white mailing-tube lid as a glare-reducing cover on the top of the jar, or trace a circle the diameter of the jar on white paper, cut it out, and lightly glue it to the top of the jar.

STEP 19:
Okay, are you ready? This is the moment of truth. This is where you pull the elephant's trunk and see if the light comes on. We suggest getting a friend to make drumroll sounds for full dramatic effect. Ready? Okay . . . plug it in! It worked, didn't it? Isn't that cool? You totally just made a lamp. **l**

you + lamp + skillz = electrician
(and awesomeness)

tip

Large instant coffee jars make great lamp forms for this project, but don't bother trying to drink all that joe. Use it to dye your jeans instead. Get a big bucket with a lid, dissolve all the coffee in 2 gallons (7.5L) of hot water and soak your jeans in it for 24 hours to get that cool worn-in tint that the shops charge an arm and a leg for.

→ 5 ← Lighting Tips for Beginners

from contributing guru
• • • • • • •
David Hobby

1. The sun behind you? Forget it.

You know that little blurb on the old film boxes that said to put the sun behind you for the best photos? Forget about it. Use sidelight, three-quarter light, and backlight to give your photos more depth. Try overexposing with strong backlight to correctly expose the face while getting an ethereal feel in the background. Filling in with the flash will let you vary the effect.

> TIP: Sidelight and backlight look best when the sun is at a low angle. Shoot in the early morning and late evening—as the pros do.

2. Don't be direct. Bounce around the subject.

Never, never ever, never ever, ever, ever, if you can help it, fire your on-camera flash directly into someone's face. Bounce flash is almost always better than direct flash. With a bounce flash, your subject's face will be less shiny and flat, the background more even, and the photo more flattering all around. We like to tilt our flash up and backward just slightly to bounce off the ceiling and the wall behind us.

Off-camera flash is even better than bounce flash. But the common thread for both types is getting your light to come from a different direction than your camera lens. That is what gives your subject shape.

3. Aluminum foil can save the day.

What do you do if you only have a point-and-shoot with a direct flash? Take a seldom-used card from your wallet (phone card, insurance card, etc.) and cover one side with aluminum foil. Keep it with you. When needed, hold the card in front of your point-and-shoot's tiny, built-in flash at a 45-degree angle to bounce the light off a wall or ceiling. The wall or ceiling (and subject) have to be fairly close—and neutrally colored—for this trick to work well.

4. Be choosy.

Fire your flash through a cardboard tube (a makeshift "snoot") to restrict the light beam to a narrow area. Some subjects are much more interesting when you do not light the entire frame. Being selective can give you a lot more control over your final photograph. (See also Light Painting Made Easy, page 144.)

5. Bedsheets aren't just for the bed.

Want to shoot a window-lit portrait but the harsh sun is streaming directly through? Clip a white bedsheet over the window and watch the room turn into a beautiful, light-bathed backdrop for the perfect portrait. Simple, and it works every time.

MAGNETIC, FRIDGE-BASED
Mr. You Head

Mirrors are for the weak. There. We said it. We've thought so for years, but we never had the courage to say it out loud. Who needs a big ol' mirror taking up space when you have a perfectly good fridge? We know what you're going to say: "But I need a mirror to see how I look!"

But you don't. Not if you make a magnetic version of yourself with interchangeable outfits. **All you have to do is assemble the perfect outfit on the fridge, accessorize, and you're done.** Just throw on your optimal, fridge-tested clothing, toss your shiny locks, and sashay out the door. We think you'll find it's far more efficient than actually trying the clothes on. No more fashion-related waffling. No more piles of rejected gladrags. No more wear and tear on your delicate, sylphlike extremities. Down with the tyranny of our reflective oppressors!

WHAT YOU'LL NEED:

* 2 white sheets or a white wall and a roll of white butcher paper

* Camera

* Tripod

* Masking tape

* Buddy who's handy with a camera

* Several changes of clothing

* Printable magnet sheets (available at office supply stores)

* Scissors or a craft knife and cutting mat

* Refrigerator or other magnetic surface

STEP 1:
Hang one white sheet on the wall and spread the other on the floor in front of it (or roll out enough butcher paper for someone to stand on).

STEP 2:
Set up your camera on a tripod. Mark the position of the tripod on the floor with tape in case it gets moved accidentally during the shoot.

STEP 3:
Now go stand on the white sheet, up against the white wall, and strip down to your skivvies. This is why your grandma always told you to wear clean underwear. Strike a pose that will be easy to re-create each time you change clothes. We chose a position with one arm in the air, kind of squinting into the distance. Have your friend tape out the position of your feet and mark your position on the wall at key points (elbows, the top of the head, and hands).

STEP 5:
Start shooting! Start out in your underwear and put on one item of clothing at a time until you're fully dressed. Start with jeans, then a shirt, then a jacket and so on. Take a picture with each new addition. Change each piece until you've exhausted your wardrobe. Try on some hats while you're at it, throw on a shoulder bag, or perhaps try a fetching apron for that hostess-with-the-mostest vibe. Try some different facial expressions too. ANGRY YOU. Happy you! *Emotionally unstable you.*

STEP 6:
When you're all done, give your pal a pat on the back. You kids did some good work today. Then, in Photoshop (or whatever photo software you love best), cut out all the figures from their backgrounds. This doesn't need to be terribly exact as long as you don't lop off any bits of the person. Cut and paste all the figures into one document and arrange them so they'll print onto one magnet sheet (or 2 if you have lots of changes of clothes). You can rotate the figures to make them fit more easily on the sheet, since you'll be cutting them out anyway. The figures should all be the same size, between 3" and 5" (7–12cm).

STEP 7:
Print the document onto a printable magnet sheet.

STEP 8:
Cut out the first figure (the one in the skivvies) from the magnet sheet using scissors or a craft knife. Then cut out each article of clothing in the rest of the photos. Cut out everything separately, including accessories and heads with different expressions. When you're done, you should have one whole figure and a little pile of shirts, pants, and other paraphernalia.

STEP 9:
Put everything up on your fridge. Try on different outfits, accessorize, or change your head depending on what mood you're in that day. See? We don't need no stinking mirrors.

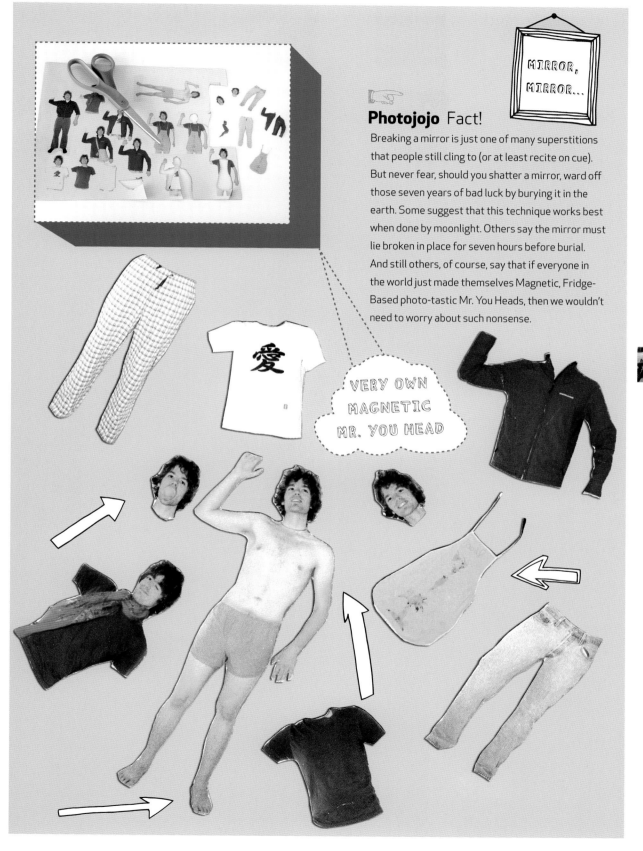

MIRROR, MIRROR...

☞ **Photojojo** Fact!

Breaking a mirror is just one of many superstitions that people still cling to (or at least recite on cue). But never fear, should you shatter a mirror, ward off those seven years of bad luck by burying it in the earth. Some suggest that this technique works best when done by moonlight. Others say the mirror must lie broken in place for seven hours before burial. And still others, of course, say that if everyone in the world just made themselves Magnetic, Fridge-Based photo-tastic Mr. You Heads, then we wouldn't need to worry about such nonsense.

VERY OWN MAGNETIC MR. YOU HEAD

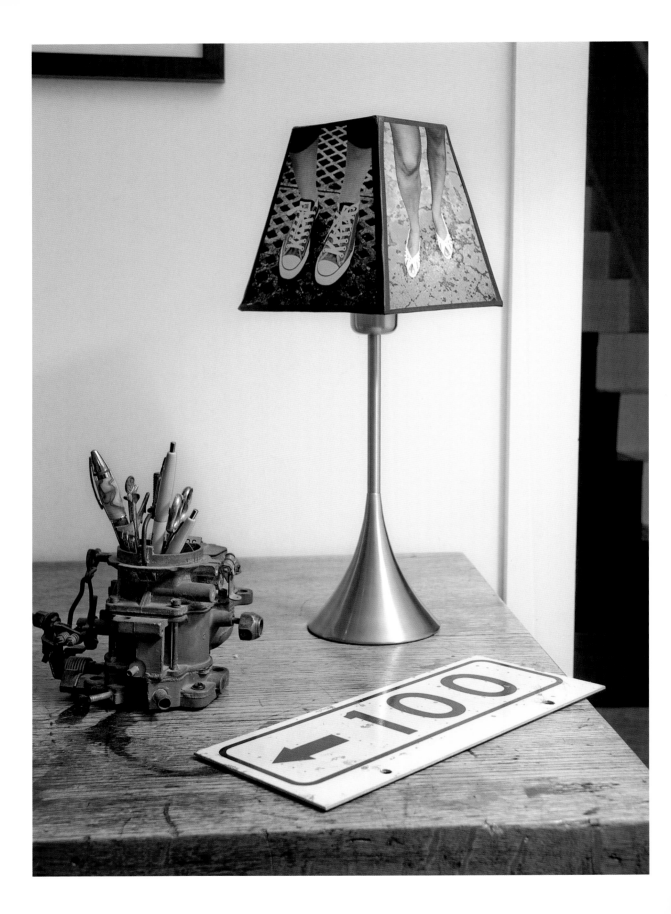

How many times have you walked into a friend's apartment and been able to name their Ikea lamps on sight?

"Hey, isn't that Kvart?"

"No, actually that's Pöbli. The one over there is Kvart."

If you've had that conversation, or if you blushed with embarrassed familiarity while watching the Ikea scene in *Fight Club*, then it's time to break the mold. And we've got just the solution. Transform your cookie-cutter flat-pack life with a lamp that's also a four-sided picture frame. All you need is a lampshade frame, some photos and some tape to make a lighted master-piece all your own. It's simple, striking, and, best of all, one-of-a-kind. We bet all your pals will be kicking their Pöblis in jealousy when they see it.

WHAT YOU'LL NEED:

* Lampshade frame (We used a 7" [18cm] square frame that we got from lampshop.com.) or plain white lampshade

* Heavy paper (cardstock, kraft paper, or grocery bag)

* Pencil

* Scissors

* Ruler

* 2–4 high-resolution digital photos

* 8½" x 11" (21.5cm x 28cm) photo paper without a watermark on the back (We used Canon Matte.) or cardstock

* Artist's tape (white, black, or the color of your choice—look for it next to the masking tape at art stores)

* Lamp

STEP 1:
Trace the lampshade on heavy paper, angling your pencil toward the inside of the frame. (The template should be a bit smaller than the frame dimensions.) **a**

STEP 2:
Cut out your template and hold it against the frame to see if it fits. It should be just slightly smaller than the frame. Trim if necessary. Measure the dimensions of your template (top, bottom, and sides). **b**

STEP 3:
Choose the photos you want to use (we used a different one for each side of the frame). Resize them in image-editing software to make sure they will fit within the dimensions of your template. (For example, our template was 7" [18cm] wide at the bottom, 7" [18cm] tall, and 4" [10cm] wide at the top, so our photo needed to be at least 7" x 7" [18cm x 18cm].)

STEP 4:
Print your photos. If you are using cardstock instead of photo paper, the plain-paper setting will give you the best print quality.

STEP 5:
Place your template on top of the photo and trace around it with a pencil. Cut out the shape you traced. Repeat this step with the remaining photos. **c, d**

STEP 6:
Tape the photos onto the frame using the artist's tape. Tape the sides only for now, and do your best to place the tape neatly and evenly along the side of the frame. Cut the tape a bit longer than you need, and tuck the extra length into the inside of the frame. **e, f**

STEP 7:
When all the sides are taped, place tape along the top edge of the frame. Cut the tape neatly, since the edges will show. Now tape the bottom of the frame, again keeping the edges of the tape as neat as possible. **g**

STEP 8:
Attach your shade to the lamp, turn it on, and bask in 60 watts of pure photo joy—or, if you're using CFLs (good for you), 15 or so. You've earned it.

Photojojo Fact!

No expense was spared decorating Hearst Castle in San Simeon, California, including the custom lampshades made from the fifteenth-century Gregorian prayer books that light up William Randolph Hearst's private library. The manuscript pages would have taken artisans about a year to painstakingly hand-letter. Fortunately, the materials you'll need for our Photo Lampshade won't cramp your hand—or your style.

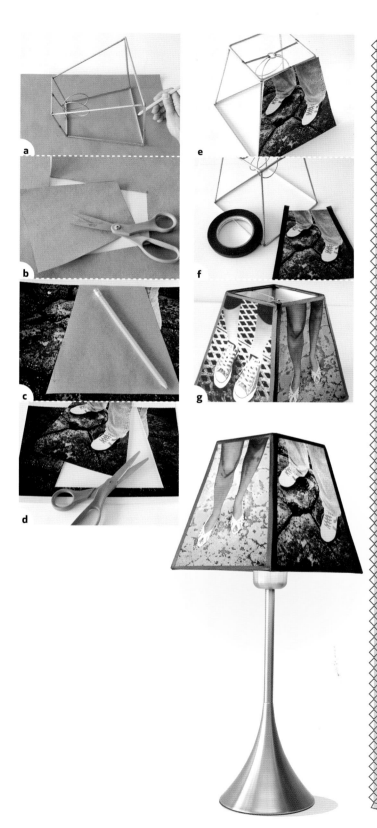

a

b

c

d

e

f

g

A FEW FRIVOLOUS FACTS ABOUT THE **LIGHT BULB**

Joseph Swan demonstrated a commercially viable lightbulb in England in early 1879, almost a year before Thomas Edison filed the patent for his version, sparking a who-invented-it-first debate that still rages among the incandescently obsessed.

Tungsten, from which lightbulb filaments are made today, has the highest melting point of any pure metal: 6,192°F (3,422°C).

Mosley Street in Newcastle-upon-Tyne, the location of Joseph Swan's office, was the first street in the world to be lit by electric light bulbs.

The world's largest working lightbulb is thirteen feet tall, weighs eight tons, and stands on the former site of Thomas Edison's workshop in Edison, New Jersey.

The world's longest-burning light bulb resides at Fire Station No. 6 in Livermore, California, where it has been burning brightly since 1901 (though it took a week off in 1937 while the station was renovated).

Urban legend states that Henry Ford arranged for Thomas Edison's last breath to be captured in a test tube. Find out for yourself at The Henry Ford® museum in Dearborn, Michigan, where the tube (and its contents) is on display.

Circular Lampshades

If you can't find a rectangular lamp-shade, never fear! This is just as easy to do with round shades. Choose a cylindrical shade instead of a cone, though—it's a whole lot easier.

WHAT YOU'LL NEED:

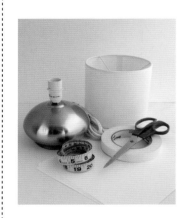

* White circular lampshade
* Tape measure
* 2–4 high-resolution digital photos
* 8½" x 11" (21.5cm x 28cm) photo paper without a watermark on the back (we used Canon Matte) or cardstock
* Scissors
* Artist's tape (white, black, or the color of your choice—look for it next to the masking tape at art stores)
* Lamp

STEP 1:

If you have a circular shade, measure its height and circumference with a tape measure. Resize or crop your photos in image-editing software to fit that size. Our shade was 5½" high and 19" around (14cm x 48.5cm), so we made 2 photos each 5½" high and 9½" long (14cm x 24cm).

STEP 2:

Cut the photos to size and place them facedown, side by side. Push the edges together until they are flush, then tape them together on the back side.

STEP 3:

Wrap the photos around the shade and tape the edges of the photos in place. Cut the tape a bit longer than it needs to be and tape the extra inside the shade. Then wrap the top and bottom of the shade with tape as shown on page 117, or leave them unwrapped if you choose.

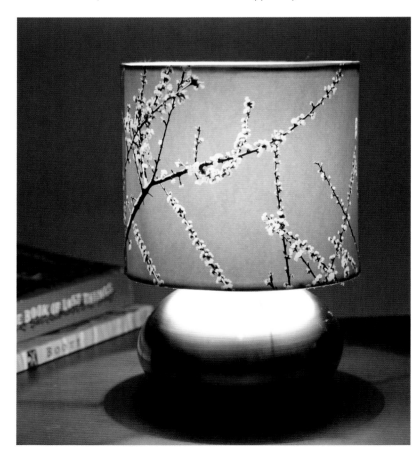

SPECTACULAR
Eyeglass Frames

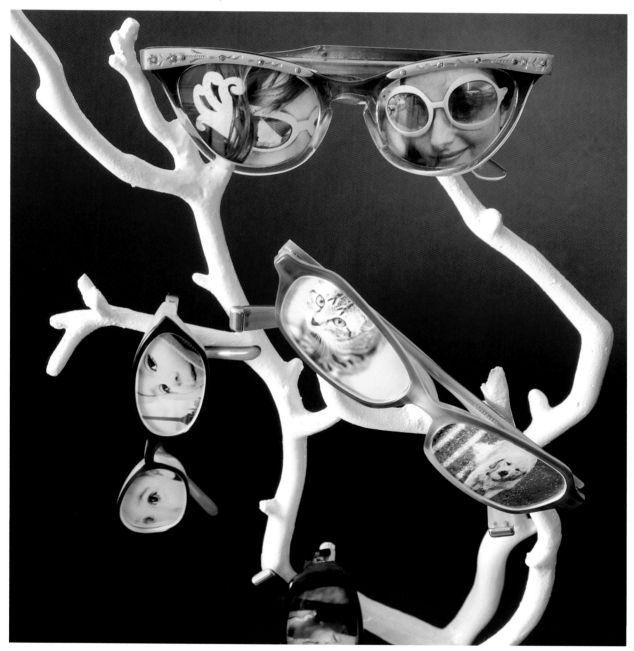

WHAT YOU'LL NEED:

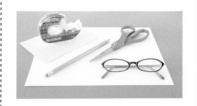

* Pair of glasses
* 1 sheet copy paper
* Pencil
* Scissors
* Two 4" x 6" (10cm x 15cm) or smaller photos
* Clear tape

Turn your specs into a hanging pair of frames:

* Follow the instructions for making your eyeglass frames, then remove the arms from your glasses with a mini screwdriver. Next, cut two 15" (38cm) lengths of fishing line. Thread the line through each side of the glasses where the arms were attached, tie each end of the line to one side of the glasses, and hang your glasses like a picture frame—at eye level. You know, so they remain in sight. (Last one, promise!)

Have your eyeglasses seen better days? On the lookout for a change? Been eyeing a new set of designer frames down at the mall? **Bring your trusty specs back to life by transforming your frames into a frame**—for photos, that is.

Spectacles make a surprisingly nifty photo frame and a great excuse for getting a new pair! While you're at it, cruise the thrift shops and plumb the swap meets for vintage eyewear. Not only are retro glasses fetching and oh-so-collectible, but eyeglass frames look great in groups. Hang them from your bathroom mirror, or dress up your desk. Everything they touch instantly looks brainier.

STEP 1:
First you'll need a template to cut your photos to size. Remove one lens from the frames and trace its outline onto the sheet of paper with a pencil. **a**

STEP 2:
Cut along the line you drew. Hold it behind the glass lens to make sure it fits properly. If it doesn't, trim it until it does. For thick frames, you'll have a larger area that needs to be trimmed away—it may help to place the template on the lens and press your fingernail along the edge, then trim to the marks you made. **b**

STEP 3:
Once you have your template ready, use it to cut out a lens-shaped piece from your photos. Put the template on top of the photo, trace around it, and cut out the outlined area. Flip the template over and repeat on the photo for the other lens. **c, d**

STEP 4:
Return the lenses to the frame. Use a small amount of clear tape to tape your photos into place behind each lens. Place the tape on the frame itself, and use small pieces so the tape stays hidden.

STEP 5:
Straighten out the arms of the glasses and set up the frames somewhere where they'll be in clear view. (Okay, Okay. We'll stop.)

from contributing guru
• • • • • •
Tiffany Threadgould

tip

Take a close-up photo of each of your eyes, then frame 'em in your eyeglass frames. Slip on your glasses, lean back, and take a leisurely nap—no one will be the wiser!

The Amazing Miracle *of* 3-D Glasses!

Though most people wear glasses to improve their vision, we do occasionally use them to trick our brain into seeing objects *not* as they appear. The bestest and most fun trick of them all messes up our depth perception to achieve one awesome effect—3-D!

Three-dimensional photography works with special lenses to manipulate our perception of depth in the same way that our brain works with our eyes to help us navigate the world around us and keep those toe-stubbing incidents to a minimum.

Here's how depth perception works: Our eyes are spaced slightly apart and therefore perceive objects from slightly different angles. The brain merges the

images from each eye into one three-dimensional image. The disparity between the two images helps our brain figure out how far away objects may be.

You can create this effect photographically by taking two pictures of an object from slightly different angles. Three-dimensional glasses channel one image into the left eye and the other image into the right eye. The brain receives these two images and creates the illusion of three dimensions, just like it does for real, three-dimensional objects.

There are several methods of channeling these images to the brain, including color filters, polarizing filters, and fancy-schmancy LCD technology. In the case of the classic red-and-blue glasses, one image is tinted red, and the other is tinted blue. The tinted glasses filter out each corresponding color so that only one image enters each eye—you can't see a red image through a red filter or a blue image through a blue filter. Then, your brain kicks in to make you think you're actually seeing in three dimensions.

There you go, folks: **SCIENCE IN ACTION!**

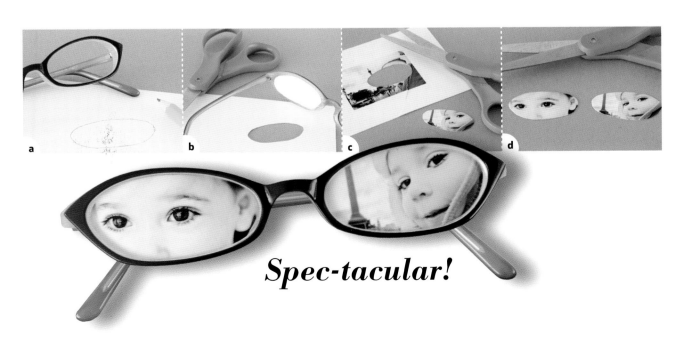

a b c d

Spec-tacular!

PHOTO SILHOUETTE *Prints*

The last time we went to the zoo, we came home with a ton of pictures. Problem was, most of them were crummy. They were blurry, the color was off, and the animals were too far away and looked pixelly when we cropped in. But you know what? We didn't mind. Most of the photos had really good silhouettes of animals, and **our graphic-design hero Graham told us about a way to turn those silhouettes into block-print stamps.** We're pretty pleased with the results.

Photos that have clear, strong silhouettes work best for this project. The photos don't even have to be good quality as long as there's an obvious silhouette. Of course, this technique works with any kind of silhouette—person or object, animal, vegetable, or mineral. And the stamps make for stylish journal covers, customized stationery, tote bags, and more!

WHAT YOU'LL NEED:

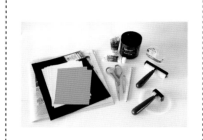

* A lovely silhouette-y photo

* Plain paper

* Scissors or a craft knife and cutting mat

* Pencil

* Watercolor paper or colored art paper

* Newspaper

* 2 rollers and/or brayers

* Water-based block-printing ink (such as Speedball®)

* Metal, glass, or plastic surface for spreading out ink (such as a Speedball metal bench hook)

* Waxed paper (optional)

* Tweezers

from contributing guru
.
Graham Moore

STEP 1:

In your image editor, resize your photo to the height you want for the final print. Print it on plain paper and you're good to go. You can even take existing prints and scale them up on the office copy machine. (Not that we're suggesting you misuse company time and resources in such a manner. Certainly not.)

STEP 2:

Cut out your shapes with scissors or a craft knife. It may be easier to cut out the shape if you trace the outline with a pen or pencil before cutting it out. **a**

STEP 3:

Before you start slinging ink around, prepare the surface you want to print on. This will work on nearly any porous surface, but stick to watercolor or drawing paper for your first efforts. Cut the paper to your desired size (or otherwise prep whatever it is you'll be stamping) and lay it on clean newspaper or waxed paper, near where you will be inking the silhouettes, but out of smudge range.

STEP 4:

Cover your work surface with newspaper. This is gonna get mess-ay.

Using a roller or brayer, roll out some block-printing ink on a nonabsorbent surface. (Ideally this would be a Speedball metal bench hook or an 8" x 10" [20.5cm x 25.5cm] piece of plastic or glass. We don't have those things, so we used a clean plastic lid from a take-out container. A little small, but it worked. The harder the surface, the easier it will be for the ink to spread evenly.) On a clean surface (newspaper or waxed paper) apply ink onto the silhouette using the inked roller. Hold the shape at the bottom with your finger and roll the ink away from you. **b, c, d**

STEP 5:

After the shape has been generously inked, turn it over and lay it inked-side down on the paper you prepared earlier. (You will find a pair of tweezers comes in handy for lifting up the inked shape.) Use a second clean roller to apply pressure onto the back of the inked image, transferring it to the surface below. You could also cover the shape with a sheet of waxed paper and use your fingers to rub the ink onto the paper. **e**

STEP 6:

Using the tweezers again, carefully peel up the silhouette, revealing the stamp it has left. Welcome to Stampy Town, population: YOU! **f**

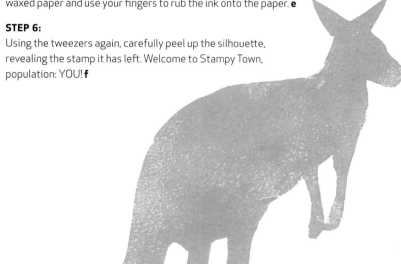

a

b

c

d

SILKSCREEN FOR CHEATERS

Yes, silkscreening is awesome and yes, it is the zenith of hipster craftiness. But it is also a pain in the ischial callosity. Fortunately for you, Photo Silhouette Prints work just as well on cloth as they do on paper. Print or photocopy your image as usual, but use double-stick tape to attach it to a piece of craft foam or felt before you cut it out. Cut out the paper and the foam at the same time to make one thick silhouette. Use fabric or silkscreen ink and apply it to the foam cutout with the roller. When it comes time to transfer the image, put it on a T-shirt instead of plain old paper! It's just like screen-printing but a kajillion times easier.

(*Oh, and if you were wondering, ischial callosities are what some less fortunate primates have instead of big ol' fabulous human booties.*)

Welcome to Stampy Town!

e

f

More Ideas for Stampy Goodness:

* Use different color inks for different color stamps. Your composition can consist of one color or as many as you like! Try overlapping different colors to produce interesting results. Whether you plan your composition ahead of time or make it up as you go, this process is a great way to get creative or hone your design chops!

PART TWO

HAVE MORE FUN WITH A CAMERA

Hooray! You got all the way through Part One, and here you are at Part Two.

Welcome.
Pull up a
chair.

Make yourself
at home.

Here in Part Two, we're going to make your awesome photos even more awesome. We've got a whole slew of projects and ideas that will get you shooting more, make your pictures more interesting, and remind you that cameras should be toys as much as they are tools.

Break out the CAMERA

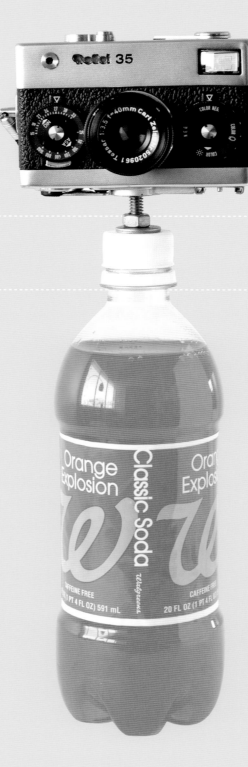

nd above all, have FUN

CHAPTER 6:
[IN A RUT?
INSPIRING IDEAS TO
GET YOU SHOOTING]

Project 365

People often say that their whole lives flashed before their eyes during a traumatic event. We think that sounds pretty incredible. Imagine being able to look back at any day of your life and recall what you did, who you met, what you learned. . . . **That's what Project 365 is about: taking one photo every day for a year.** Your yearlong photo album will document your travels and accomplishments, your haircuts and relationships. Using your camera every day will help you learn its limits and how to work around them. You will get better at composing your shots and at shooting under any lighting conditions, and you'll become more creative with your photography when you're forced to come up with something new every single day.

Thousands of photographers have created their own daily photographic history. Just follow these simple steps to create one of your own.

WHAT YOU'LL NEED:

* A camera that you can take with you everywhere.

from contributing
guru
· · · · · ·
Taylor McKnight

STEP 1:

Bring your camera everywhere. Yes, *everywhere*. Grocery stores, restaurants, parties, work, and school. Going to a movie theater? Snap a pic of the flick with your phone—there are photo ops everywhere. If you have one of those teeny-tiny cameras, you have no excuse not to have it in your pocket all the time. And if you don't? Camera phones will work in a pinch, or make yourself a sneaky jacket cam (page 178)!

STEP 2:

Post each photo online. This is one of the best ways to stay motivated as you take daily photos because you're committed to the project in a very public way, which makes it harder to stop. Also, the feedback you get from friends who follow along with your progress can be really encouraging.

STEP 2.5:

Make posting easy. You can use a blog and create an entry for each photo, but for true ease of use, try a photo-sharing site. There are even photoblogging sites that are geared specifically toward a photo-a-day workflow. With a little research, you should be able to find the site that works best for you. Make posting fast and easy and you'll be much more likely to do it every day.

STEP 3:

Don't stop. No matter what. This is perhaps the most important tip of all. You *will* get tired of taking a photo every single day. Some days, you *will* consider giving up. Don't. The end result is worth the effort. Remind yourself why you wanted to do it in first place. There will be times you'll think there's nothing interesting left to photograph, and times you'll think you didn't do anything exciting enough to record. There's always a great photo to be made. Get out of the house and take a walk. Or stay inside and look around. Take a photo of something important to you. Take a photo of the inside of your house so you can see how your taste has changed over the years. Take a photo of anything—just *don't stop*.

day 342,
Let it rain

day 343,
That's Juanita,
my fish

More Ideas:

*Vary your themes. Try to capture the day's events in a single photo. Perform photographic experiments. Take a photo of someone new you met, something you ate for the first time, or something you just learned how to do. Take a photo of something that made you smile. Tell a story. Use your blog entry, or your photo description, to explain what's going on in each day's photograph. How good did that dinner taste? What made you want to take a photo of that stranger? It'll help you remember down the road, and it gives friends following along a better appreciation of why you took the photo you did. You don't need to write a lot, just enough to add some color. And don't forget to take a photo of yourself at least once a month so you can remember how you've changed, too. (Stumped for ideas? It happens. Just search for "Project 365" on the Web, and you'll find tons of other folks' Project 365 sites; they're great for ideas.)

Growin' a 'stache!

day 345,
Scrabble tournament
with Scott

day 346,
At the car wash

day 344,
Jam session

Photographing *Strangers*

(Conquer Your Fears with *Bribery*)

This weekend you're going to spend some time outdoors, explore a new neighborhood, hone your portrait-taking skills, make people smile, and walk away with some amazing photographs. Sound good? Then we've got the perfect photo project for you!

Armed with a camera and a few simple tools, **you too can conquer the art of the impromptu street portrait.** Sometimes you're stuck in a photography rut, craving new subjects, new faces. And sometimes you find yourself feeling too shy to shove your lens in a stranger's face, even if the moment captured would make an incredible photograph. We know the feeling. Heck, we have enough trouble talking to people at parties, much less trying to chat up a stranger on the street. That's why we've come up with an easy solution to these quandaries. It lies just down the sidewalk from you, at the turn of any corner, on any street.

WHAT YOU'LL NEED:

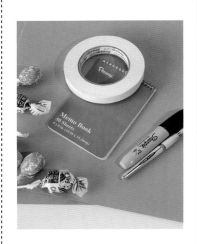

* Camera
* Friend
* Notebook
* Pen
* Paper
* Masking tape
* Candy
* Poster board

from contributing
gurus
• • • • • •
Zach Klein and
Youngna Park

STEP 1:
Select a neighborhood (the less familiar the better!) and find a photo buddy to accompany you on your mission. On a sunny, well-tempered day, set out with your buddy and camera, lenses, notebook, pen, paper, masking tape, and a seasonally appropriate form of barter (lollipops, candy canes, candy hearts, candy corn).

STEP 2:
Run to the nearest drugstore and buy brightly colored poster board. We chose blue, but grab whatever is in stock. It's usually about $1 per sheet. Buy 2, one to make a sign and one as a backdrop. Or get creative and buy multiple poster board backdrops.

STEP 3:
Set up on a busy block or corner and tape your backdrop somewhere where you'll get good light (5 Lighting Tips for Beginners, page 109). Use your other poster board to make a friendly sign explaining what you're up to—something like "Free Lollipops for Portraits!"

Now act as a car salesman would. Chat with all who pass by—the young, the old, the serious, the jovial.

Just strike up a conversation! Where is he from? Where is she going? Where did he get that hat? Does he know he looks just like your friend George? Your job is to get them to slow down so you can tell them what you're doing. They may be surprised or disbelieving at first, but just be honest, explain what you're doing, and you'll be surprised by how many people are perfectly willing to spare a few minutes to help out.

➤ 5 ◄
Ways to
Take Amazing
Portraits

1. Use the frame.

The emphasis in any portrait should always be on the person. Fill the frame with her face, or compose your shot to make her the most interesting thing in the picture.

2. Keep it simple.

To keep the focus on the subject, choose simple backgrounds and keep distracting elements out of the foreground. When a tree or a lamppost or other background element draws the eye away from the person, move around until you find an angle that takes it out of the picture.

3. Create interest.

When you can't eliminate a distracting background, move the person away from it and use a low aperture (f4.0) to blur the background. This will create an interesting texture behind the person, but won't take focus away from his face.

4. Use natural light.

On-camera flash is great when you really need it, and it's handy for filling in backlit pictures. That said, avoid using it for portraits unless you really have to. Natural light is almost always your best option. The exception is harsh noonday sun, which brings out the nooks and crannies of a person's skin in the most unpleasant way. Shoot in the morning or afternoon when you can. If you have to shoot at noon, move the person into the shade for more flattering light.

5. Make the pose count.

A head-on portrait with the person staring directly into the lens is usually boring. Turn your subject away from the camera slightly, or get up higher than she is and have her look up at you. It'll make for a more interesting photo and will be more flattering to her.

Obsessive Consumption

It started on January 22, 2002, with the purchase of a $30 green couch from the Salvation Army. Our friend Kate took a picture of the couch, kept the receipt, and then decided she would do this for everything she bought for the rest of graduate school (an odyssey of about two years). Her photographs became an interesting look into her patterns of consumption, and a surprisingly good way to document what was going on in her life.

Here's how you can make your own photo diary of all the things you spend money on. Years later you'll be able to look back and remember little moments that would otherwise be lost: the beautiful flowers you bought to cheer yourself up on a rainy day in February, the strange gummy candy from the Japanese convenience store, the dinner you had on that terrible blind date.

WHAT YOU'LL NEED:

* Small camera you can carry with you everywhere
* Envelopes or files for storing prints and receipts (optional), or clear plastic pages from photo supply shops

How to Do It:

Whenever you buy anything, whip out that camera and take a picture of the item you've purchased, keep the receipt, and store the picture and the receipt in an envelope or Print File page. Mark the outside of the envelope with the date. (You can also set aside a special file or album on your computer for storing digital photos and forgo the receipts.) If you want, add a note about where you were, who you were with, or why you bought that thing.

Try to take a picture of the product at the time of purchase. Don't worry about composing the perfect product shot, just capture the moment. Taking the pressure off will keep you shooting.

Don't forget to document the intangible things as well: movies, concerts, and visits to the museum are all opportunities to take great photos.

Why Do It:

Eventually your envelopes will contain more than just a photo of the purchase and its receipt. Some purchases will embarrass you, some will make you laugh, and others will contain minute moments that would have been lost if you didn't have the pictures to remind you of them. Other items have been lost, eaten, or thrown or given away, but you still have the photo. You own part of the history of the object.

Best of all, having a camera on you at all times and shooting a few times a day will inevitably make you a better photographer.

day **1**, Costco shopping

day **5**, taco night

day **10**, painting supplies

day **12**, healthy groceries

day **15**, gas

day **18**, water in the park

day **21**, Mom's birthday present

day **31**, breakfast

day **40**, a pick me up

from contributing guru
· · · · · · ·
Kate
Bingaman-Burt

More Ideas:

* Nothing says you have to do this project 24/7/365. Try a month or just a weekend and see how it goes. Try it for a week if you're on a budget and you want to get a handle on where your money goes. Do it on the weekends when you're eating and doing and buying interesting things. Try it when you go on vacation! Sure, you'll be the oddball tourist taking pictures of her food, but you'll remember a lot more of your vacation than those people who just stood in front of the Eiffel Tower and grinned while a stranger took their picture.

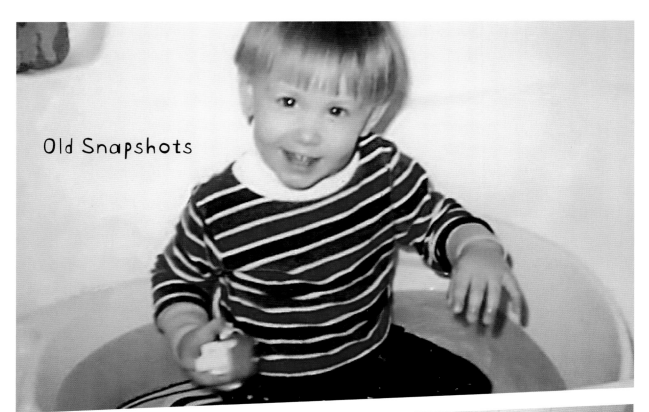

Old Snapshots

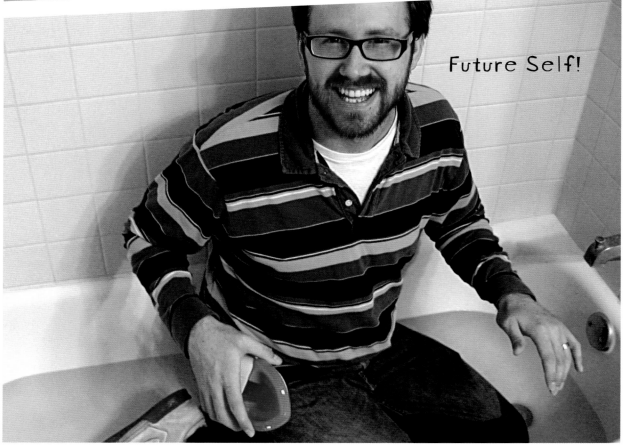

Future Self!

DIY
Time Machine

You know that really great picture of you when you were little? Maybe it's the one where you look like a sumo wrestler or the one where you're wearing the giant hi-fi headphones. You might think that photo would be impossible to top, but if you had a version of it starring the modern-day you, well, wonders might never cease. **Same picture, same pose, twenty years in the future.**

You may have seen this idea as part of Ze Frank's YoungMe/NowMe project, but we first heard about it from a reader named Norieah, who then vanished into thin air as though she had never existed. We believe that overuse of this photographic time machine technique caused the space-time continuum to tear apart and swallow her whole. Our thoughts go out to her loved ones.

WHAT YOU'LL NEED:

* Your very favorite picture of yourself as a kid

* Clothes and props that match the picture

* Location that looks similar to the background in the picture

* Camera

* Friend to take the picture

STEP 1:

Really study the snapshot of yourself as a kid. Look at the clothes, the pose, the facial expression, the background, and anything else that catches your eye. Round up clothes, props, accessories, and a location that match the ones in the photo. The closer you can get to re-creating the original props, the better the final product will be.

STEP 2:

Put on the clothes and set up the scene. Practice your pose and expression a few times until you get them right. Have your friend stand with the original photo behind the camera to make sure everything looks right. When everything looks good, have your friend start snapping away! Take lots of shots to make sure you get it right.

STEP 3:

When you're all done, print out the best of the new photos and frame it side-by-side with the original. Better yet, scan the original so you can give a copy to your parents. That's right—you just became their favorite child. Congratulations.

from contributing guru
• • • • • • •
Norieah "Doe"

More Ideas:

* Get other people involved! Recreate that old picture of you sitting on your brother. Or try the one of your dad holding you when you were two weeks old.

* If you have a kid, choose a photo of yourself when you were his or her age and recreate the picture with your kid standing in for you. We guarantee heartwarming results and lots of giggles. Older children will love dressing up to recreate pictures of themselves from five or ten years earlier. Start a whole new tradition of family photo time capsules by recreating that moment, again, in another five years.

Dress Your Baby in *Horn-Rims* & *Moustaches*

from contributing guru
• • • • • • •
Whitney Scott

You know you've thought it: All babies look alike in pictures. So how to get a kid to stand out amidst the madding crowd of chubby smiling faces? A moustache, that's how. It adds just a touch of the debonair devil-may-care panache that every baby needs. Or perhaps your favorite child is a budding intellectual. Coke-bottle glasses are just the thing to bring out his or her inner sophisticate.

The Eyeglasses

STEP 1:
Scrounge around your local flea markets and garage or estate sales for the thickest, most vintage-y glasses you can find. The thicker the glass, the more distorted the eyes, and, of course, the funnier the picture.

It's always best to take a friend on these shopping trips so you won't find yourself snagging strangers to ask, "How do my eyes look in these glasses? Bulgy enough?"

STEP 2:
Gather your victims, bespectacle them, and take some shots! Remember to find natural light or bounce your light around so you don't get a glare—and unless you really don't like your friends/baby/friends' babies, don't let them leave the glasses on too long, or a serious headache could result!

STEP 3:
Grab your camera and start snappin' away!

The Moustache

STEP 1:
Choose your moustache. Will it be the wafer-thin Salvador Dalí? The burly Tom Selleck? The olde-tymey Wyatt Earp? Word to the wise: Although you may like the look of the Charlie Chaplin, it will almost certainly be misinterpreted.

STEP 2:
With an eyeliner pencil (not waterproof, please—you'll want to remove it later with a minimum of scrubbing), draw your chosen moustache on your favorite baby. It really does need to be your favorite baby; otherwise, the child may not feel the full sense of superiority that a moustache lends.

STEP 3:
Improvise! Would you like a unibrow to go with that 'stache? Perhaps a dashing set of muttonchops would lend a certain nautical flair.

STEP 4:
Grab your camera and take some photos before the offspring becomes completely fed up with you. When you're done, give the kid a treat for putting up with a parent or doting friend like yourself. It may be many, many years before he or she learns to appreciate it.

➤ Make ◆ Your Own Photo *Time* Capsule

(2 Super Methods)

As Doc Brown will tell you, sending a message to yourself in the past is a tricky matter. Fortunately, sending a message to a future you is far less error prone and requires neither flux capacitor nor plutonium.

Our friend Raul Gutierrez recently opened an envelope he sent himself twenty-one years ago, with instructions to add a photo-booth self-portrait to the one contained within it. The similarities two decades later are striking. Inspired by his example, we've compiled a short list of ideas for creating your own ongoing photo time capsule—an easy, fun photo project you can do anytime.

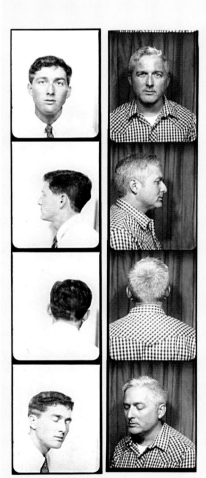

Method 1:

HOW TO DO IT:

Raul has been squirreling away photos for his future self since he was a kid. (He's got an envelope from his 15-year-old self waiting for his 45-year-old self.)

His process is simple. He'll snap a self-portrait, slip it an envelope, write a date for when it can be opened, then put it in a filing cabinet by date or in a book he knows he'll reread.

Given enough time, he'll forget what's inside. When discovered, each envelope becomes photo treasure!

WHEN TO DO IT:

It's up to you. We think a note sent to some random date in the future is a pretty fun thing. Who knows what you'll be doing or where you'll be in exactly one year or 999 days from today?

Focus on inflection points: an arrival, a departure, a graduation, a birth, a death, a new job, a girlfriend, a house, or a car. Take a self-portrait, a photo of a place you know you'll be able to find again, or a photo of someone you know will still be in your life years from now. **Part of the magic in the ongoing time capsule is revisiting a subject after many years to see how it's changed over time.** Or how your future self reinterprets the same subject when taking a photo years later.

GOOD PLACES TO HIDE THINGS:

Whatever project or subject you settle on, you'll need a way to make sure you find your photo and instructions in the future. Good places to hide things depend on your subject. Here are some examples:

Want to take a photo whenever you change apartments? Hide your photo envelope and instructions under a piece of furniture or something heavy you're sure to take with you when you move. (A television, stereo, or bookcase are good bets.)

from contributing gurus
· · · · · · ·
Raul Gutierrez
and Adam Varga

Taking a photo whenever you travel? Tape your envelope to the inside of your favorite suitcase so it's visible whenever you start packing.

Hide your photo and instructions in a book you're sure to read again, in the back of a desk drawer, or in a photo album.

Stuff the photo and instructions in the attic, then use FutureMe.org to e-mail yourself the location years later. (Hopefully you've held onto that Gmail or Yahoo e-mail address years from now.)

Method 2:

HOW TO DO IT:

Buy a cheap disposable camera.

Take your disposable camera everywhere you go for a week or on a vacation. Or take pictures of all your friends. Fill it up with photos.

Write your name, address, phone, e-mail, today's date, and the words "Photo Time Capsule! Develop me in a few years" on the camera. Sock it in a drawer.

WHEN TO FIND IT:

Let time pass. Move in and out of relationships, jobs, apartments. Find happiness and live life fully.

Eventually, rediscover the camera in some dusty box, bookshelf, or corner. Develop it.

Admire the odd stains and scratches on the photos you get back. Marvel at what your sepia-toned life was once like. Sigh, smile.

Contributor Adam Varga notes: "I like to think that disposable cameras are like wine. The longer you wait to develop them (or drink them), the better they are."

We couldn't agree more.

tip

Memory cards are now cheap enough that you could do this just as well with a big SD card. (Or a USB memory stick.) It's a little less retro, but still fun.

Chapter 7:

[NOT YOUR TYPICAL PHOTOS]

Light Painting

Made Easy!

Normally, when you take a photo, the shutter opens for a fraction of a second, light enters and hits the film or image sensor, and a moment of time is frozen as a photograph. Light painting is different.

As the name implies, **light painting is sort of like painting, except the canvas is a photograph, and the paints are light.** With light painting, you take your photographs in darkness, leaving the shutter open for long periods, and manipulate points or beams of light in front of the lens. Each light painting can take minutes or even *hours*, depending on the effect you want. Such a long exposure allows you to use flashlights and other sources of light to "paint" in midair and pick out objects that you want to appear in the photograph. The technique will open up a whole new avenue of artistry in your photography, and the effect is surreal!

WHAT YOU'LL NEED:

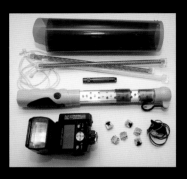

* Lights

* Dark, nonreflective clothing (preferably all black)

* Camera with long exposure capability (5 seconds or longer)

* Tripod

* Shutter release cable with lock or remote release (optional)

* Stopwatch

* Very dark neutral density filter (optional, for light painting in daylight)

* Perky assistant (optional but always helpful)

from contributing guru
• • • • • • •
Matt Nuzzaco

STEP 1:
Gather up all the lights you can get your grubby little mitts on.

STEP 2:
Suit up in stealthy black and head out into the long, dark night. Find an empty area with very little light. If necessary, set up the camera and tripod against a wall to block background light.

STEP 3:
With the camera and tripod in position, zoom out as far as possible and set the ISO film speed to the lowest setting possible (usually ISO 50 or 100) and the aperture to the highest setting possible (usually f22). This will ensure that as little light as possible will be captured by your camera sensor, decreasing interference from background or unwanted light sources.

STEP 4:
Next you need to figure out an appropriate shutter speed. This will vary depending on the brightness of the lights you'll use, how dark it is outside, and your ISO and aperture settings.

First, turn on your flashlight and stuff it in your pocket—it'll be too hard to find the on switch in the dark once the exposure starts. Then start by setting your shutter speed to 2–4 seconds and clicking your shutter. Quickly get about 5' (1.5m) in front of your camera, turn around to face the lens, and use the flashlight to sign your name in midair as if the flashlight were a pen. Repeat, retracing your signature in the same spot, until the shutter closes. Be sure to sign your name backwards (or reverse the image later on).

Check out the result on your camera's LCD, then repeat at longer and longer shutter speeds until you get the effect you want. (With some point-and-shoot cameras, you may only have the option of using the night setting.)

STEP 5:
To focus the camera, use the manual setting. Your camera will have a tough time auto-focusing in pitch-black conditions. If you're using auto-focus, shine a flashlight on the object you want to focus on, half-press your shutter to lock in the focus, and then switch to manual focus so the focus will not change.

Note:
For longer shutter speeds, see if your camera has a bulb setting. Bulb mode means the shutter will stay open as long as you have the shutter button pressed (or until you press it again). A remote shutter trigger is useful in this case.

STEP 6:
Make a mental note of the edges of your scene so your paintings won't get cut off. Activate the shutter, get in front of the lens, and paint!

Different methods to try:

Light writing or drawing: Use a light as a pen to spell out a message while facing your camera. Or draw shapes (animals, happy little families standing in front of their home, mushroom clouds). It's like an invisible whiteboard!

It's all experimentation. You can use a long shutter speed (minutes or hours) with your maximum aperture and lowest-of-low ISO to create longer, more intricate paintings. If you use a neutral density filter, you can keep the shutter open even longer, or for a short time during the day. For shorter paintings, reduce your shutter time and drop your aperture or raise your ISO to compensate.

Selective lighting: Pick out people, objects, or terrain in your scene and selectively light them up with a flashlight or a flash. You can use light to "paint" the surface of a car or even create the appearance of smoke or mist! Since the camera will only record what's lit up, you can create some ghostly effects with floating disembodied faces or people who appear more than once in the frame.

Abstract craziness: Wave a bunch of lights around just to see what you come up with.

tip

Don't be afraid to get close to the camera. Some interesting effects can be achieved by waving a light quickly right in front of the lens.

If you can get your hands on a powerful spotlight, use it to light up larger and more distant objects (a portion of a building or even a bridge).

If it's really dark, tape a tiny light to the top of your camera so that you can always see where it is in relation to where you're standing.

Great Light Sources for Light Painting:

* Flashlights
* LEDs
* External flash units
* Sparklers
* Glow sticks
* Long fluorescent tube lights
* Wind-resistant lighters
* Mobile phones
* Laser pointers
* Electroluminescent wire
* Almost anything that lights up (kids' toys, rope lights, E. T. the Extra-Terrestrial)

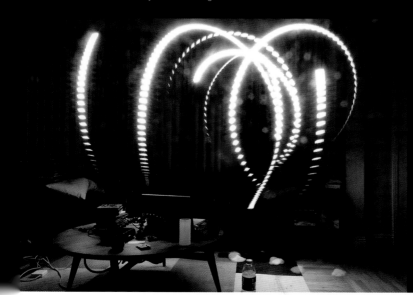

Crazy Ideas:

Crazy Idea #1:
Recruit a model. You can paint a person by having him stand still while the camera shutter is open. Move around him, painting with the light source. Then with a big bright light or a flash unit, flash him to bake his image brightly into the photo. The end result will be a clear photo of the person with a bunch of light painted on or around him.

Crazy Idea #2:
Stencil into thin air. Create a stencil design on flat cardboard, cut it out, and attach it to the front of a simple opaque box. Cut out a hole from the back of the box, through which you'll shine the light source. It helps to add a piece of translucent paper or sheer fabric between the stencil and the light source to diffuse the light and give you even lighting on the entire stencil. If you want to add some color, use a piece of colored plastic wrap.

Crazy Idea #3:
Wave electroluminescent wire around wildly. The wire is so thin that it will create a very ethereal, electric, smokelike effect.

Crazy Idea #4:
Use an off-camera flash unit that has a modeling mode. This mode emits a series of extremely bright flashes very quickly. Move around while holding the button down. The quicker you move, the farther apart the light bursts will be. Keep in mind the angle of the flash. Think of this technique as calligraphy; you can vary the thickness of the light, depending on how the flash is angled toward the camera. This angling will allow some nice smooth tapering effects.

HOW TO
TAKE
Better
PICTURES

Bring your camera with you everywhere.

Bizarrely, having a nice camera seems to deter people from throwing it in their bag and carrying it around everywhere. Almost nobody we know who has an SLR carries it with her every day. That's not to say those of you who already have nice big super-cameras should discard them and go solely for the budget subcompact model. But you might consider picking up a cheap, tiny, digital camera on sale.

If you have a camera with you all the time, you'll shoot more and the extra practice will inevitably make you a better photographer. Plus, you won't spend as much time kicking yourself over shots you missed because you didn't have a camera with you.

Pay attention to light.

When you see something every day, you learn not to notice it. In the case of light, you have to unlearn your habits and really start looking at it. Good light can transform a mediocre picture the same way bad light can ruin a great one.

Start looking for patterns of light: shafts of sunlight, rosy colors at sunset, the way the lamplight falls on someone reading a book. Take pictures of interesting light, no matter what it illuminates, and you'll be amazed at how much it informs the rest of your photography.

Know that light is not all the same color.

If you have a really good auto white-balance setting on your camera, you'll never need to worry about this. If not, or if you're shooting film, you need to know that different types of light have different color casts. Fluorescent light, for example, is green. This is why people photographed under fluorescent light tend to look slightly ill. Household lightbulbs have a yellow cast, and twilight has a blue cast.

Why should you care? Because, if you take a picture that has a color cast (that sickly fluorescent portrait, for example), you can correct the color using image-editing software. Like G. I. Joe says, knowing is half the battle. If you can see that the color of your picture is off, you'll be able fix it later on. Turn to page 7 for more tips on correcting color.

Embrace the macro setting.

That little flower symbol on your camera's dial is so underrated. What a lot of people don't realize is that it's not just a setting for taking pretty flower pictures. It shortens the camera's focusing distance, so you can get close enough to small objects to take an interesting picture that isn't blurry. Whether you're photographing a piece of jewelry to sell on eBay, or taking a snapshot of a butterfly, that little flower icon will make a big difference.

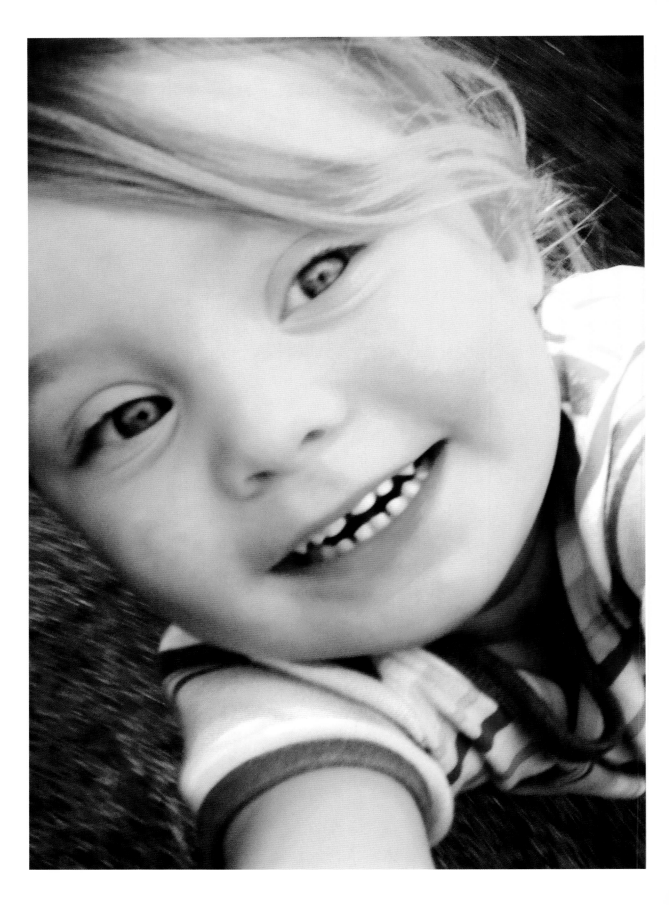

Spinning

You + Kid +
Centrifugal Force = *Awesome!*

You're twirling. The warm sun is falling on your face, the soft grass is under your bare feet, and an ecstatic child is beaming at you. That's the sort of moment that makes us love summer. No such memory? Fear not! **With a small, willing human and a helpful friend, you can make your very own magic moment!** (And a stunning photo record to boot.)

Disclaimer: Kids love this project. Photojojo and its subsidiaries (Wacky Co. Industries, Silly Nonsense Incorporated, Toxic Sludge Distributors LLC, et al.) will not be held responsible for giggling, chortling or merriment on the part of any child who engages in this activity. Also, upon cessation of this activity, pestering, whining, and begging to recommence said activity is natural and only to be expected. You have been warned.

WHAT YOU'LL NEED:

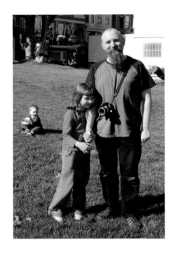

* Buddy

* Portable kid-sized kid

* Camera

STEP 1:
Position your friend behind you and the child in front, with your friend holding the camera above your arms and pointing it down toward the child. Select a slowish shutter speed of $^1/_{15}$th second to blur the background.

STEP 2:
Altogether now: spin! Once your giddy little subject is aloft, advise your friend to start snapping. **a, b**

STEP 3:
Review your photos, and repeat as necessary. (Wait for your head to stop spinning first.)

If you're really dedicated and really strong, give your buddy a piggyback ride while you spin the little person. Your pal can take the pictures over your shoulder. Don't worry: If you're really committed, photography will give you superhuman strength. If your friend gets seasick too easily and can't help you out, strap the camera to your chest and use a remote or cable release to snap photos continuously as you spin.

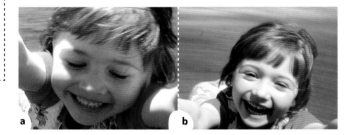

Photojojo Fact!

Centrifugal force is what makes that kiddo's feet leave the ground when you spin her around. It's the same outward force that squishes you up against the walls on a those spaceship carnival rides. Centrifugal's opposite is centripetal force, which is what makes a figure skater spin faster when she draws in her arms and legs.

Why Does Spinning Make You *dizzy*?

It all comes down to the way your inner ear relays messages to your brain. There are canals inside your ear filled with hairlike sensor cells and liquid. When you move your head, the liquid moves, too, tugging on the hairlike cells that then send signals about their position to your brain, helping it determine the orientation of your body (up, down, sideways, whatever). If you spin long enough, the liquid will keep moving in the direction of the spin even after you stop. This confuses your poor brain, which thinks you're still spinning around. So you get dizzy and off balance, and if it was a really good spin, you fall over.

Astronauts and scuba divers sometimes get dizzy because the hairlike cells in their ears don't detect the usual up-or-down pull of gravity. Astronauts often get "spacesickness" for a few days until they get used to the odd sensation, and divers can become disoriented because their brain can't tell which way is up and which way is down.

The Amazing
Doggie Cam

WHAT YOU'LL NEED:

* Bendable mini tripod
* Exceptionally patient and well-behaved dog
* Self-adhesive athletic bandage
* Treats, treats, and more treats
* Small camera (with video mode, optional)

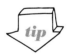
tip

If you don't have a bendable mini tripod already (they're awesome!), we heartily recommend the investment. For this project we used the Gorillapod SLR, though any mini tripod will do. Just make sure it's large enough to comfortably fit around your dog. Don't want to go through all this hassle? For $79, you could spring for the original Doggie-Cam. This tiny, lightweight, 4.5-megapixel camera connects to your dog's collar and is made just for this! (But why buy when you can DIY, we always say.)

Boy, if we only knew what dogs went through. Having to go for walks even when it's raining. Doing their private business in full view of gawking onlookers. Not to mention the constant strain of being petted and taking naps. Our canine compadres always seem to get the short end of the bone in life, so that's why we're inventing a Photojojo first: the Doggie Cam. **By sticking a camera on our four-legged friend Molly, we finally saw the world as she sees it—**full of hydrants to mark, butts to sniff, and snooty cats just brimming with disrespect.

If your dog is like Molly and is initially wary of the 'pod, try showing it to her while giving her treats for a few days before your experiment. Then try it on sans camera and give her more treats. Pretty soon she'll be thrilled to see it and will be up for anything.

(Thanks to reader Wayne Pyle for pointing us to what we should admit is the first doggie cam and hooking us on this idea.)

STEP 1:
Attach the mini tripod to the dog. The trick that worked best for us was wrapping 2 legs of the 'pod around Molly's neck, tucking the ends of the legs under her collar, laying the third leg down her back, and wrapping it all in place with the athletic bandage. The other dogs at the park mocked her a little, but she got over it. The treats helped.

Note:

If your dog doesn't take to the tripod, try adjusting where you place it. Not many dogs we know like something wrapped around their head, but you might be able to wrap the 'pod snugly and safely around the dog's back and chest.

If your dog still doesn't like the tripod, you'll have to give the cat a try.

STEP 2:
Set the camera to video mode and hit record. For photos, set your camera to automatically capture a new photo every minute (if your camera has a time-lapse feature) or use the self-timer feature. Alternatively, buy a wireless remote control and fire at will!

STEP 3:
Adjust the camera as necessary as your dog explores the world gonzo-style. If the camera slides down to the side, making the video lopsided, readjust the bandage so that the camera stays centered. (It takes practice.) If you have a harness for your dog, try hanging the camera upside-down from it to view the world in yet a different light. (You can use iMovie or other video-editing software to flip the video right side up later.)

Note of caution: Make sure, of course, that Fido's alright with his or her participation in this project and that the mini tripod doesn't restrict breathing or anything like that. If in doubt, don't do it! (Did we really have to tell you that?) We should probably also note that you're doing this at your own risk—pooches and cameras don't always go well together, although in most circumstances we think the worst that could happen is that your camera falls to the ground.

There you have it, friends! Go out and, *dog-willing,* give it a try!

Any Fido will do!

Camera Toss: Throw Your Camera, Get Amazing Pictures

Reckless, stupid, downright insane. Camera tossers have been called worse. Camera tossing is, well, just what it sounds like. Set your camera on long exposure or self-timer mode, press the shutter, and toss it into the air just before it goes off. Catch the thing (or have it land on a soft surface), and ogle the results.

Why would you do this? Quite simply, it's the photographs: beautiful, abstract images you can't get any other way. Many photographers also find the technique liberating, as it forces them to exert less control over the final image.

We won't blame you if you decide not to try this one. (And we won't take responsibility if you do.) But if you decide to give it a shot, we'd love to see what you come up with!

The Camera

Many cameras have been lost to the practice of camera tossing. You are unquestionably tempting fate, and sooner or later you *will* drop your camera. Don't use one you can't afford to destroy.

For our experiments, we used an early digital model that we have hated for years because of its epic shutter lag.

Warnings aside, here are some qualifications for cameras that would work well: small and compact; inexpensive; long exposure capability; manual settings for focus and exposure are useful but not required; shock-resistant battery and memory card compartments; timer functions and "shutter lag" can help you get your throw started before the exposure starts; the ability to turn off the flash can help save batteries but isn't required. You can cover the flash with a piece of black tape if you can't turn it off.

Characteristics of cameras that won't work well: moving parts and protruding lens barrels—they're more prone to damage; cameras that won't complete an exposure if your finger leaves the button; expensive, nice, lovely cameras that you actually care about.

tip

You can also tie a tether around your wrist and attach the other end to the camera as a safety line.

The Throw

There are lots of different ways to throw a camera and each of them will produce different results. Experiment with all of them and see what suits you best.

The end-over-end: Flip the camera end over end so the lens sweeps a full 360 degrees or more over the subject.
The spinner: Spin the camera on its lens axis.
The outer space: Throw the camera as high as you can.
The crazy Harry: Short, wild, and chaotic: Anything goes.
The parabola: A simple up-and-down trajectory with as little rotation as possible.
The hail Mary: Get a friend to come with you and throw the camera for the longest pass you can safely catch.

The Catch

The easiest, simplest way to keep your camera from hitting the ground is just to catch it. The key is to catch it gently, bending your knees to absorb any shock. Practice with a medium-heavy object (such as a 2-lb [.9kg] weight) until you get the hang of it.

If you're practicing at home, you can skip the catch and let the camera land on a soft surface, such as a bed with lots of pillows. Out in the field, try bringing a few friends with you and holding a blanket at the corners like the old-fashioned fireman's net.

Just for the record, even very gentle landings can cause damage to protruding lenses. We're just saying.

WHAT YOU'LL NEED:

* Small inexpensive camera
* Camera tether (optional)
* Electrical or black photo tape (optional)

The Technique

It's easiest to shoot at night or in a dark room so you can get the long exposures needed for really good motion blur. Experiment with exposure times until you find something you like. Lamps, car lights, and anything that glows are good objects to photograph when you're learning the technique.

To get the perfectly fluid patterns that camera tossing is famous for, you'll need to keep anything from interfering with the camera's motion while it's exposing the photo. This means that none of the exposure should occur before or after the camera is airborne.

Use a self-timer to allow you to launch the camera before the shutter opens. Or set a longer-than-usual exposure time and cover the lens with your hand until you throw it. Of course, the visual record of the camera hitting the bed or ricocheting off the ceiling might produce interesting results of its own.

Try starting the photo as you normally would, but send it flying part way through the exposure for a combination of reality and crazy swirls. Or leave the flash on for a similar effect! (Be sure to have a soft landing zone ready for that one. It's hard to catch a camera when its flash has just blinded you.)

Have fun out there, everybody! And if you lose a camera in the process, be proud that it died heroically in battle. It's a much better end than getting forgotten on a cable car or drowned in spilled coffee. Valhalla and its busty Valkyries reserve a special corner of heaven for brave cameras like yours.

shiny

orange

Photo Safari

How to Shoot a *Wild* Adjective

Have you been lacking inspiration these days? Shooting the same things over and over? Are you bored to tears, banging your head against the wall and wailing with artistic frustration?

Calm down. Take a sip of water. Now let's fix that boredom problem of yours.

What you need is to go on a Photo Safari. Your quarry: the wily, elusive adjective. Your weapons: your camera, your wits, and an appetite for photographic mayhem.

Pick a random adjective, such as *oily* or *hirsute*, grab your camera, and get out there. Find a greasy burger to illustrate *oily* or a heavily bearded man to demonstrate *hirsute*. Pretty soon your boredom will melt away as you find yourself thinking differently, shooting differently, and very possibly having a good time.

WHAT YOU'LL NEED:

* Camera

* Your boundless creativity

from contributing
guru
· · · · · · ·
Kristin Meier

STEP 1:

Assign yourself a random adjective. There are several ways to do this. Search online for a "random word generator." Be hard on yourself and resist the urge to keep generating words until you find one you like. If you can't get to a computer, pick the 12th adjective in a newspaper article or on page 84 of a book. Or ask a friend or stranger, Mad-Libs style. Sometimes inspiration strikes immediately. Other times words require mulling over, the perfect covert activity to occupy you during boring meetings, minutes spent on hold, and endless traffic jams.

STEP 2:

Head out into the wild outdoors, adjective and camera in hand! Your mission: shoot photos that fit your adjective. Literally or figuratively.

STEP 3:

Keep shooting! Once you've bagged words like *xeric*, *prolix*, and *palatable*, make sure to mount your trophies on the wall. No taxidermic skills required.

More Ideas:

* Kids love this! Set them loose with a list of adjectives and a disposable camera and prepare to be amazed. (This may also, totally by coincidence, get the little buggers out of the house and buy you some peace and quiet. We're just saying.)

* Or, get a group of friends together and turn your safari into a full-blown photo scavenger hunt! Assign those adjectives, or pick a list of random nouns to find, or even try one of the following themes:
　　Collect pictures of all the numbers up to 15 or 25.
　　Collect every letter of the alphabet.
　　Get pics of local landmarks with tourists standing next to 'em.
　　Shoot photos of different kinds of clothing (hats, jackets, jewelry).
　　Get photos of as many strangers as possible midjump.

adjective: SHINY

Photo Hide-and-Seek

Hide-and-seek is one of the most basic of games. Nearly everyone has memories of hiding in a dark closet chuckling at one's own cleverness, while a clueless playmate searched fruitlessly behind the bookcase, the sofa, and even in the basement (even though everybody knew the basement was out of bounds). But the fun needn't end with childhood. Just add a little photographic twist and you've got a whole new version of the game. This photo variant of the classic pastime can be played almost anywhere. Round up a group of friends (young or old) who like to have fun with reckless childish abandon, and the game is on.

WHAT YOU'LL NEED:

* Digital camera
* Group of people
* Colorful objects you can hide (something that won't be missed if it's lost)

from contributing guru
• • • • • •
Shannon Patrick Ramos

STEP 1:

One person starts as "it." He takes a photo of the object (unseen by any of the other players), then hides the object. (Hint: A close-up photo makes it more difficult to find than a wide shot.)

STEP 2:

Everyone else has a chance to look at the photo before they begin their search. They may look at the photo for as long as they wish, but remember: the first person to find the object is the winner!

STEP 3:

Once a player finds the object, she becomes "it" and will photograph and hide the next object. That's it! Have fun!

tip

There's likely to be a lot of smiling going on while you play hide-and-seek. As long as you've got a camera out and friends running around smiling, don't forget to get some fun snapshots!

adjective: ORANGE

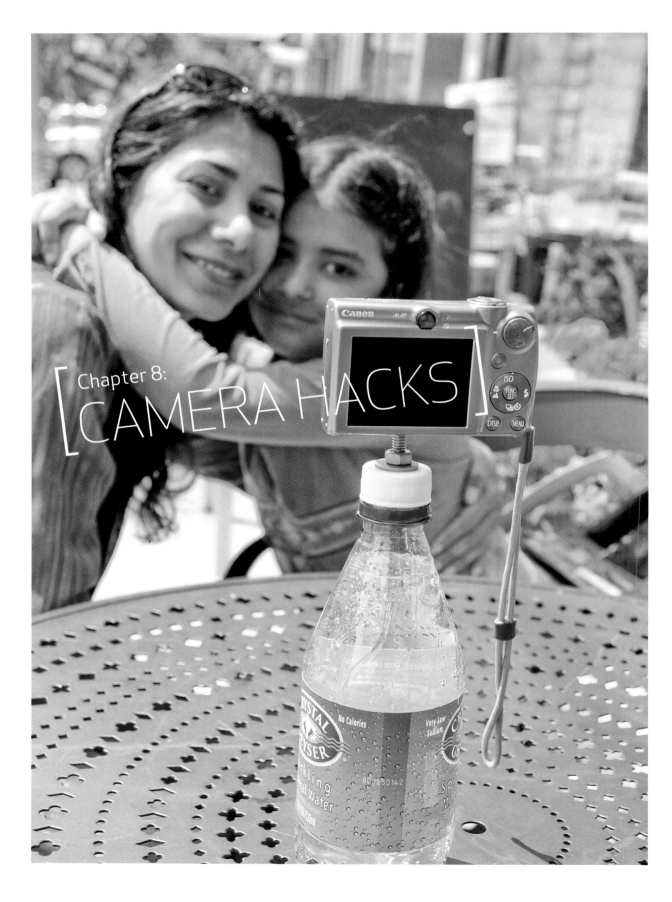

Chapter 8:
[CAMERA HACKS]

Turn a what into a whaaaa? You heard us.

Why would you do such a thing? We'll tell you why.

Picture yourself out hiking in the wilderness, just you and your shmoopy, and you come across the most gorgeous vista you've ever seen. **You'd love a photo of the two of you out in the wild, but nobody's around to take your picture.** What do you do? Do you wedge your camera into the crook of a tree and hope it doesn't fall? Do you prop it up on a stack of rocks? No, silly! You pull out your bottle-cap tripod, pop it onto the bottle of water you're already carrying, set the camera up, and get the best snapshot you've ever seen.

WHAT YOU'LL NEED:

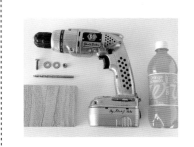

* Small scrap of wood
* 20-oz (0.6L) plastic bottle, with its cap (Enjoy the delicious beverage of your choice!)
* Electric drill and 1/4" (6mm) drill bit
* Sandpaper (optional)
* 2 metal washers (small enough in diameter to fit inside the bottle cap, but with a 1/4" [6mm] or wider opening)
* 1/4" (6mm) hex bolt
* 1/4" (6mm) hex nut

STEP 1:

Place a piece of scrap wood underneath the bottle cap (just so you don't drill into your worktable or anything else you care about). Drill a hole though the center of the top of the bottle cap using the power drill. If you feel like it, you can sand the edge of the hole using sandpaper. If not, hey, it's a free country. **a**

STEP 2:

Place a washer on the bolt. Slide the bolt through the hole in the bottle cap so the thread end sticks out the top. Place the other washer and the nut on the bolt. **b, c**

STEP 3:

Tighten the nut well. If you don't tighten the bolt enough, it will be more difficult to take the camera on and off the tripod.

STEP 4:

If your bottle is still full of Canfield's Diet Chocolate Fudge Soda, great! If not, fill the bottle with water or sand. Screw the cap onto your bottle. (We know you're a smartie and figured this out already, but the hole in the cap means your bottle is no longer watertight, so don't knock it over.) **d**

STEP 5:

Screw the end of the bolt into the tripod mount of your camera. Voilà! Instant tripod. This tripod works best with small point-and-shoot cameras. So when you put your Hasselblad with the 300X telephoto lens on there and it falls over, don't say we didn't warn you. If you don't want to carry a bottle full of sand around with you, just throw the cap into your camera bag. Whenever you need a tripod, just buy yourself some pop (or fish an empty bottle out of the recycling bin.)

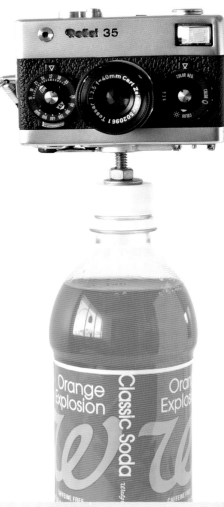

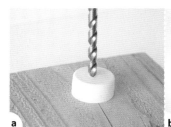

a

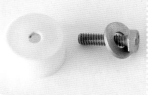

b

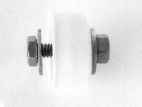

c

d

THE TRIPOD: THEN AND NOW

Taking great photographs on the road has always been a concern. As early as 1854, the Council of the Royal Geographical Society, London, began distributing some version of what would become *Hints to Travellers: Scientific and General*, which espouses nine essentials for photographic exploration (a dashing safari hat is not one of them).

1. CAMERA

Preferably a mahogany, brass-bound, bellows-bodied camera.

2. SLIDES

Not of the delicate changing box and single-slide system variety.

3. FOCUSSING CLOTH

Of black velvet (for the Goths) or waterproof sheeting (for the nerds).

4. CAMERA-STAND

A.K.A.: the tripod.

5. POCKET LEVEL

To ensure that the mahogany, brass-bound, bellows-bodied camera takes a sweet straight shot whilst perched on the camera-stand.

6. LENSES

For both landscape photography (the single meniscus lens) and for interiors and portraits (the doublet).

7. SENSITIVE PLATES

Stored in a soldered tin case packed inside a wool-lined wood box—for damp sea voyages.

8. LANTERN

Equipped with a red bulb for developing the sensitive plates.

9. EQUIPMENT FOR DEVELOPMENT

Because no one wants to wait for that sea voyage home to see their pictures.

That's it? Whew! That must've been a mighty big backpack. Luckily, with your new bottle-cap tripod head, you'll probably be able to sneak in some adventure without so much back strain—or that three-month sea voyage. But like the great travelers of olde, you'll always be prepared.

In the armchair? Though you can find used copies of *Hints to Travellers*, they'll cost 'ya. Look for facsimile editions on the Web, or snag the reprinted 1906 edition from Amazon.

THE **String Monopod**

(MacGyver Would Be Proud)

Okay, so picture this: you're in the middle of the jungle, chasing after commandos/terrorists/litterbugs. You need some crucial photographic evidence to send back to Headquarters and convict the Bad Guys. But light's fading fast, and your surging adrenaline is making your hands shake. How can you steady your camera and get that all-important tack-sharp photo that will save the day? You've got no tripod, but fishing through your gear sack, you come up with some string, a couple of washers, and an eyebolt. **Now is the time to ask yourself: "What would MacGyver do?"**

Why, manufacture a ready-for-anything monopod, of course. Tie everything together, attach it all to your camera, and nab that shot of the escaping villains. That's right, you just saved the world.

WHAT YOU'LL NEED:

* Heavy-duty string or narrow rope, 2'–9' (61cm–2.7m) (We used "twisted mason line.")

* Scissors

* 8¼" (6mm) eyebolt

* Metal washer, 1" (2.5cm) or wider

* Glue (optional)

*v.*2.0

Fancy Pants Duopod

If you want to get really fancy, tie 2 strings, about 2' (61cm) long, to the eyebolt. (Two? TWO? Yes, we're MAD!) Attach a clip or carabiner to each string and clip the strings to your belt loops. The extra anchors will keep your camera even more still. And your pants stay up, too!

STEP 1:

The amount of string you need depends on your height. You want enough to reach from your eye level down to the ground, plus about 6" (15cm). So measure that distance (or command your lackeys to carry out your bidding) and cut the string accordingly.

STEP 2:

Tie one end of the string through the hole in the eyebolt. If you know how to make fancy knots, go nuts. We got kicked out of our Scout troop after the soap-carving debacle, so we just used a good old-fashioned square knot. At least we think that's what it's called. **a**

STEP 3:

Tie the other end of the string through the hole in the washer. Make with the knots, Captain Fancypants. If your string is slippery and your knots start to come undone, put a drop of glue on the knot and let it dry. That'll hold it. **b**

STEP 4:

Screw the eyebolt into the tripod mount on your camera. You don't have to tighten too much, just enough to keep the bolt from coming out. **c**

STEP 5:

Step on the washer and raise the camera to your eye so the string is taut. The tension of the string will help keep your camera still. When you're not using the monopod, wrap the string around the washer and throw it your camera bag.

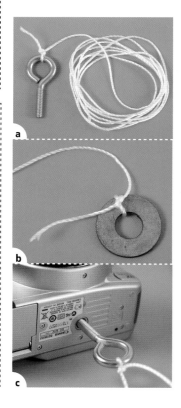

Disposable Camera Chain Letter

(a.k.a. Around the World in 24 Photos)

Disposable cameras are so underrated. Yeah, they're plastic, and yeah, they take crummy photos. But the plastic crumminess just means you wouldn't mind too much if you dropped the camera in the pool, or threw it overhand to a pal across a crowded room, or even lost the camera altogether. And that, right there, is why disposable cameras are so great: because you'd be willing to do things with a disposable that you wouldn't dream of doing with a nice camera.

Case in point: mailing a camera off to a total stranger in the hopes that he'll take a snapshot and send it back to you. And that's the point of this game: see how far you can send a camera before it makes its way back to you.

WHAT YOU'LL NEED:

* Disposable camera (Note: There is always strength in numbers. Buy and send out a few cameras for this game in case one of them gets lost along the way and doesn't make it home. Highly recommended.)

* Box

* Padded envelopes

* Stamps

STEP 1:

Take one really good picture with the disposable camera.

STEP 2:

Put the camera and a self-addressed padded envelope in a box. Include directions to take one photo and pass it on to somebody else, and to send the camera back to you when the film is used up. You can also include a list for people to write their e-mail addresses on so they can see the pictures when you get the camera back. Or have people write down their names and cities so you can see where the camera's been.

STEP 3:

Give the packet to a friend who wants to be part of the game. The goal of the game is to get the camera as far away as possible before it makes its way home to you. Try mailing it to a friend who has family in Thailand and ask him to keep the game going. Or send it to somebody starting off on a road trip and ask her to hand it to a friend along the route.

STEP 4:

When you finally get the camera back, develop all the pictures and see where your camera's been!

More Ideas:

* Play alphabetically: If you live in Atlanta, send the camera to somebody in Brooklyn. When he's taken his picture, have him send it to someone in Chicago, and so on. You might have to skip X and Z. (Conveniently, there are only 24 exposures on a roll anyway.)

* Marooned: When you're traveling, leave a disposable camera somewhere with a self-addressed, stamped envelope and a nice note asking the finder to take a whole bunch of pictures before sending the camera back to you.

169

Kodak

from contributing guru
· · · · · · ·
Adam Varga

MAKE A
Flash Diffuser

Out of a Film Container!

Harsh, unflattering flash got you down? Does it wash out the skin of everyone you photograph? Does it shine the spotlight of shame on each and every oily patch of their skin? Does it turn everyone it touches into a shiny pasty mess? Take heart, victims of flash trauma, for relief is in sight. Just turn an old film container into a flash diffuser! **A few strategic cuts make it easy to slip the container onto your camera's pop-up flash, and voilà—soft, beautiful lighting.** The translucent white plastic takes the edge off that unforgiving flash, just like the fancy softboxes that the pros use. Trust us: Once you make one of these babies, you'll never go anywhere without it again.

WHAT YOU'LL NEED:

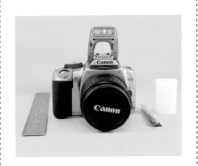

* Camera with a pop-up flash
* Ruler
* Craft knife
* White film container (Your local photo lab probably has a few in the trash can. Sweet-talk the clerk into giving you some free ones.)

STEP 1:
This flash diffuser is essentially a film container with a hole cut in the side. Since the hole needs to be just large enough to slip the flash into, measure the length and width of your flash and mark the container accordingly. **a**

STEP 2:
Using a sharp blade, carefully cut a rectangular hole in the side of the film container. Don't cut through the lip of the container. Make the hole just slightly larger than the width of the flash. **b**

STEP 3:
Slide the film container onto the flash, keeping the lid on the container. If the fit is too snug, make the cut a little wider. If it's too loose, a little tape should keep it on. **c**

STEP 4:
Take photos as you would normally. The film container will spread out your flash's harsh light. Your camera should automatically adjust exposure to make up for the reduced light output.

a b c

More Ideas:

* Make your flash diffuser into a psychedelic color flash. Pick up a sampler booklet of colored gels at a local photo supply shop. Just snip the gel you want to use out of the booklet, slip it inside your diffuser in front of the flash, and fire away! (Set your camera's white balance to a pre-selected mode so its auto-balance smarts don't cancel the gel color out.)

Say CHEESE!

(And Other Techniques for Getting Kids to Smile)

If we've learned anything from Hollywood's penchant for pairing muscle-bound leading lads with toddlers, it's that taking care of tykes ain't easy. But if you think changing diapers is the hard part, just try getting one to smile on demand. Here's a quick tip for getting the smaller humans in your life to smile.

WHAT YOU'LL NEED:

* PEZ dispenser (Any kind of PEZ dispenser will do; bright colors are best.)
* Craft knife
* Camera with a hot shoe
* An adorable youth

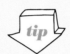

tip

Mix and match dispensers for variety. If all else fails, dispense candy to the child. If that fails, dispense candy to yourself. You can't win 'em all.

STEP 1:
Carefully cut away at the bottom of your PEZ dispenser with the craft knife until it'll slide into your camera's hot shoe (the clip at the top of the camera for attaching an external flash). Try it on for size a few times as you go to make sure it doesn't end up too loose.

STEP 2:
When you're ready to shoot, train your camera at the unsuspecting child. Let his or her eyes wander up to the strange, colorful, plastic contraption goofily perched on your camera.

STEP 3:
Capture a rare moment of unexpected joy.

173

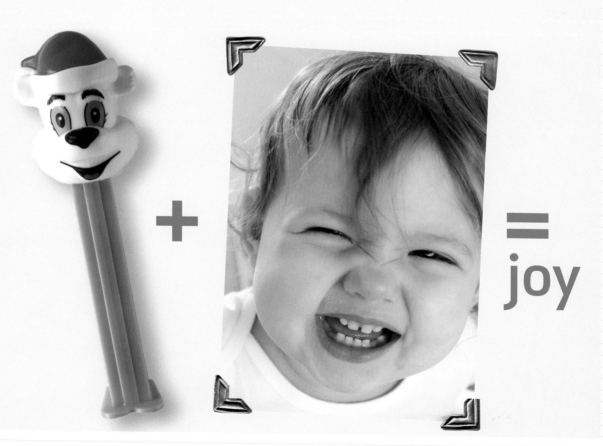

+ = joy

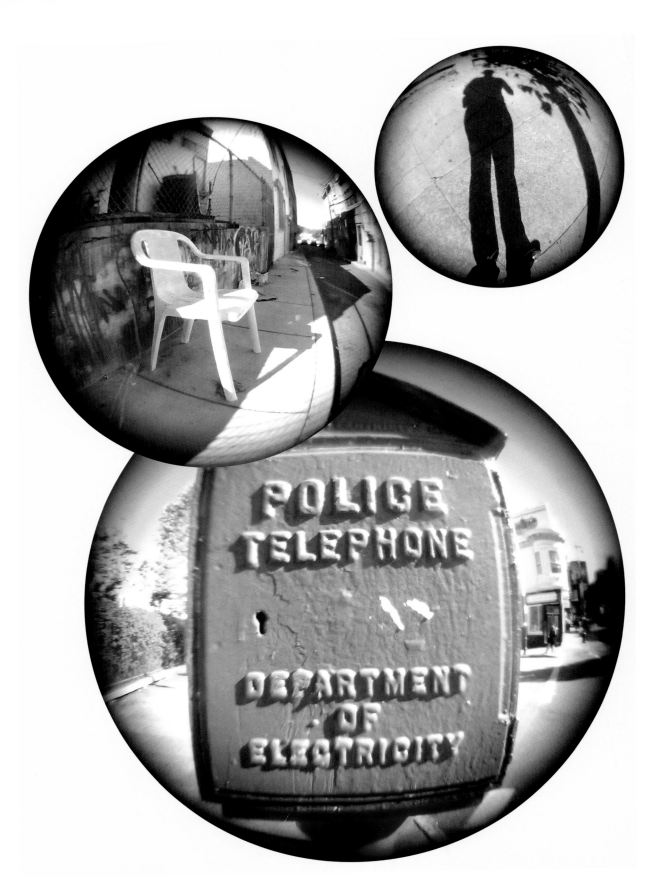

CREATE A CHEAP
Fish-Eye Lens

(With a Peephole *and* a Pair of Glasses!)

All cameras have lenses—they're what gets the world "out there" funneled into your camera as an image, one that can then be imprinted onto film or a digital sensor. A fish-eye lens has an extremely wide angle that takes in a very broad, hemispherical image, lending a neat little "round" effect to things. Fish-eyes are the über-talented "Peripheral Vision Man" of the lens squad, capturing up to a 220-degree field of view, though usually it's closer to 180 degrees.

You can pack a lot of information into your pictures with a fish-eye. They're useful for landscape photography, and they can help you make people with unusually large noses or heads (like kids) seem even more out of proportion. You'll be mighty impressed with how easy this is; it's one of the easiest camera hacks around. With the materials in hand, **you'll be ready to shoot in less than ten minutes!**

WHAT YOU'LL NEED:

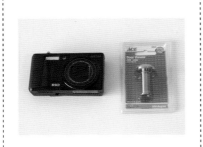

* A wide-angle peephole (you know, the thing you look out of when somebody comes to your apartment)
* Masking tape (optional)
* A point-and-shoot camera[†]

[†] All you SLR folks can skip to the next page; we've got something special just for you!

STEP 1:

Remove the threaded backing from the peephole. Tape a little masking tape (black, for preference) over the threaded edge, so you don't scratch your camera lens. **a**

STEP 2:

Hold (or tape) the peephole in front of your camera lens and zoom all the way in. If the camera has trouble focusing, try changing the focus mode to center-weighted or switch the shooting mode to macro. **b**

STEP 3:

Once you've got some cool photos, load them into your computer for editing. You'll be able to see the inside of the peephole, so cut out everything except the circle of your image. The easiest way to do this is to place guides at the top and along one side of the image circle and use the circular selection tool to select the image circle. Delete everything else or fill it in black or white. Voilà! Perfectly circular fish-eye photos, all from your little point-and-shoot! Whoda thunk it?

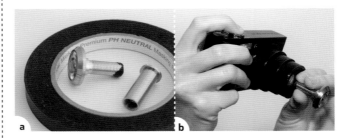

a b

Shooting with Your Fish-Eye Lens:

* When you're shooting with your new fish-eye lens attached, keep your regular camera lens zoomed out all the way for maximum effect. If you have multiple lenses, stick with the one that's the widest.

* If you're using auto-focus, go ahead and allow it to set the aperture and shutter speed—but then switch it to manual to focus. The fish-eye throws off the camera's focusing computer, so it will endlessly keep refocusing and never take the picture unless you step in to do the fine-tuning manually.

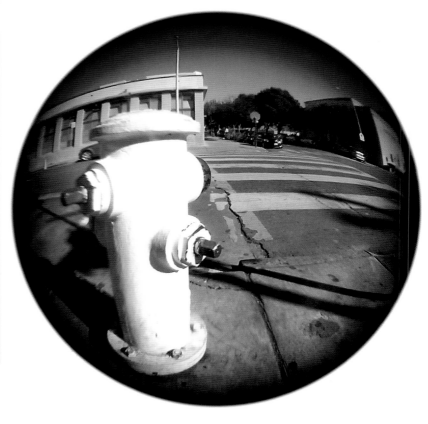

For SLR Cameras

What good is that big fancy SLR if you can't make yourself a fish-eye lens? Don't worry, we've got a version of this project for you, too. The fish-eye effect is bit less pronounced than the peephole version, but it's still a lot cheaper than an ultra-wide-angle lens!

WHAT YOU'LL NEED:

* Pair of old glasses that you don't mind putting the hurt on or a cheap pair of reading glasses from the drugstore. They need to be "positive" lenses (i.e., for farsighted people.) They also need to have a fairly strong prescription—the stronger the prescription, the thicker the lens, and the better your fish-eye effect.

* Electrical or masking tape

* SLR camera

from contributing gurus
• • • • • • •
Daniel Bigler and Melissa Lawson

STEP 1:

Pop one of the lenses out of the glasses. Apologize to Grandma if she sees you doing this to her favorite pair of specs.

STEP 2:

Tear off 2 lengths of electrical or masking tape long enough to fit across the glasses' lens (about 3" [7.5cm] should do the trick). Stick one length of tape lengthwise onto the top edge of the lens and the other onto the bottom edge. About half the tape's width should extend over each edge of the lens. **a**

STEP 3:

Carefully put the newfangled fish-eye lens over the camera's lens. It should face the same way it did in its frame: convex side out. With the tape, secure the fish-eye lens to the exterior of the camera's lens body. Ta-dah! **b**

a

b

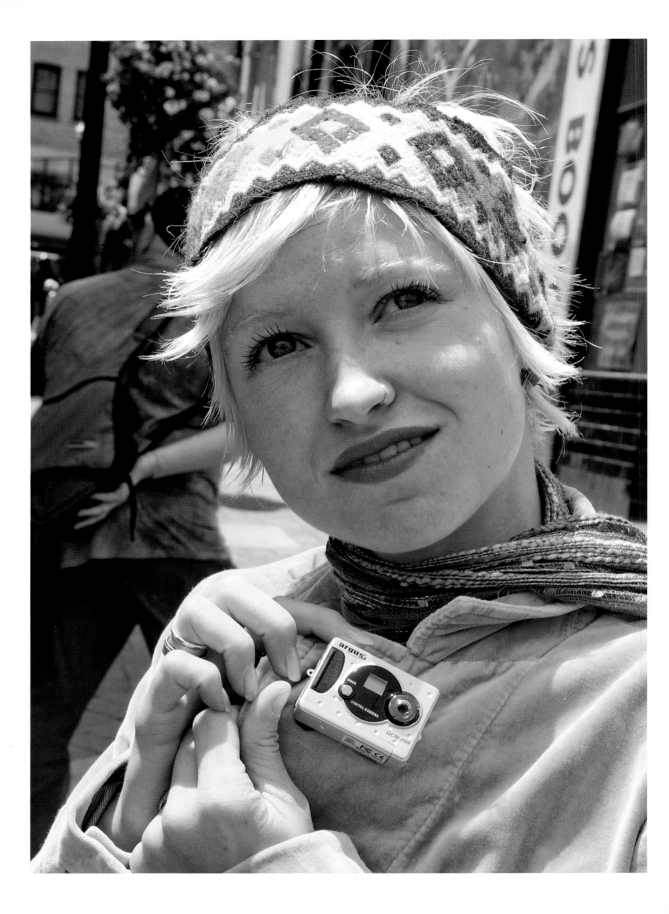

MAKE A HIDDEN
Jacket Camera

(a.k.a. The Spy Who Shot Me)

Your jacket should always be equipped to take photos—that's our philosophy. Especially if you, like us, spend your days stalking evildoers, and catching the criminal element in the act is of the utmost importance.

With a little bit of Velcro, your camera can always be at hand, nestled secretly under the collar of your coat. Miniature digital keychain cameras that fit in the palm of your hand are now commonplace and available for under $10. Many even have a video-recording mode. Add one to your jacket, then flip up your collar and snap away, practically undetected. With a jacket like that, you'll always be ready to capture once-in-a-lifetime events. Not to mention super-villains perpetrating their villainies!

WHAT YOU'LL NEED:

* Adhesive Velcro tabs or dots
* Mini digital keychain camera (We got ours from Amazon.com, but we've also seen them at office supply stores and drugstores.)
* Crime-fighting jacket (with a collar)

Photojojo Fact!

Though we don't endorse actually spying on your friends and neighbors, spy coats have a long lineage. In the 1970s, the KGB created their own version of the Hidden Jacket Camera. In their version, one of the coat's buttons would open and close via remote shutter release, revealing a tiny camera lens that would quickly (and sneakily) snap the picture.

from contributing guru
• • • • • • •
Cy Tymony

STEP 1:
Apply the hook side of the Velcro tabs to the back of the camera. **a**

STEP 2:
Press the loop side of the Velcro pieces to the underside of the jacket's collar. **b**

STEP 3:
Attach the camera to the collar. **c**

STEP 4:
When you see an awesome scene unfolding, flip up your collar and snap away. Nobody will suspect a thing. Mwah ha ha ha HA!

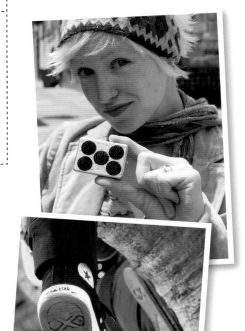

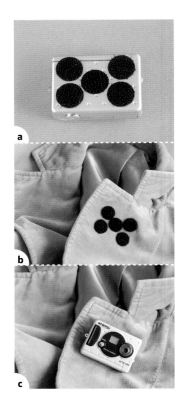

a

b

c

MAKE A
Pinhole Camera
Out of Your SLR

WHAT YOU'LL NEED:

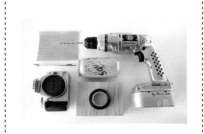

* Digital SLR body (no lens necessary)

* Body cap to fit

* Drill and $1/4$" (6mm) drill bit

* Sandpaper

* Scrap of thin metal (soda or beer cans work perfectly)

* Sewing needle

* Craft knife handle (no blade needed)

* Tape

from contributing
guru
• • • • • • •
Lee Meredith

We do love digital photography, for oh-so-many reasons, but sometimes we miss the excitement of film. Especially with older film cameras, so much of the outcome is up to the camera. Maybe the light meter is broken, or the range-finder focus is hard to judge—the image remains a mystery until after the strip is developed.

Well, we find that we get a similar kind of excited rush from that lack of full control when we twist our homemade pinhole "lens" onto our digital SLR body. **By mimicking a pinhole camera, we get to play around more than usual** but retain some control in the process since we get to see the results instantly on that glorious LCD screen. And we don't have to put time and money into developing each photo, of course. Hooray for digital!

STEP 1:
Drill a $1/4$" (6mm) hole in the exact center of the body cap, and sand down any major messy edges around the hole.

STEP 2:
Cut a piece of metal about $1/2$" (13mm) square. **a**

STEP 3:
Tighten your needle into the craft knife to give it a handle and gently twist the needle into the center of the metal square. Be sure to twist and not just push—you need to make a perfect circle, so *gentle* is the key word here. **b**

Note:

A smaller-size pinhole will grant a higher level of clarity in your photos. Since the whole point of shooting a digital body through a pinhole lens is obviously not sharpness, you can just make the hole a comfortable size with your needle. We recommend making several different holes, each on a separate metal square, to find which size is your favorite.

STEP 4:
Carefully sand both sides of the hole, then twist the needle back into it to poke out any slivers that got pushed in when sanding. Repeat this step until you have a smooth, clear hole, free of any raised metal edges. (A loupe comes in handy to see the hole magnified.) **c**

STEP 5:
Securely tape the pinhole to the outside of the body cap, centering the hole inside the bigger cap hole. That's it; you've just made a lens! **d, e**

a

b

c

tip

And now here's the fun part: time to shoot! You'll need to set your camera to fully manual—exposure and focus—and then just experiment to find what works best for you. You'll need a long shutter speed, so a tripod is a useful tool, but you can substitute a tabletop or shelf, or just let there be motion blur. With your fixed pinhole aperture, you can play with shutter speed, ISO, and lighting combinations to find the outcomes that you like best. This is the beauty of digital— the trial-and-error method is quick, easy, and free!

d

e

PINHOLE
MAGIC!

RESOURCES
Where to Find Awesome Stuff

As a great philosopher once said, creativity is 1 percent inspiration, 10 percent perspiration, and 89 percent knowing where to find cool stuff. So here's the dirt on where you can find the cool stuff you need. You'll be able to find supplies to make any of the Photojojo projects in here, but don't forget to stop and smell the glue. Er, sorry, roses. You may find things in here that inspire you to make up brand-new projects of your own!

Online Photo Sharing: Photojojo's Top Three Sites

Everybody's talking about online photo sharing, but there are a bazillion different websites out there clamoring for your attention. How do you know which one is right for little ol' you? Sites such as Shutterfly, Costco, Snapfish, and Kodak Gallery all boast cheap prints, but there's a lot more you can do with your photos online.

Here's our guide to our favorite ways to share photos on the Web:

Flickr (www.flickr.com)

First of all, Flickr is really easy to use, and the free basic account gives you loads of storage space. You can order prints and create photo books, just like the other photo sites. You can even personalize your credit card or make business cards with your photos.

The thing we like best about Flickr, though, is the community. We follow lots of people we only know from Flickr, but we still consider them our friends. People from all over the globe use it to share their photos.

There are games to play, groups to join, and tons of independent applications available to enhance the Flickr experience. We even know people who have had their photos published just because somebody liked what they saw on Flickr.

Picasa Web Albums (picasa.google.com)

Picasa is a combination photo organizer and photo-sharing site. You can download the free software (designed by Google) to organize and edit your photo collection. (As of now, the software is only for PC users, but it's so similar to iPhoto that Mac users don't really need it.) You can crop photos, enhance color, take out red-eye—all the things you need to gussy up your photos. It's easy to use, makes exporting and posting photos to your personal website a breeze, and even lets you geo-tag your photos so people know where you took them!

Picasa Web Albums is an online gallery site where you can share albums with your friends and family. Both PC and Mac users can use Picasa. You can add captions and comments and even download whole albums. It's fast, simple, and looks good. And with 1GB of storage included for free, it's not too shabby.

Facebook (www.facebook.com)

As of this writing, more photos are uploaded to Facebook than any other site. It's great for sharing pictures with your existing friends, and you can upload as many photos as you want for free.

Our favorite feature of Facebook is the ability to "tag" photos. If you have a photo of one of your friends, you can "tag 'em." Your friend will get an e-mail about it instantly, and it will automatically be collected in his or her profile photos.

Heck, most of us are on Facebook all the time anyway; why not keep our photos on there as well?

Image-Editing Software

You really can't function as a digital photographer without one of these programs. Seriously. You'll need to color balance, adjust exposure and contrast, or at the very least, resize your images so you can print at home.

The software you use doesn't have to be pricey or fancy, but you definitely need something. Chances are, some form of image editor or organizer came bundled with your computer or camera. If not, here are a few choices to consider:

Photoshop: The gold standard of image-editing software, Photoshop is the one all the others imitate, and with good reason: Adobe has spent loads of time and effort developing it into a great product. Unfortunately for most of us, it's also really expensive.

If you can't acquire the full program, Photoshop Elements is a limited but decent substitute that comes bundled with some digital cameras and scanners. There is also a free Web-based version called Photoshop Express (www.photoshop.com/express).

iPhoto: If you have a Mac computer, you already have iPhoto. It's a good, serviceable program that lets you crop, adjust color balance, set your print size—the basics. If you need to perform more complicated functions than basic editing and organization, you may need something stronger.

Picasa (picasa.google.com): A whole lot like iPhoto, Picasa is a free software download for Windows-based computers. Great for organizing, basic editing, and photo sharing, it's one of the best options out there.

GIMP (gimp.org): Stands for GNU Image Manipulation Program. It's a whole lot like Photoshop, and it's free. Like Photoshop, it can do a lot of really cool stuff, which means there's a lot to learn when you start using it. If you need a more powerful image editor than iPhoto or Picasa, and you don't have a rich uncle from Australia, bring out the GIMP.

Three Great Ways the Web Can Decorate Your Walls for You

Vector Magic (vectormagic.com): Ever had Grandma Edna e-mail you her latest vacation cruise photos, only to find the images so small and pixelated that she and Gramps look like they were made of LEGOs? Vector Magic has the answer. A free website from the folks at Stanford, Vector Magic takes your raster

images (such as jpegs) and turns them into smooth vector drawings.

Unlike raster images, vector drawings are made of geometric shapes instead of pixels, so you can infinitely resize them with no fuzziness or blockiness! This makes them ideal for blowing up a small photo to, say, the size of your bedroom wall. The nice thing about Vector Magic is that it's Web based and will run on most computers. Plus, its algorithms do an impressive job of translating photographs into realistic vectors—something others choke on.

So dump those passé pixels . . . and give your tiny photos a new photographic life, smooth and vectorized!

The Rasterbator (homokaasu.org/ rasterbator): Not since we used PrintShop on our Commodore 64 has mural printing been this addictive. The Rasterbator is a website that makes printing your photographs HUGE way easier (and way cheaper) than the print jockeys at your local copy shop. It's simple: Upload your jpeg file to the Rasterbator and it spits back a printer-friendly PDF. Use your trusty, or crummy, inkjet (or better yet, the laser printer at work) and a few minutes later you're holding a Rasterbated bundle of sheets ready for assembly into one chic wall mural.

Take that, small.

Block Posters (www.blockposters.com): Wanna blow up Uncle Lou to Leviathanlike proportions without breaking the bank?

Lou might be a Luddite, but you're not. So before you head out to get an expensive enlargement made, hit the Web. Block Posters will turn any photo into a poster using the printer in your home or office. Tell it how many sheets you want to use, upload your pic, and seconds later it'll spit back a PDF. Hit Print, piece together the sheets, and you've got yourself one pixelicious photo poster!

What's the difference? Vector Magic smoothes out pixels into Adobe Illustrator–like shapes, like the look of a silkscreen or woodblock print. Rasterbator gives your photos a newspaperlike dotted quality, while Block Posters preserves the appearance of the original photo. They're all pretty nifty!

Online Sources

At Photojojo, we spend our time chained to our computers. Literally. The Overlords come to loosen our manacles once a year (on Arbor Day—it's a very underrated holiday). Naturally, when we need something, we turn to the vast resources of The Interwebs. Here are some of the sites we like to buy stuff from (but please don't tell the Overlords we were shopping at work):

Amazon (www.amazon.com): Sometimes it seems that you can find anything you can think of here. The search function makes this a good place to start your search when you're trying to find a specific type of item and don't know where to look.

B&H Photo (www.bhphotovideo.com): All hail the photography mecca. Sure, you can find better deals if you search around the Web, but B&H usually has everything you could possibly need in terms of photo gear and accessories.

The Crafty PC (www.thecraftypc.com): A good source of specialty inkjet papers, such as backlight film and metallic paper, and loads of craft supplies designed for inkjet photo transfers.

Decal Paper (www.decalpaper.com): Inkjet-printable tattoo decals! Awesome. Their stock also includes decals that transfer photos to a variety of surfaces, including wood, ceramics, and wax.

Dick Blick (www.dickblick.com): Heaps upon heaps of art supplies, this is the place to go if you don't live near a well-stocked art supply shop.

Etsy (www.etsy.com): Good place to look for craft supplies if you need a small amount of something specific. You can get good deals when other crafters empty out their stash of supplies. Use the search function to find what you need.

Icing Images (www.icingimages.com): This is where we got our photo cupcake icing sheets. Of course, there are other sources for similar products, such as www.photofrost.com and www.kopykake.com.

Inkpress (www.inkpresspaper.com): Manufacturer of the photo canvas we use in some of our sewing projects. See the Inkpress dealer list for a source near you.

National Artcraft (www.nationalartcraft. com): This vast virtual warehouse was our source for inkjet-printable fabric sheets (we used the 200-thread-count cotton sheets). Chances are if you need something specific for an obscure craft project, you'll be able to find that here, too.

Brick & Mortar Shops:

In our capitalist peregrinations (i.e., shopping trips to find supplies for this book) it was often easier to just stop in at the local big-box strip mall and gather lots of supplies at once.

If you live in an area that has great local craft stores, fabric stores, hardware stores, and art supply shops, by all means take advantage of them and support local businesses. If not, go ahead and stock up at the most convenient place. For us, those included the helpful folks at:

Ace Hardware: www.acehardware.com, (866) 290-5334

Home Depot: www.homedepot.com, (800) 553-3199

Ikea: www.ikea.com

Jo-Ann: www.joann.com, (888) 739-4120

Michaels: www.michaels.com, (800) 642-4235

Office Depot: www.officedepot.com, (800) 463-3768

Pearl Art & Craft Supply: www.pearlpaint .com, (800) 451-7327

Radio Shack: www.radioshack.com, (800) 843-7422

Staples: www.staples.com, (800) 378-2753

Target: www.target.com, (800) 440-0680

Utrecht: www.utrechtart.com, (800) 223-9132

Walgreens: www.walgreens.com, (877) 250-5823

Thanks to everybody that helped us as we wandered (wall-eyed and dazed) from aisle to aisle.

CONTRIBUTING GURUS

We can't begin to tell you how amazing these contributors are. Some of them wrote for Photojojo back in the day, some are Photojojo readers with brilliant ideas, and some are heroes of ours with which we have always wanted to work.

Daniel Bigler (page 177) blogs about things, does handstands while balancing bananas on his nose, and eats quarters—all on his website, www.thisisdaniel.com.

Kate Bingaman-Burt (page 137) is an assistant professor of graphic design at Mississippi State University. She is currently hand drawing all of her credit card statements until they are paid off. Visit her at www.obsessiveconsumption.com.

Steven Dodds (page 19) is author of *Tools* and *Re-Creative*. He has been a guest on the HGTV show *She's Crafty* and has written for *Readymade* magazine. Steve works as an architect and designer in New York City and lives with his wife, Jerry, and daughter Samantha.

Norieah "Doe" (page 140) is one awesome Photojojo reader. All we know about Norieah is that she sent us a great idea. But then we couldn't reach her, so we'd like to say, Thanks, Norieah! That was a great idea!

Nichole Esmon (page 63) has a list of things to do before 2018 that includes making her own cream soda, paying for a stranger's dinner, and spending a night on a train. Visit her at www.esmon.net.

Derek Fagerstrom & Lauren Smith (page 32) left their super fun, kinda crazy lives in New York City and went home to the San Francisco Bay Area to start up the Curiosity Shoppe (www.curiosityshoppeonline.com) for the simple reason that they're obsessed with beautiful things.

Raul Gutierrez (page 143) the photographer and blogger, is not to be confused with Raul Gutierrez, the Fu-Shih Kempo Knife Fighting Master. Visit him at www.mexicanpictures.com/headingeast.

Michael Herzog (page 106) morphs simple materials and common items into simply elegant and useful design items. Michael sells his designs and publishes DIY instructions for them on DoDesignDIY.com.

David Hobby (page 109) is a professional photojournalist. David writes the best darn photography lighting blog known to man. We do not exaggerate. Check out the goods at strobist.blogspot.com.

Julie Jackson (page 72) is the gal who lived in Rome for a semester and never once saw the Sistine Chapel because there were too many Fiorucci stores in her path. Visit her at subversivecrossstitch.com.

Alicia Kachmar (page 62) is a writer, photographer, and all-around smart cookie. She writes a blog about cooking, crafting, photography, and traveling. She also sells the cutest crocheted critters around at EternalSunshine.etsy.com. Visit her at www.aliciakachmar.com.

Amy Karol (page 87) is the author of a crafty book about sewing, *Bend-the-Rules Sewing*. Amy lives in Portland, Oregon with her husband and three beautiful daughters. Visit her at angrychicken.typepad.com.

Zach Klein (page 134) is a decent, creative, and productive guy living in Brooklyn. Visit his websites, secretenemyhideout.com and www.zachklein.com.

Melissa Lawson (page 177) is a student at Massachusetts College of Art in Boston. She loves making and reading zines, sewing, bleaching her hair too much, and bringing her six cameras everywhere she goes.

Nikki Mans (page 29) makes stuff and sells it on Etsy at whimsylove.etsy.com—some days she's a wacky goofball ("whimsy") and other days she's a girly romantic ("love"). Read her blog at whimsy-girl.blogspot.com.

Taylor McKnight (page 130) currently spends his time making his websites, The Hype Machine (hypem.com) and SCHED* (sched.org), rock. After completing two Project 365s he started a Flickr Group for others to participate. Join more than 5,000 members at tmcknight.com.

Kristin Meier (page 160) can usually be found leading a posh and glamorous life as a teacher, traveler, and photographer extraordinaire. Most recently, however, she has gone undercover as a suburban minivan-driving mom to three groovy kids and loves it.

Lee Meredith (page 182), also known by the moniker Leethal, is a designer, photographer, and creator of things from who lives in Portland, Oregon. She sells her home and clothing accessories, and shows you how to make them yourself, on her DIY blog and zine (do stuff!), all found at leethal.net.

Graham Moore (page 124) is a graphic designer who specializes in DIY techniques and actually gets his hands dirty. He teaches at Art Center College of Design in Pasadena, California.

Matt Nuzzaco (page 146) is a genius by day, photographer by night, and friend to small animals everywhere. You can learn more about him at www.nuzz.org.

Youngna Park (page 134) likes words, books, storytelling, letter-writing, bright colors, and delicious food, which she sometimes writes about. She lives in New York City. Visit her at www.youngnapark.com and her photography at jenbekman.com and www.20x200.com.

Shannon Patrick Ramos (page 161) spent a great deal of his childhood playing with friends, making up rules for games, and generally running amok. Visit him at shannonpatrick17.blogspot.com.

Whitney Scott (page 141) is a full-time mom and photographer. She lives with her husband and two children in Carthage, Missouri, where her zany life is viewable for all to see at www.scottphotography.org.

Liz Slagus (page 66) has taught new media art courses for the University of Connecticut and the University of Rochester via Eyebeam Education, for which she develops school, youth, & family-related courses.

Esther K. Smith (page 71) makes books at Purgatory Pie Press. Her work has been exhibited at MoMA, the Whitney, the National Gallery of Art, and London's Tate, among others. Esther is the author of *How to Make Books* and *Magic Books & Paper Toys*. Visit her at www. EKSmithMuseum.com and www.PurgatoryPiePress.com.

Danielle Strle (page 100) was born and raised in Normal, Illinois, where Strle was not always synonymous with Style. A year in Japan and a move to New York changed all that, and Strle has been styling ever since. Visit her at www.strlestyle.com.

Tiffany Threadgould (page 120) began designing when she lived in New York City. The garbage that lined the streets at night became the inspiration and material from which her designs evolved. She received her master's degree in industrial design and is still inspired by discards from the streets.

Cy Tymony (page 180) has always loved science. Cy's three *Sneaky Uses for Everyday Things* books teach how ordinary objects can be used in extraordinary ways.

Adam Varga (page 143, 169) is a photographer and web developer in New York City. He has hiked the Appalachian Trail, adopted a dog named Alex, and built countless awesome websites. Visit him at adamvarga.com.

CONTRIBUTING PHOTOGRAPHERS

Thanks to all the amazing readers and friends who let us use their photos for the projects in this book.

Mia Roca Alcover: page 109, above

Nadia Bahari with model Muhammad Danial Elyeas: page 135, below

Susan Buck: page 161, above right

Kate Bingaman-Burt: page 137

Hunter Block: page 160, below right

Kara Canal: page 63, below

Andrew Ferguson: page 135, above © Andrew Ferguson

Katarina Gavrilica: page 63, above

Ron Goebel: page 138

Raul Gutierrez: page 142

Alanna Hale: page 33

Matt Jourdian with model Trevor Bittinger: page 131, above right

Kolby Kirk: page 121, above; page 158, above

Jake Krohn: page 140, below

Tiffany Love: page 141, below

Taylor McKnight: page 128; pages 130–131, below images

Marcel Molina, Jr.: page 161, below right

Ricky Montalvo: page 6

Dan Morelle / www.danmorelle. com: page 150

Hanna Nikkanen: page 140, center

Matt Nuzzaco: pages 145, 147, 148

Enrica P.: page 160, below center

Bre Pettis: page 132

Kara Plikaitis: page 155, top; page 161, below left; page 173, right;

Whitney Scott: page 2; page 141, above

Sumul Shah: page 160, below left; page 161, below center

FLICKR

Addled: pages 12, 15, 25, 84, 87

alicia954: page 118

Amit Gupta: pages 12, 15, 25; page 26, below; pages 30, 48, 51, 74, 77–79, 88, 92, 93, 110, 113

amymat: pages 12, 15; page 16, left; page 18; page 25; page 26, above left

Andrew Wilkinson: pages 12, 15; page 26, above right; page 98, center; page 101, above right

Ankou: page 12

armisteadbooker: page 101, below right

autovac: pages 12, 15; page 98, below right

bhaggs: pages 12, 15

cel.: pages 12, 15; page 119, below

chriskalani: pages 12, 15

chromogenic: pages 12, 15, 37

Dave Schumaker: page 101, above

davebias: pages 12, 15

EmThree'd: pages 12, 15, 25

everyplace: pages 12, 15, 37

felipesimon: pages 12, 15; page 119, center

girlhula: pages 12, 15; page 119, above left

hunter~: pages 12, 15, 71; page 98, below center; page 101, below

Inkyhack: pages 12, 15

kthread: pages 12, 15

lomokev: pages 12, 15, 19, 105, 107, 108, 114, 117

matt semel: page 98, left

Mareen Fischinger: pages 12, 14, 15, 19; page 34, above; pages 37, 64, 66, 67

mattlehrer: page 12

maybe a mezzo: pages 12, 15, 94, 97

melissa..: pages 12, 15

mike arauz: pages 12, 71

mister mark davis: pages 12, 15

net_efekt: pages 12, 15

no3rdw: pages 12, 15

noradio: pages 12, 15; page 101, left

Not Emily: pages 12, 15

peter thomsen: pages 12, 15; page 26, above center

petrmara: pages 42, 44, 45

pingnews.com: pages 12, 15

reemer: page 12, 15

Rev Dan Catt: pages 5, 12, 15, 25; page 34, below; pages 36, 46, 152

sahadeva: pages 12, 15, 30

sesame ellis: page 12; page 16,

right; pages 18, 25; page 119, left; page 121, below sgoralnick: pages 12, 15, 37, 80, 83

shannonpatrick17: page 12

Squiz1210: pages 12, 15, 44, 45

starpuncher: pages 12, 15, 71

Stewart: pages 12, 15, 25

suchstuff: pages 12, 15

sumul: pages 12, 15; page 98, above right

susan Buck: pages 12, 15, 19

swissmiss: pages 12, 15, 20, 23, 25, 83

The Coyote: pages 12, 15

The Man in Blue: page 12

Tony Lupo: page 25

traviscrawford: pages 12, 15

TylerKnott: pages 12, 151; page 119, below right

uberwert: pages 12, 15

uapa: pages 12, 15

Vincent Kelly: pages 12, 15, 30; page 119, above right

William WM: page 12

Yellow on the Inside: pages 68, 71

youngna: pages 12, 15; page 102, center; page 104

Cross-Stitch Meets Photography (page 73): cross-stitch by Greta Poulsen

Photojojo would like to thank the following folks, who are chock full of awesome:

Arvind and Suman Gupta; Ankur Gupta; Bryan Noel; Clay Jensen; Doug Jensen and the whole Jensen family; Yashi Johnson and and the whole Johnson family; Susan Buck; Amy Matthews; Britta Ameel; Nathanael Johnson; Beth Goldstein; Reverend Dan, Modesty, and all the Catt family; Contessa Trujillo and Jeffrey Peña; Lunani Yen; Ayesha Mattu; Emann Mehmood; Mikee Lapid; Clare Bayley; Tom, Denise, and Yoshimi Collier; Derek Dukes; Todd Lappin and family; Faruk Ates; Atish Mehta; Lynn Collette; Yasmine Khan; Mathew and Michael Parker; all the superstars at Potter Craft; Danielle Svetcov and Jim Levine; Laurel Frydenborg; Laura Miner; Kara Canal; Heather Champ; Jen Bekman; Janelle Gunther; Mareen Fischinger; Sahadeva Hammari, and everyone who's subscribed to our newsletter, sent us tips or love notes, volunteered to help, and supported us.

—We do this for you.

INDEX

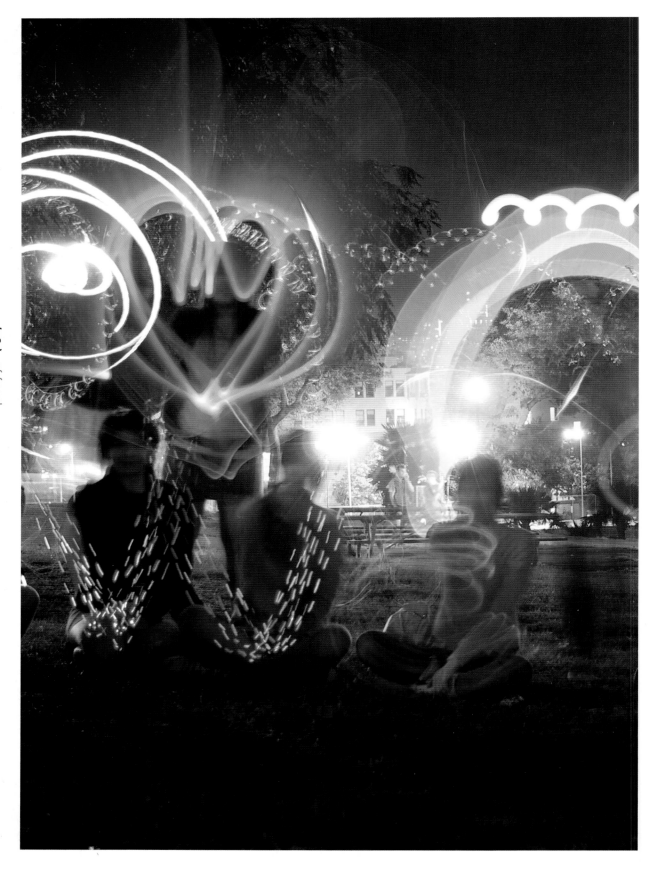